thinking creatively

new ways to unlock your visual imagination

R O B I N L A N D A

HOW
**DESIGN
BOOKS**

CINCINNATI, OHIO

about the author

Robin Landa is a designer, writer and creative consultant to corporations, and Professor of Visual Communications, Department of Design, at Kean University, New Jersey. She is included among the group the Carnegie Foundation for the Advancement of Teaching calls the "great teachers of our time." She has lectured across the country and has been interviewed on radio, television, and the World Wide Web on the subjects of grahic design, creativity and advertising. Most recently, her article "Invisible Advertising" appeared in *Digital Steam* magazine on the World Wide Web, and "Do the Twist," about creative visual thinking, in *Critique* magazine.

Robin Landa has written four books about art and design, including the recently published *Graphic Design Solutions* (Delmar). She has won many awards from many organizations, including the New Jersey Authors, the National League of Pen Women, National Society of Arts and Letters, Art Directors Club of New Jersey, and Creativity 26.

Library of Congress Cataloging-in-Publication Data

Landa, Robin.

 Thinking creatively: new ways to unlock your visual imagination / Robin Landa. — 1st ed.

 p. cm.

 Includes index.

 ISBN 0-89134-843-3 (hardcover)

 1. Commercial art—Design. 2. Visual communicationPsychological aspects. 3. Graphic arts—Technique I. Title

NC1000.L36 1998 98-18728

741.2—dc21 CIP

ISBN 1-58180-338-9 (pbk: alk paper)

Editors: Lynn Haller and Joyce Dolan

Production Editors: Saundra Hesse and Amy Jeynes

Designer: Brian Roeth

Interior Production: Ruth Preston

Cover Illustration: Celia Johnson

For Harry, my forever tango partner.

acknowledgments

There is a clear level of excellence and creativity in the graphic design profession. This book is a homage to all the brilliant designers, illustrators, art directors and copywriters who take creative leaps. Great thanks to all the generous professionals who contributed their outstanding work; their names appear next to their work. And special thanks to Denise Anderson, Arnie Arlow, Steven Brower, Rick Eiber, Karl Hirschmann, Martin Holloway, Mark Kaufman, Susan Knape, Eva Roberts, Jilly Simons and Rick Tharp for their interviews.

Heartfelt thanks to Lynn Haller, acquisitions editor, whose great skills, pithiness, humor and savoir faire made this book work. It was my great fortune to work with Lynn.

Also, much thanks to Joyce Dolan, Kate York, Saundra Hesse, Brian Roeth, Amy Jeynes and all the fine professionals at North Light Books.

Kind thanks to my colleagues Denise Anderson, Rose Gonnella, Martin Holloway and Alan Robbins for their support and contributions. Much apprecation to my students for continually inspiring me.

My friends and family were, as always, very supportive of this endeavor. Thanks to Albert Boulanger, Victor Eskenazi, Don Fishbein, Lillian and Bernard Fishbein, Susan Damsky, Paul Fields, Angel Figueroa, Tony Guggino, Nathan Daniel Hescock, Greg Leshé, David Oliveira, Robin Paiken, the Rogers family, and Keith Van Norman; thanks to Benjamin Soencksen for his translation and to the staff and faculty at Stepping Out Dance Studio in New York City, who provided a wonderfully creative haven.

Loving thanks to my mother, who suspected I was working on yet another book but had the good grace not to nudge me about it.

And finally, sweet thanks to my *tanguero*, Dr. Harry Gruenspan, who has forever changed my life.

table of contents

thinking about
visual thinking

How to get through the creative process, how to problem solve, and the importance of form
and content to design. This section includes determining objectives and strategies, developing
design criteria, doing research, creating a concept, designing, dealing with clients, form, content
and the interdependence of form and content.

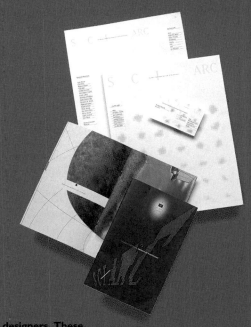

part two | 34

visualization and stimulation: creative approaches and exercises

Includes sixteen creative approaches to graphic design employed by top designers. These approaches will change your graphic design techniques forever and will tap into your creativity like nothing else. It also includes forty-five visual thinking exercises (plus twelve "celebrity" exercises) you can use to enhance your creative approach to specific graphic design problems or as a visual workout—mind-blowing experiments you won't find anywhere else.

part three | 132

visual thinking in practice

Interviews with Denise Anderson, Arnie Arlow, Steven Brower, Rick Eiber, Karl Hirschmann, Martin Holloway, Mark Kaufman, Susan Knape, Eva Roberts, Jilly Simons and Rick Tharp demonstrate how creative thinking is applied in the real world of graphic design.

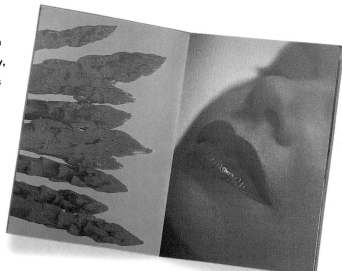

introduction

There are only two approaches to design: the pretty and the smart. The designer who takes the pretty approach says, "I'll make this look good." Period.

The designer who likes to probe, investigate and experiment takes the smart approach and says, "Let me think about this problem, figure out a concept, consider the aesthetics, and express it visually."

The smart approach is the more difficult of the two. You have to struggle, ideate, ruminate, brood, interpret and explore. You must try different creative approaches and maybe fail. But when you succeed, you'll end up with an intelligent design solution. And when you take the smart approach, you're thinking creatively.

According to multimedia designer Alan Robbins, thinking creatively means two things: thinking about what you see and visualizing what you think.

It means that you analyze what you see, whether it's the work of other designers and artists or anything else. It means that you're a keen observer.

It's also the ability to think in visual terms—to understand the design language so well that you can manipulate the elements and principles to communicate an idea in visual form. You can take a subject, develop a concept for it and communicate its meaning through the visual language we call graphic design. You know which images, forms, shapes, type and colors are appropriate for the subject, and you can make the design creative and memorable.

Thinking creatively requires three abilities:

• Problem solving—the formulation of concepts and solutions

• Creativity—to see possibilities in any given problem

• Visualization—the representation of concepts in visual form.

We all know that making things aesthetically pleasing is a large part of what designers do. It's what separates the designer from the nondesigner with access to clip art and page layout software. But there's much more to design than just making things look good. The art of graphic design is about using words and visuals to create effective communication. After all, a designer is an idea person who has the ability to communicate through a visual language.

"Prettying something up" is not the most important part of design. Creative visual thinking is.

Here's What This Book Can Do For Your Graphic Design

Based on the philosophy that there's much more to design than just making things look good, this book addresses several crucial issues.

PART ONE, THINKING ABOUT VISUAL THINKING, explains and explores the vital steps involved in solving a graphic design problem. Creativity and problem-solving are interdependent in graphic design.

A creative solution to a client's problem is appropriate, functional, and memorable; communicates; has impact and visual interest; and is stimulating and well-executed. This section tells you how to get through the process and how to problem solve. It also takes an in-depth look at the critical interdependence of form and content.

PART TWO, VISUALIZATION AND STIMULATION, expands your vision and opens your mind's eyes. The sixteen creative approaches outlined in this section will make you see things in a fresh way, a new light. They spice up things. They are intelligent and relevant. These approaches will change your graphic design forever and will tap into your creativity like nothing else. The examples will allow you to see how master designers utilize creative approaches.

Use the forty-five visual thinking exercises to enhance your approaches to specific graphic design problems, or do them as a visual workout. The exercises are wonderfully varied; some are inspired by the arts and literature, some address practical applications and some are pure creative jolts. These exercises are eye-opening experiments in creativity you won't find anywhere else.

PART THREE, VISUAL THINKING IN PRACTICE, offers eleven interviews and an afterword on inspiration and stimulation. Graphic designers are creative artists who solve practical problems. These interviews demonstrate how creative visual thinking manifests itself in the real world of design practice.

Graphic designers cannot live on design annuals alone. In this section, you'll learn what other designers and art directors do for inspiration and stimulation. And after you read it, maybe you'll go on and do some knock-out creative visual thinking of your own.

thinking about
visual thinking

part **one**

When you see a design that makes you say, "WOW!" it's most likely the result of creative visual thinking. Creative designers think about what they see and are able to see what they think. **Creative visual thinking** is about solving communication problems, conceptualizing, exploring and experimentation. Creative designers find the *process* as interesting as the design *solution.* This part walks you through the essential steps in the creative process, while showing you designs that have benefited from creative visual thinking at its best.

The Creative Process

It is virtually impossible to employ creative visual thinking without going through the practicalities of the creative process and approaching graphic design as a problem-solving discipline. As designer Martin Holloway says, "It is important to keep in mind that in graphic design, problem-solving and creativity occur simultaneously. If graphic design does not solve a problem, then it is simply self-indulgence—a kind of pointless talking to one's self."

Artistic Yet Practical

Graphic design brings together two different things: artistic creation and the practical world of commerce. A designer is a creative artist who deals with the realities of planning: client needs, craft, materials (papers, inks, glues and varnishes), budgets and visual communication.

"Design is intelligence made visual. Your solution says a great deal about your research methods, organization, attitude, experience and creative process, as well as your design skill," says Rick Eiber of Rick Eiber Design (RED).

Creative Solutions

A designer must make connections in the mind between creativity and process in order to successfully communicate a message to an audience and answer a client's needs.

Let's say a client needs a logo—a visual mark to express the spirit or personality of her company. A graphic designer can solve that problem. According to noted historian Philip B. Meggs, "Graphic designers characterize themselves as problem-solvers and, by definition, are hunters engaged in a search for solutions."

The graphic designer hunts for a solution and then presents the client with a logo or two. While great solutions probably pop out of some designers' heads like Athena bursting from Zeus, most good designers follow the same fundamental steps in hunting for solutions. These steps are:

- Determining objectives and developing a strategy
- Determining design criteria
- Doing research
- Creating a concept
- Designing

It's hard to jump-start a creative solution that exhibits great visual thinking skills without these fundamental steps. Let's examine them in more detail—and I'll include a few useful questions you should ask yourself when coming up with your own creative concepts.

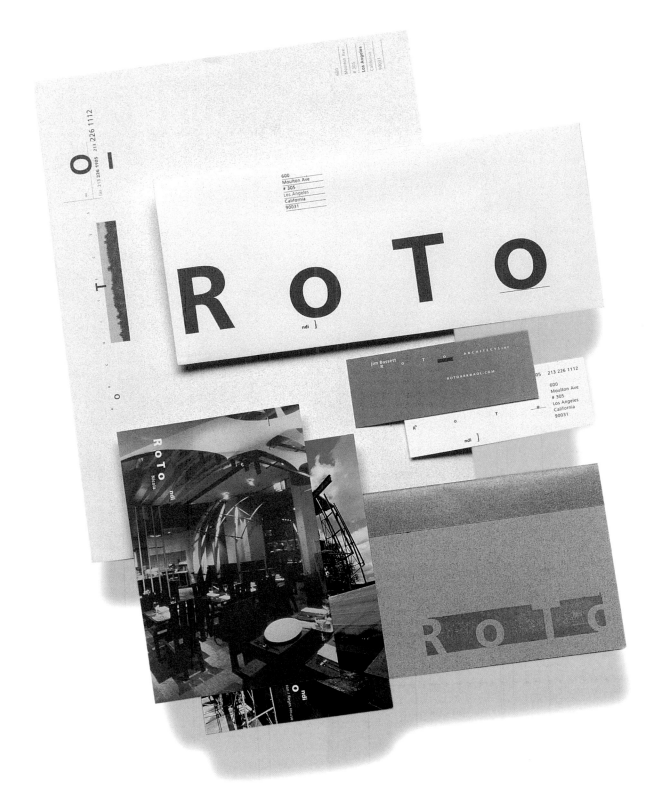

title: RoToArchitects Identity

description of work: Name, logotype, stationery system, minipress kit and project postcards

design firm: April Greiman/Los Angeles, CA

designer: April Greiman

digital photographer: April Greiman

client: Michael Rotondi/RoToArchitects

"Michael Rotondi formed his own business, and he wanted me to make a logo from his last name. I came up with RoTo and ndi. Typically people misspelled his name Rotundi—therefore, the RoTo with a line under the second o. RoTo was so great to work with graphically and sounded playful. Later, he went into partnership and the name evolved into RoToArchitects. We then went from seeding the name with the correct spelling of RoTo to adding 'site or place' with the digital image on the letterhead."

Determine Objectives and Develop a Strategy

A client has a specific need, like a promotional brochure or a shopping bag design. Most often, the client has objectives—things this project should accomplish. Sometimes the objectives are clear and articulate; sometimes they are muddled and difficult to decipher. For example, the client may say, "I need a poster to advertise an upcoming sales conference for company employees." That's clear. Or he may simply say, "I need something for a conference." That's not clear, and you'll need more information in order to proceed.

If your client's objectives are clear, your task is a lot easier—you have been told what problem you've been hired to solve. If they are unclear, you must discuss them further with the client in order to clarify them. Why? That's simple: If you don't know what the problem is, you won't be able to solve it.

Steps to Determine Project Objectives and Strategy

STEP 1. Talk to the client. Clarify the objectives. Make sure you know what the client really needs and thinks. Listen carefully. Denise M. Anderson, design director of DMA, suggests asking the client these questions:

- What is the history of your firm?
- What are your short term and long term goals?
- What do you want this project to achieve?
- What work have other designers done for you previously? What were the results?
- What is your business/marketing strategy?
- What do you want to convey about your firm? Your product?

STEP 2. List the objectives. Then write a statement for each graphic design problem consisting of a clear, succinct description of your objectives. This statement should summarize the key messages that will be expressed in the design—for example, facts or information, desired spirit or image, unique points and position in the market. This statement is the narrative or verbal version of the visual you need to create. Keep going back to this statement as you design to make sure you're on track; you can also use it later to demonstrate to the client the rationale behind your design.

STEP 3. Devise a strategy, that is, a plan to execute your objectives as effectively as possible. Design strategy is determined by goals, objectives, audience and marketplace. A strategy is *not* the same as a design concept. A strategy is a plan of action; a design concept is a scheme to solve a design problem. However, strategy and concept are interdependent; you go back and forth from one to the other to solve the design problem. With or without your client's help, work out a plan of action intended to accomplish your objectives or goals.

creative solutions

To ultimately provide a creative solution for your client, keep in mind these goals while determining your objectives and developing strategy:

- Clarity. Make sure you understand the client's needs.
- Thoroughness—enough to blow past the competition.
- Thoughtfulness.
- Intelligence.
- Insight into the audience.

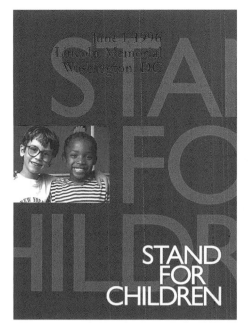

title: *Stand for Children*

description of work: Promotional materials

editor: Darrell Fearn

designer: Melanie Alden-Roberts

client: Stand for Children/Children's Defense Fund

"These pieces were part of a family of materials promoting a rally in Washington. Posters utilizing the same art as the postcard were posted all over the city. These materials reduced the focus of the rally to one thing: children. Simple and easy to understand. Nothing unnecessary was used. The colors are playful and friendly, as a child's world should be."

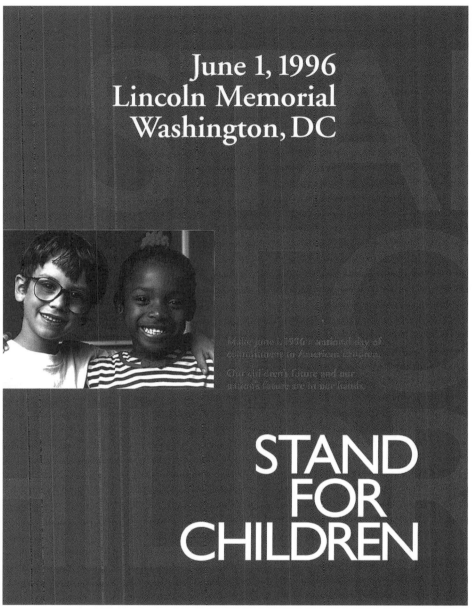

Clarify Your Objectives and Strategy

These questions will help clarify your design objectives and strategy for each project:

- What is the function of the design?
- What is its purpose?
- What is its role in the greater marketing plan?
- Who is the audience?
- Where will it be seen and for how long?
- What spirit should be conveyed?
- What are the unique (or common) selling points of the product, service or organization? Where is it ranked in the marketplace?

Let's examine each question in more detail.

What Is the Function of the Design?

All visual communication is functional. For example, a pictogram on a restroom door signifies gender. An advertisement is meant to promote sales, distinguish a product, inform, provoke, motivate and call the consumer to action. An editorial layout can enhance communication and readability, and add interest.

A designer is a creative consultant to a client, someone who best understands what the client needs and what a graphic design piece can do for the client's business. Realizing that all visual communication is functional allows a designer to suggest the appropriate vehicle.

Understanding the vehicle's function also allows the designer to make intelligent decisions about form and content. How graphic elements and principles are used varies from vehicle to vehicle. Where a piece will be seen, from what distance and in what context, all contribute to how it functions and how it will be designed. For example, a poster is seen from a distance; therefore, type and visuals must be larger in size than in an editorial layout.

What Is the Purpose of the Design?

All graphic design serves a purpose. Most often, it falls into one of three categories: information, editorial or promotional.

- Information design informs and identifies. It includes corporate identity systems, logos, letterheads, menus, symbols, pictograms, charts, diagrams, maps, calendars, Web banners and sites, and signage.
- Editorial design is the design and layout of publications, and includes magazines, newspapers, books, annual reports and other corporate publications, newsletters and periodicals.
- Promotional design is meant to promote sales or to persuade. It includes advertisements (print, TV, WWW, direct mail, billboards), invitations, packaging, point-of-purchase displays, brochures, sales promotions, T-shirts, posters, book jackets and album covers.

At times, these categories overlap. A poster, for example, informs. However, it is also intended to promote.

What Is Its Role in the Greater Marketing Plan?

Most individual design pieces are part of a larger marketing effort. If a corporation has a visual identity, all design pieces for that corporation should relate to the identity. Most designers provide a standards manual for a visual identity system or logo. The spirit of each piece should also convey the spirit of the company.

Who Is the Audience?

You need to identify your consumer market. Consider the following audience characteristics:

- Is it a local, national or international audience?
- Does it range or vary in age?
- Is it one gender or ethnic group?
- Is it a trade or professional group?

Where Will It Be Seen and For How Long?

Where will your design be seen? Will it be alone or lined up next to the competition on a shelf or display or on an electronic screen? Will it be seen up close like a business card, or from a

title: *Why London?*

description of work: Marketing brochure

design firm: George Tscherny, Inc./New York, NY

designer: George Tscherny

client: PKL Limited

PKL Limited rents and sells real estate in London. The premise in leaving the company's name off the cover was the strategy that they needed to 'sell' the city of London before selling the company. The result was a cover that teased the reader into turning the page for answers to that question.

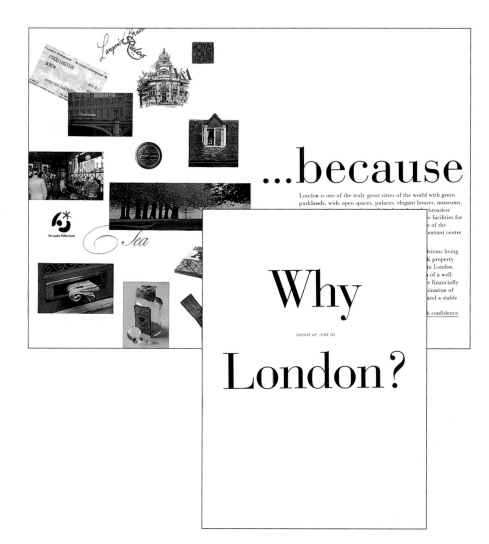

distance like a poster? Is it a seasonal or short-term piece, or will it be used for a long period of time?

Answering these questions helps you determine size, color, type, shape and materials to use, as well as impact and speed of communication.

What Spirit Should Be Conveyed?

Just like people, every company should have a spirit or personality. But how do you identify it? The company's purpose or product is the point of departure for determining its spirit.

Let's say the product is a cereal. What kind of cereal is it? Is it sweet and aimed at kids, or nutritious and geared toward health-conscious adults? Is it hot or cold cereal? With basic questions like these answered, you can then determine the personality of the product. For example, it may have a "fun" personality. Or it may convey "healthy but light-hearted" or "serious fiber."

What Are the Selling Points and Ranking of the Company?

Unless the company you're designing for is the only one of its kind, most likely there are similar products or services on the market. Hunt for ways that your design can distinguish the product or service.

Perhaps it's a parity product, that is, a product that's not significantly different from the competition. If so, you could simply take one quality and "own" it. An owned quality or proposition is valuable, because it's something the audience will associate with your company alone. Take a product like women's slippers, for example. It could own comfort. Elegance. A flattering style. Washable fabric. Your design, whether it's an ad, package or label, can reflect an owned quality.

Is your company's product or service the finest? The worst? Average? Most expensive? Least expensive? You need to know how it is valued in the marketplace.

Determine Design Criteria

Not all clients have millions to spend. Whether you are designing for print, the Web or TV, there are usually limitations as a result of budget and time constraints, availability of materials like paper, printer's capabilities, media costs or downloading time on the Web.

Budget, time and usage are the main factors. How much money has been budgeted for the entire project? Is there money for hiring experts like photographers, copywriters, Web programmers or models?

How much time do you have to get this produced? How long will the printer, the illustrator, the copywriter and Web or video production take?

"The time constraints that have been foisted upon us in the brave new digital/cellular/wired world force me to have a little self-discipline," says Mark Kaufman of Art O Mat Design. "I'm not always chasing windmills; I need to focus on a couple of good ideas instead of being all over the map with a dozen mediocre ones. Even though we might do hundreds of thumbnails at the outset of a job, most are weeded out, some are filed away for future use, and we're usually left with two or three starting points. What you do with these is where the creativity is."

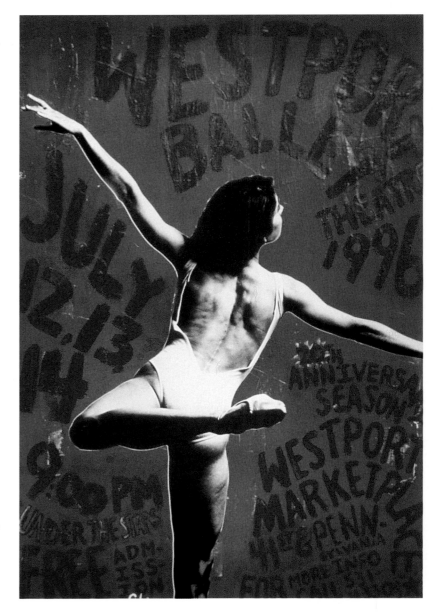

title: Westport Ballet Poster

description of work: Poster

design firm: Muller + Company/Kansas City, MO

designer/illustrator: Jon Simonsen

photographer: Kenny Johnson

client: Westport Ballet

"This poster combines the grace of the ballet with the gritty feel of the Westport district in Kansas City. The creative leap this poster takes is in its homemade design. The image is a simple black and white ballerina, while all the typography is hand-painted, giving it almost a spray-painted look. The effect is an elegant ballet poster that doesn't get too snooty for its audience."

Research

Usually, your client will provide the research—the essential and pertinent information about the product or service. However, that may not be enough information, and off you must go to do additional research.

You can never know too much about your product. Sometimes a fact or visual you find leads to a concept. And thanks to CD-ROMs and the Internet, finding information has never been easier. So there's no excuse for skipping this step.

title: The Mexican Museum Twentieth Anniversary Poster

description of work: Poster

design firm: Morla Design, Inc./San Francisco, CA

designers: Jennifer Morla, Craig Bailey

client: Bacchus Press

"The Mexican Museum Twentieth Anniversary Poster was designed to commemorate the museum's commitment to San Francisco and was meant to be enjoyed long after the museum's twentieth anniversary. The portrait of Frida Kahlo and the quintessential image of Our Lady of Guadalupe (Mexico's most popular religious icon), combined with Lotteria (Mexican Bingo game) imagery, vivid colors and twentieth-century wood block type, celebrate the Mexican culture and the museum's anniversary.

"As the museum was planning on using the poster to increase their visibility prior to their capital campaign drive, we wanted to get a full understanding of their beliefs about Mexican art. The director's stated vision was: 'I'm interested in enlarging the scope of what people think of as Mexican art and enlarging the definition of what American art is.' Using this idea as a guideline, we looked into both traditional and contemporary Mexican icons and incorporated them as a unified representation of the Mexican museum."

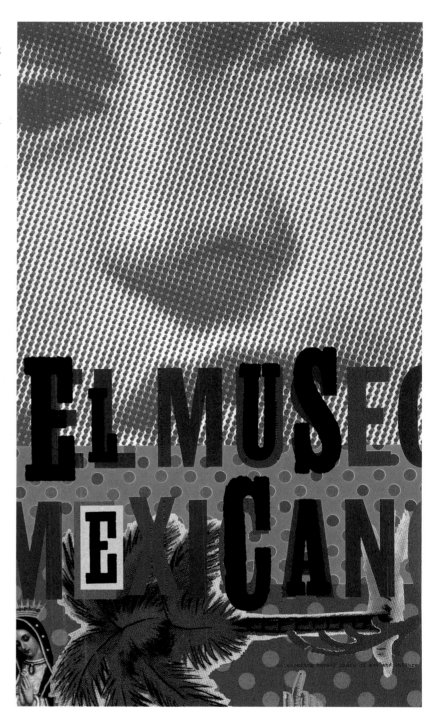

Create a Concept

A design concept can be defined as the creative solution to a design problem. Conceiving a concept is the hardest part of the creative process, the part that separates the creative designer from the mediocre one.

It's the underlying logic, thinking or reasoning for how you design a piece—the primary idea behind the piece. It is derived from instances or occurrences, born of a thought or notion. Some people call it a plan or scheme. Others say it's simply a new combination of old things.

You can formulate it or stumble upon it. You can discover it doing research or talking to the client. It can come to you in the middle of the night or in the shower. Even a song or movie can trigger a concept.

Essentially, it means you have a reason for what you are doing, for the imagery and colors you select, for cropping something or using a particular font. It's the framework for all your design decisions. It's the *raison d'etre*. This reason and the elements you use to convey it should accurately communicate the established objectives.

title: *Oh Really?*
description of work: Advertorial
design firm: Carbone Smolan Associates/New York, NY
creative director: Leslie Smolan
art director: Laurel Shoemaker
designer: John Nishimoto
copywriter: Berenter Greenhouse & Webster
client: Berenter Greenhouse & Webster for the British Tourist Authority

"High energy infuses high tea. Carbone Smolan Associates was asked by Berenter Greenhouse & Webster to design an advertorial on behalf of their client, the British Tourist Authority, based on the 'unexpected side' of Britain. The result was Oh Really?, a bold, colorful tribute to Britain. The high energy print promotion presents a variety of Britain's unconventional offerings with dynamic visuals and engaging copy. CSA's successful concepts and designs spice up tea time and showcase the untraditional offering of the merry ole motherland we all know and love."

what is a creative solution?

- It's a solution to the client's problem.
- It's expressed through the design medium/language.
- It's appropriate for the client/product, spirit and objectives.
- It communicates clearly.
- It's functional. A package has to open; a pictogram has to identify; a map has to direct.
- It has impact.
- It's memorable.
- It's original.
- It's fresh, stimulating, exciting and stunning.
- It's executed appropriately and well.

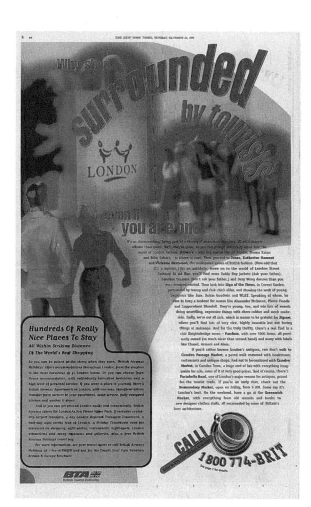

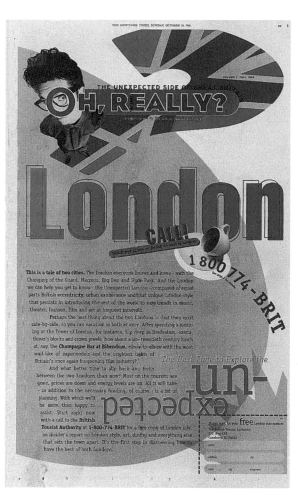

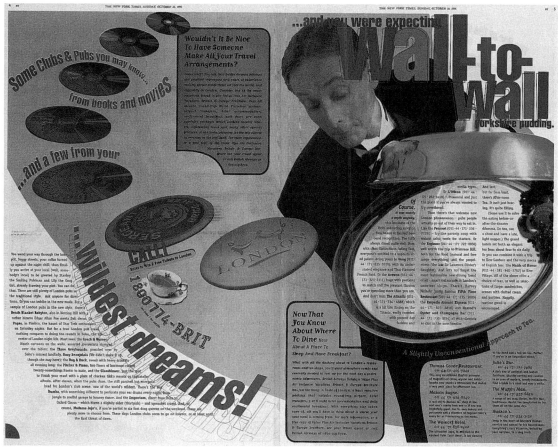

Develop the Concept

Your point of departure when developing the concept should be the objectives and strategy. You must know your subject and do your research. Then you think. Feel. Listen. Ruminate.

Here are some ways to help you develop a concept.

- Define your problem in your own words. Ask yourself: What do I have to do? How can I communicate it visually?

- Know the message. What do you have to communicate? Do you have to persuade people to buy something or give them information?

- Think. Use your intelligence. Your genius. Think it all the way through.

- Make a list of anything and everything related to your subject.

- Talk to people. Ask what they think about your product or company. Do a little homespun market research.

- Brainstorm. Take your list and think of anything analogous to it. Don't judge during brainstorming. Just keep thinking.

- Use a good dictionary. If you have an idea, look it up. Expand on it. Understand it fully.

- Look at visuals. Paintings. Book covers. Photographs. Wood type. Ephemera. Old toys. *Anything.*

- Fool around. Find some visuals related to your subject. Crop them. Chop them up and reconfigure them. Feed them through a fax or copier. Change textures. Explore.

- Ruminate. Go away and do something else. Put your project on the back burner. Relax.

- Take notes. Always have a pad and pen handy. (Don't trust your memory; you may forget. Besides, writing it down may lead to something else.) Write down everything you think of. It may be something you can use.

- Change directions. Maybe you can't think of anything because you're headed down the wrong path. Try another way.

- Analyze great movies or books, or other great designs or ads. Figure out how other people came up with concepts.

- Trust your intuition. If you have an idea, run with it. See where it goes. But . . . know the difference between a cliché and a fresh idea.

title: Paul Dresher Ensemble Poster
description of work: Poster
design firm: Morla Design, Inc./San Francisco, CA
designers: Jennifer Morla, Craig Bailey
client: Paul Dresher Ensemble

"This poster announces two music performances by the Paul Dresher Ensemble, an avant-garde musical troupe. The challenge was to communicate an awareness of the equal importance of both events. We used clear vellum to conceptually entice the audience to turn the poster over, highlighting the fact that there were two separate performances. In order to create this poster, we had to gain an understanding of the nature of the work done by the Paul Dresher Ensemble. The poster reflects the duality of the artist's work. Clear vellum stock was used, thereby creating two posters that could not be easily viewed as separate or united."

Slow Fire Paul Dresher Ensemble
Saturday, June 1, 8 p.m. in Concert
Friday, May 31, 8 p.m.

One Big Idea

Two Contrasting Evenings

Paul Dresher Ensemble 1996 Home Season

One Big Idea Two Contrasting Evenings
Four Premieres of Contemporary Music
One Last Chance to See the Performance
Classic SLOW FIRE

Friday May 31, 8 p.m.
We don't know what to call it, but we know what it is:
The Paul Dresher Ensemble Electro-Acoustic Band in Concert
An evening of uncategorizable contemporary music which shows stylistic boundaries to be as artificial as the Berlin Wall (and in need of similar treatment).

Featuring premieres by Paul Dresher, Jay Cloidt, Mark Applebaum, and Paul Hanson and performed by a group of musical virtuosi equally at home on the concert stage, night club, dance hall, or Bulgarian bandstand.

Performed by:
Phil Aaberg, piano & keyboard
Gene Reffkin, electronic percussion
Amy Knoles, electronic percussion
Paul Hanson, electric bassoon
Craig Fry, violin.

Center for the Arts
at Yerba Buena Gardens Theater
701 Mission Street in San Francisco

Tickets:
$12 Friday, May 31 Concert
$15 Saturday, June 1 performance of SLOW FIRE
Special $20 combined performance ticket!
$2 discount for students and seniors

Reservations and Information:
Center for the Arts Box Office, 415/978-2787
All BASS Outlets 510/762-BASS
or 415/776-1999
and TIX/Union Square

Design

The way you put everything together—how you arrange the elements—is the design. It's how you translate your concept into visual form. It's everything you learned in "basic design" in school and then some.

It includes the imagery or visuals, graphic elements and type or lettering. It's the materials you choose, such as paper, metal, glass or cloth; ink, coatings or varnishes; bindings and covers. The design involves craftsmanship—how well something is made—and it's grand if the design has a personal aesthetic, point of view or style.

Some designers just make things look good. That's not enough to qualify as creative. For a design solution to be creative, it has to have an underlying concept. Even the words *design solution* imply there is a problem to solve.

Fundamental Stages of the Design Process

First, you create thumbnail sketches, or small, rough drawings of your visual ideas. And yes, even today most designers still sketch them with a pen or pencil.

From there, you move on to roughs, which give you a clearer picture of the design.

Comprehensives (comps) are the next stage; they usually look as close to a printed or finished piece as possible. Computers enable us to create great comps, and most clients now expect to see comps that look like finished pieces. A designer usually shows three comps to a client. If you've done a good job at the outset of determining objectives and strategy and formulating a concept, your designs will probably be on target.

At this stage, the client may say, "I like comp A the best in general, but I like the typography in comp B better."

The designer will then rework the design and go back to the client for approval.

The final step is getting the design piece produced. Most designers build relationships with printers and vendors (illustrators, photographers, film houses and others, such as messenger

services). Establishing loyalties usually affords more flexibility; printers and vendors will grant more favors if you're a repeat customer. Denise M. Anderson, president of DMA and profiled in Part Three, recommends using medium-sized companies because they have sufficient capabilities but are still small enough to care about keeping your business.

Suggestions to Avoid Client Changes

- Get information up front to focus your design efforts.
- Make a genuine effort to solve the client's problem.
- Do your research so you can justify what you've designed as beneficial for the client.
- Have a rationale for everything you've done. Explain why it's the best possible solution and why it will help them. Remember, *you're* the visual communications expert.
- Sell your concepts to the client. A good salesperson gets work approved.
- Earn the client's respect.
- If you must make client changes, try to maintain the purity of the original concept as much as possible.
- Minimize wasted time. Remember—design is a business.

At different stages of the project, clients may want changes. Unfortunately, some clients are never satisfied, and sometimes you just have to cut your losses and drop them.

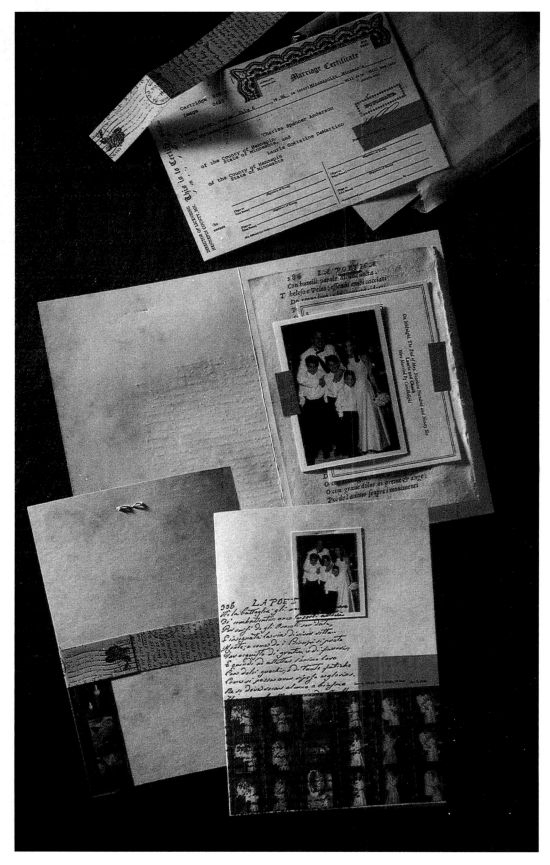

title: Wedding Announcement

design firm: DeMartino Design
(Studio d)/Minneapolis, MN

art director/designer: Laurie DeMartino

photographer: Joan Buccina

client: Laurie DeMartino and Charles S.
Anderson

"Our wedding announcement was created from the ceremony photographs, pieces of our marriage certificate and letters written to one another, along with pages from an Italian book we found on our honeymoon. Printing is letterpress and offset ."

title: Herman Miller Showroom

description of work: Showroom

design firm: Carbone Smolan Associates/New York, NY

creative director: Ken Carbone

art director: Claire Taylor

designer: Eric Smith

client: Herman Miller

"Can serendipity be designed? Carbone Smolan Associates integrated displays for furniture manufacturer Herman Miller to facilitate the fortuitous, adventitious design experience. The system is part of Herman Miller's new Manhattan showroom designed by New York architects Fox & Fowle.

"Carbone Smolan Associates designed one agile system which caters to the showroom's variety of needs—a corporate office, a retail environment and a creative institution. For over fifty years, Herman Miller has played an important role in the careers of many design masters such as Charles Eames, George Nelson and Isamu Noguchi. The works of these legendary pioneers play a dual role in our culture: They are both furniture and highlights on the timeline of the modern era. CSA's graphics and wayfinding system promote the new Herman Miller showroom as an innovative classroom; the display panels engage and educate the viewer. The consumer is exposed to the company's latest products, as well as its classics, and gains a sense of Herman Miller's design philosophy.

"The CSA-designed displays are based on modular components which present product samples, materials, photographs and colors. They accommodate the entire Herman Miller line of furniture, office systems and textiles. It allows great flexibility for the company's representatives to customize the Herman Miller offering for a broad range of clients."

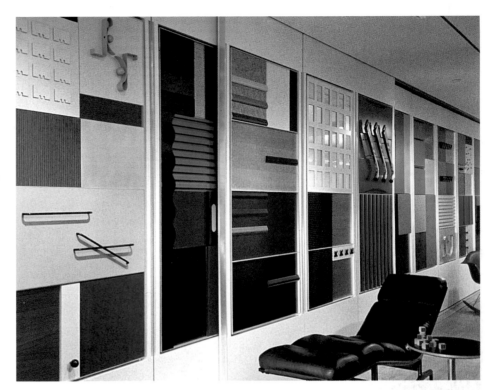

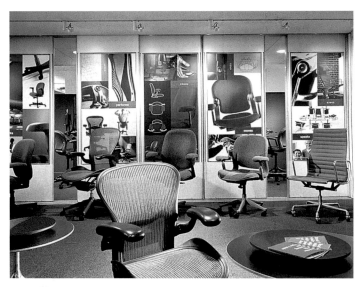

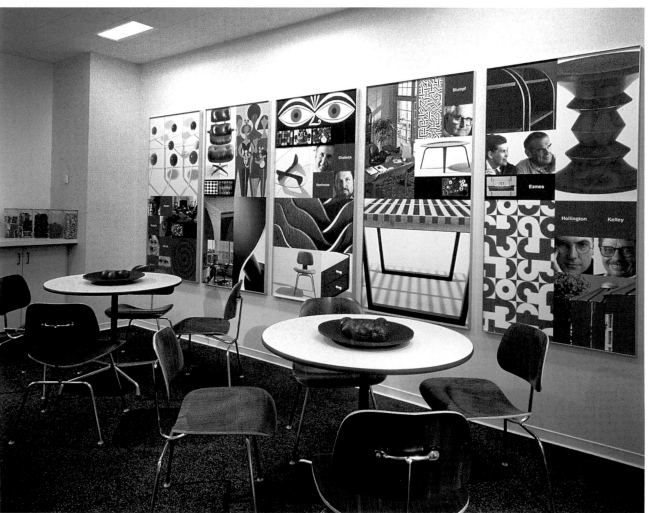

Form and Content

To think visually and creatively, you must have an understanding of the relationship between form and content. Very simply, form refers to the visual elements, or the look of things. Content refers to the subject matter, that is, the topic and information.

To make this issue as relevant to creative visual thinking as possible, let's examine form and content from three vantage points.

You could say that it is the content—the subject matter—that communicates. That content is the key to meaning, communication and impact on the viewer in graphic design and advertising. Regardless of how something is designed, the viewer will always seek the literal message.

On the other hand, you could say that form—the design, format, color, composition, shapes, etc.—has the greatest impact on the audience. The formal approach means that we concern ourselves primarily with the look of the work, both in designing and in viewing it. This approach assumes that all the visual aspects of the work have an impact—an important, powerful impact—on the viewer, regardless of what the work says literally. It does so even if the work is abstract. You can manipulate the graphic elements and principles to communicate an idea in visual form.

Finally, you could say that it is the interdependence of form and content that creates the whole message. That any designer worth his or her design awards knows there must be a working relationship between form and content in order to communicate, provoke, inform and impress. That's the basis of visual communication and creative thinking. However, in order to understand the premise that form and content are interdependent, we have to define our terms.

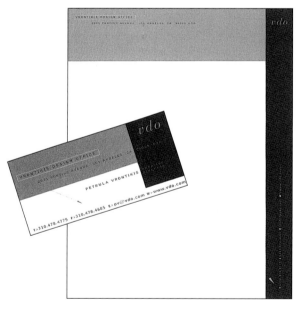

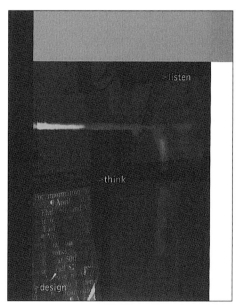

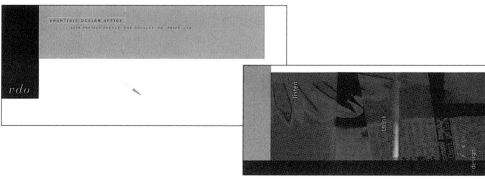

title: VDO Stationery

description of work: A stationery ensemble for a Los Angeles–based graphic design office

design firm: Vrontikis Design Office/Los Angeles, CA

art director/designer: Petrula Vrontikis

"Listen, think, design…you can see these words through the letterhead. This was part of the criteria for this system: exploring new ways of seeing traditional forms. We found a rich and beautiful image from Photonica stock and drastically altered the color palette from the original. This image was chosen for its artistic interpretation of organic, typographic and human forms. This solution represents the thoughtfulness and quality that we bring to each of our projects."

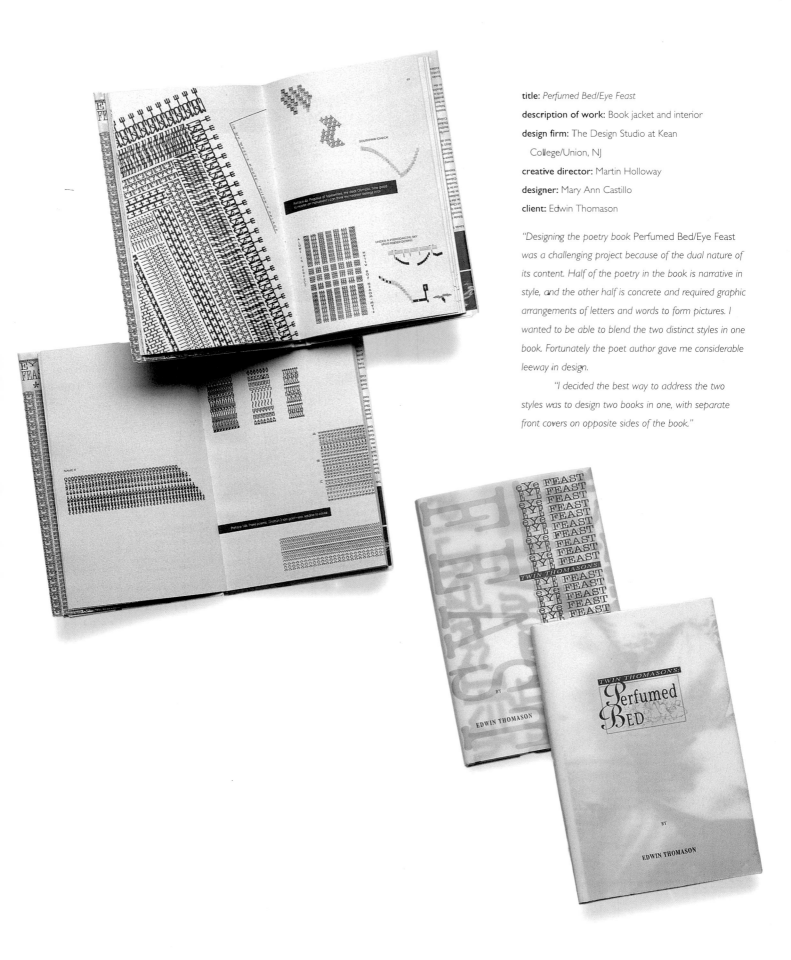

title: *Perfumed Bed/Eye Feast*

description of work: Book jacket and interior

design firm: The Design Studio at Kean
College/Union, NJ

creative director: Martin Holloway

designer: Mary Ann Castillo

client: Edwin Thomason

*"Designing the poetry book Perfumed Bed/Eye Feast
was a challenging project because of the dual nature of
its content. Half of the poetry in the book is narrative in
style, and the other half is concrete and required graphic
arrangements of letters and words to form pictures. I
wanted to be able to blend the two distinct styles in one
book. Fortunately the poet author gave me considerable
leeway in design.*

*"I decided the best way to address the two
styles was to design two books in one, with separate
front covers on opposite sides of the book."*

Form

The visual aspects of any two-dimensional medium are the elements, principles and illusions.

Elements

Elements refer to visual components, such as line, shape, color and texture. Each has a different effect on the viewer: Shape is more structural; line is more directing; and color and texture, more emotional. Going deeper into this idea, different shapes (e.g., soft vs. angular), different lines (e.g., sweeping vs. precise), different colors (e.g., warm vs. cool), and different textures (e.g., coarse vs. smooth) all have different effects on the viewer. Sometimes the exact effect of the elements of art can't be put into words, but that doesn't mean there *is* no effect.

Principles

Principles refer to the relationships among the elements. Some of these are rhythm, balance, unity, hierarchy, contrast and figure/ground. Composition depends upon the principles. Since the seventeenth century, artists, designers and theoreticians have investigated the idea that particular movements of lines and compositions affect the viewer in different ways.

An interesting example of this concerns Nicholas Poussin, the seventeenth-century painter, who believed certain compositional structures were appropriate to certain themes. He used a particular compositional structure for a particular type of subject—for instance, severe subjects would be one type of structure and joyous subjects, another. Other examples are the theories about compositional structures that fascinated late-nineteenth-century post-impressionists such as Vincent van Gogh.

Illusion

Illusion refers to the depiction of three-dimensional space on a two-dimensional surface. Illusion can be created in many ways, with "magical" results. For instance, you can trick the viewer into believing the picture plane isn't flat or that there is great depth behind it.

Even if you're an experienced designer, it can be quite useful to re-examine everything anew. The following questions should start a fresh dialectic for you:

- Why use line to describe forms rather than shapes or light and shadow?
- What meaning do colors have in different cultures?
- What is the difference in impact on the viewer between a flat surface and the illusion of three-dimensional space?
- Why create illusion? What effect does it have on the viewer?
- What is the difference in effect between a trompe l'oeil illusion and an atmospheric illusion?
- What's the difference in feeling between using all the same size shapes in a composition as opposed to using a difference in scale?
- What effect does using large shapes on a small format have?
- What difference does it make to the viewer if you use tactile textures or visual textures?
- How much variety can you establish in a composition and still have unity?
- How important is a visual hierarchy?
- Does a viewer seek a focal point?
- Is it important to have a definitive point of view in a composition?
- What effect can a pattern have?
- Is rhythm as important in design as it is in music? How does a particular design rhythm affect the viewer? Can it "enter" the viewer the way a drumbeat does?
- Does the shape of the format, the page or package, affect the viewer? How?

title: BVP Media Identity

description of work: Full identity package

design firm: Ellen Bruss Design/Denver, CO

designers: Ellen Bruss, Dae Knight

client: BVP Media, Inc.

"The idea with this work was to establish video and film work not just as a visual process, but a process that includes concept, visualization, sound and sight."

Content

Content is the subject matter: the topic, theme, message or text.

The subject in graphic design can be anything, ranging from a dog food to a company's annual report. When analyzing content, whether you're the designer or the viewer, it's always helpful to ask yourself the following questions:

What's the Message?

Communicating the literal message is crucial in visual communications. We call the literal message the *denotative* message; it carries the primary meaning to the audience. The *connotative* message, or secondary meaning, is conveyed by how something is designed. Connotative meaning expands upon communication potential.

Who Designed It?

We all know that you can look through a design annual and know who designed what. Many designers have a recognizable style. Who designs a piece influences the resulting message in a subtle way—a result of style, personal expression and cultural influences. When analyzing a design, ask yourself, what is the aesthetic attitude of the designer or the culture he or she comes from?

What is the *Zeitgeist*?

Some critics say that all design and art reflect the spirit of the times. What is communicated about the period of time in which the design was created? Has the design been influenced by cultural trends in music, literature and dance? By social change? By the political climate? By another period?

What's Innovative or New?

Although visual communications is a vernacular language, it is in constant flux, reflecting both technological advances and society. Invariably, designers, illustrators, art directors and copywriters attempt to break the established rules, shake things up, promote discourse in the design community, challenge authority, and amuse themselves, their peers and their audiences.

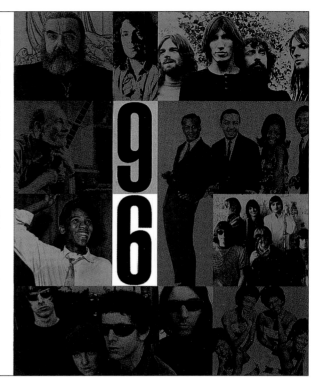

The Rock and Roll Hall of Fame's 1996 inductees are a diverse group whose music ranges from soul to psychedelia. This year's class includes folk music hero Pete Seeger as an early influence, and radio innovator Tom Donahue in the non-performer category, along with performers David Bowie, Gladys Knight and the Pips, Jefferson Airplane, Little Willie John, Pink Floyd, the Shirelles and the Velvet Underground.

CLASS of 96

David Bowie has made a career of changes, pioneering—then discarding—musical styles and personas with a dizzying frequency. He mastered glam-rock with works like "Ziggy Stardust," then turned into a soul stylist with "Young Americans," a funk rocker with "Golden Years" and "Fame," and a dance club fixture with "Let's Dance," with stops at the early roots of art rock and punk rock along the way. Bowie is an adventurous and original artist.

Gladys Knight and the Pips are one of the outstanding female-led groups of the rock and roll era. A family act that began performing at church functions, Gladys Knight and the Pips rose to prominence after signing to Motown in 1966, scoring hits spanning four decades, including "I Heard It Through the Grapevine," "Every Beat of My Heart," "Neither One of Us (Wants to be the First to Say Goodbye)," and their biggest hit, "Midnight Train to Georgia."

Jefferson Airplane epitomized the sound of San Francisco at its experimental, song-oriented best with its soul, blues and folk-influenced psychedelic rock. The band's commercial success, with such Top Ten songs as "White Rabbit" and "Somebody To Love," allowed it wide latitude for experimentation, and the Jefferson Airplane pushed hard at the boundaries of rock and roll.

Little Willie John, whose career flourished in the mid-1950s, was a master of rhythm & blues ballads. John scored his first hit with "All Around the World," and went on to record other R&B hits, such as "Talk to Me, Talk to Me," and "Sleep," his highest-charting single. He also co-wrote and was the first to record "Fever," a song covered by talents as diverse as Peggy Lee and Madonna.

It was to describe Pink Floyd that the term "underground rock" was coined by the British press in 1967. Beginning as a trailblazing psychedelic band, the group went on to a long and influential career, creating masterpieces such as Dark Side

On the cover: David Bowie. Clockwise from upper left: Tom Donahue, Syd Barrett, Pink Floyd, Gladys Knight and the Pips, Jefferson Airplane, the Shirelles, the Velvet Underground, Little Willie John, Pete Seeger

bought one started a band. Fronted by Lou Reed and discovered by Andy Warhol, the Velvets surveyed the raw edges of society in songs such as "Sweet Jane" and "Rock and Roll." Their view of modern life inspired groups such as R.E.M., U2, Pearl Jam, the Jesus and Mary Chain, David Bowie, Talking Heads and Sonic Youth.

Pete Seeger wrote or co-wrote classics of the American songbook, including "Goodnight Irene," "Where Have All the Flowers Gone?" and "If I Had a Hammer." He has been an inspiration to generations of audiences and musicians, including Bob Dylan and the Byrds.

The late disc jockey Tom Donahue is considered the father of progressive FM radio. As a San Francisco DJ in the late 1960s, Donahue invented "free form" radio and revolutionized radio broadcasting in the United States. He rebelled against the rigid Top 40 format and encouraged on-air personalities to play a wide variety of music, from rock and blues to jazz and soul.

The Rock and Roll Hall of Fame Foundation was established to honor rock and roll's most significant artists and their work. Artists become eligible for induction 25 years after the release of their first record. The nominating process begins with an annual committee meeting of several dozen rock and roll experts of widely varying tastes and experience, the committee eventually develops a list of about 15 eligible artists, which is then submitted to an international voting body of nearly 1,000 women and men from all walks of rock and roll life. Of the 15, five to seven make the final cut and are inducted into the Rock and Roll Hall of Fame. In addition, the Nominating Committee selects inductees in the categories of early influences and non-performers. Watch future Liner Notes for a complete list of the 131 inductees.

of the Moon, which stayed on the Top 200 charts for a record-breaking 741 weeks, and The Wall, the band's epic about alienation and isolation.

Formed when its members were still in high school in New Jersey in 1957, the Shirelles are the great pioneers of the infectious "girl group" sound. The group had a string of hits between 1958 and 1962, with their first, "I Met Him On a Sunday" followed by "Tonight's the Night," "Will You Love Me Tomorrow" and "Soldier Boy."

It is often said that the Velvet Underground never sold a lot of records, but every person who

SERIES

The Rock and Roll Hall of Fame and Museum kicked off its most ambitious series of public programs with the debut of the Hall of Fame Series.

Ray Davies of the Kinks
and Dickey Betts of the Allman Brothers
talk about their music.

Ray Davies of the Kinks, Dickey Betts of the Allman Brothers Band and three founding members of the Band came to Cleveland for intimate appearances in the Museum's It's Only Rock and Roll Theater.

"The Hall of Fame Series is a cornerstone of our curatorial and educational efforts," said James Henke, the Museum's Chief Curator. "We plan to bring inductees to Cleveland on a regular basis for programs that not only will celebrate their careers, but that soon abandoned the readings to field questions from the audience. In addition to discussing his early musical career and tenure as an art student, Davies spoke about his favorite Kinks projects, his songwriting process and his influences.

Dickey Betts, the lead guitarist, singer and songwriter for the Allman Brothers Band, sat down with Henke and Director of Education Robert Santelli on April 15 for a question and answer session. The conversation ranged from Betts' earliest musical experiences with his family, to his first days playing in a band professionally, to the formation of the Allman Brothers. Betts also fielded questions from the audience.

On April 14, Betts took the stage with current Allman Brothers Alan Woody and

On April 12, Ray Davies, the lead singer and songwriter of the Kinks, joked that it was appropriate for him to be the first inductee to participate in the series: "They always throw the Kinks on to do the first of anything, to see what it turns out like. And then when they've really got the format down, they invite Pete Townshend in." Davies read a few selections from his recent "unauthorized autobiography," X-Ray, but

will help us fulfill our mission of educating the public about the history and influence of rock and roll. The Hall of Fame Series will also help us continue to build our archives and our collection."

The series will feature a variety of programs, including acoustic performances, lectures, seminars, informal discussions and question and answer sessions with audience participation. As a part of the program, the Museum plans to conduct in-depth interviews, or oral histories, with the inductees.

"These really are once-in-a-lifetime programs," Henke said. "The audience gets to interact with these music legends in a very casual atmosphere. The events also bring the Museum alive in a fresh, exciting way."

Warren Haynes for a special acoustic performance. For just over an hour, the trio entertained the audience with versions of "Ramblin' Man," "In Memory of Elizabeth Reed," and "Southbound."

The final event of the inaugural weekend was originally billed as "A Conversation with the Band," but turned into a rare performance on April 15. Inductees Levon Helm, Rick Danko and Garth Hudson were joined by their current bandmates Jim Weider, Randy Ciarlante and Richard Bell on such songs as "It Makes No Difference," "Back to Memphis" and Bruce Springsteen's "Atlantic City."

As this issue went to press, the Hall of Fame Series continued in May with legendary producer Jerry Wexler, who presented the film The Atlantic Records Story May 10 and participated in a question and answer session May 11, and Roger McGuinn of the Byrds, who played an acoustic performance May 18 and held a question and answer session May 19. On June 5, Martha Reeves of Martha and the Vandellas will be discussing her life and career during "An Evening with Martha Reeves." Other events are planned for future months.

(continued)

title: Rock and Roll Hall of Fame and Museum Liner Notes

description of work: Newsletter

design firm: Nesnadny + Schwartz/Cleveland, OH

copywriter: Jeff Hagan

creative director: Mark Schwartz

designer: Brian Lavy

client: Rock and Roll Hall of Fame and Museum

"The purpose of this project was to produce a unique newsletter which accurately reflects the special nature of the Rock and Roll Hall of Fame and Museum. Nesnadny + Schwartz designed a newsletter which captures the excitement and energy of the Museum."

The Interdependence of Form and Content

For designers, the primary issue concerning form and content is figuring out the appropriate form for the subject at hand. That's the part called creative visual thinking. In other words, the form and the subject matter should be saying the same thing. Which combination of formal elements, which execution and which principles and illusions best suit the topic?

For example, let's say you're designing a book jacket for a how-to book on investing for retirement. Every element you choose—type, color, graphics and illustration—had better communicate stability, wisdom and foresight. Whether the people investing for retirement are interested in growth or annuities, they all want sound advice. If the cover seems capricious or cavalier, no one will believe the author's advice is trustworthy.

Provocative Issues Concerning Form and Content

• Denotation and connotation. The literal or denotative message, the primary meaning, can be enhanced by design. The viewer makes inferences about the design's message from what is implied—by the secondary meaning or connotative message. You can design the word *automobile* to make someone sense whether it is a big or small auto, expensive or inexpensive, or a sedan or race car.

• Irony. You could use the formal elements to express something different than or opposite to the literal message. If the form and content are incongruous, the result is either intentionally ironic or unintentionally bad design. Irony must be deliberate. It can be dramatic or subtle, depending upon your intention, format, audience and subject.

• Universality. Some theoreticians believe that compositional movements, line and shapes have a universal audience, are inclusive in scope and are understood on a primordial level by everyone. Elements like texture, pattern and color, however, may not share that universality. How you use form in relation to the content depends upon your audience and intention.

• Style. A much-discussed topic in visual communications and fine art, style is an interesting and sensitive issue when discussing form and content. A designer can create a style for a client, communicate a client's established style or impose his or her own style on a design piece. Many designers have a style. That style may or may not interfere with the way the form and content work together to communicate.

• Period. If a design does indeed communicate something about the period in which it was created, what do retro designs communicate? How does a retro style, type or imagery work with the subject of a piece? What do you say by utilizing historic style or vernacular design?

• Schools of thought. When examining the relationship between form and content, arguments arise among designers from different schools of thought. Some believe that form and content are Siamese twins, that you can't deal with one without the other. Others believe that the form or design is the message; the viewer isn't going to read the words anyway. Some believe typography should always be readable because it carries the literal message; others think using typography that makes readers work to read the text actually involves them more deeply in the content. Some designers believe there are rules about form and content; others believe all rules should be broken, and still others believe there are no rules to break. Some believe a grid must always be employed; others believe there is no need for a grid. You get the idea: The arguments go on and on.

checklist

• How can the formal elements best communicate the content?

• Why did you choose the composition, format, graphic elements, and principles for that subject?

• What connotative meaning do you want to communicate?

• What does the design communicate about the time in which it was designed? About the culture?

• What does the style (or *your* style) communicate?

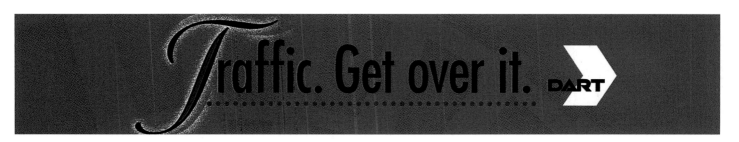

L'ook. Up in the air. It's a train. DART

Traffic. Get over it. DART

title: DART Overpass Banners

description of work: Banners to hang off mass transit overpass at major intersections

design firm: The Knape Group/Dallas, TX

creative director: Les Kerr

art director: Leslie Baker

copywriter: Paul Brandenburger

client: DART

"The copy on these elevated banners acknowledges both the unusual location and the elevated nature of the light rail bridge."

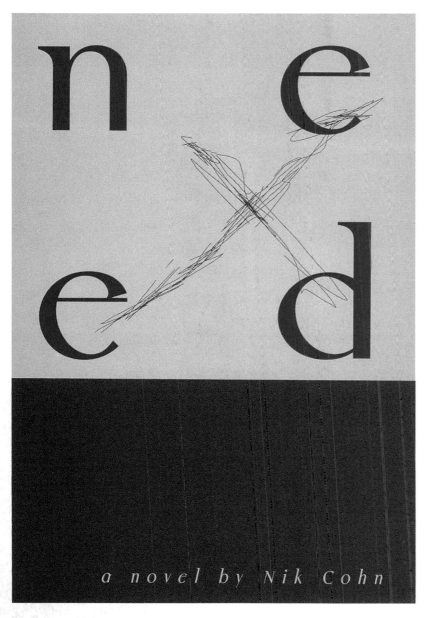

title: *Need*

author: Nik Cohn

description of work: Book jacket

art director/designer: Barbara deWilde

client: Alfred A. Knopf

"The coincidence of four characters whose seedy lives are inextricably linked and the four characters in the word need *was too great to avoid. Also, a graphic solution seemed a good foil to the previous jacket, which featured predominantly photographic imagery."*

visualization and stimulation: creative approaches and exercises

part | **two**

Of course, you can design an aesthetically pleasing piece that communicates, and your client will be perfectly happy. But that's not what attracted you to design in the first place. You want more. You want to take a **creative leap.**

The creative approaches and ideas in this part demonstrate a way of thinking, a way of exploring. Each one may not be right for every design problem or may not suit your project, but most will work for you. These creative approaches and exercises are about being open to **new ideas,** translating ideas into visuals, taking disparate things and integrating them into coherent, exciting visual wholes and translating everyday communication into **memorable graphic design.**

Elements and Principles

All graphic designers utilize the formal elements of line, shape, color, texture and format, as well as graphic principles such as balance, unity, visual hierarchy and figure/ground. However, some designers are able to take an element or principle and run with it—to make it a star, make it the focus of the design or crucial to the design concept. A designer can utilize what is inherent in the given elements or choose a principle like symmetry, as in George Tscherny's UCLA Extension cover.

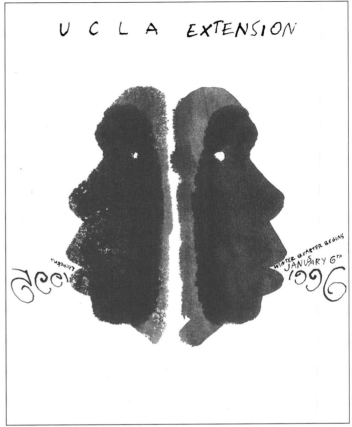

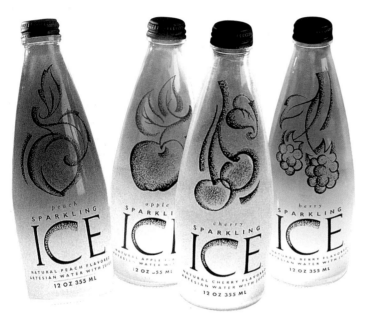

title: Talking Rain Sparkling Ice Bottle Packaging

description of work: Bottles for a sparkling fruit-juice-flavored water

design firm: Hornall Anderson Design Works, Inc./Seattle, WA

art director: Jack Anderson

designers: Jack Anderson, Julia LaPine, Jill Bustamante

client: Talking Rain

Line: "The bold and playful [linear] illustration style creates a solid image and allows for individual product differentiation. The surreal, conceptual interpretation of the fruit flavors distinguishes the brand from competing products that focus on literal representations of fruit. Other unique bottle elements include the graphics being applied directly to the bottles' surface rather than on paper labels, the gradated frost to add the 'ice' effect, and the black cap."

title: UCLA Extension Catalog

description of work: Catalog cover for January 1996 winter quarter

design firm: George Tscherny, Inc./New York, NY

creative director: InJu Sturgeon

designer/illustrator: George Tscherny

client: UCLA Extension

Balance/Symmetry: "The month of January was named for the ancient Roman god Janus who traditionally looks back to the past year and forward to the new one. The two opposite faces of Janus are appropriate images to symbolize the winter quarter as it begins on the threshold of the new year.

"The double faces were created by painting one face and then 'offsetting' it à la Rorschach tests. On the assumption that people don't read, especially mirror writing, I sneaked my signature into the mirror image."

title: Material Dreams Catalog

description of work: Catalog for gallery exhibition

design firm: Matsumoto Incorporated/New York, NY

art director/designer: Takaaki Matsumoto

client: Takashimaya

Texture: "This catalog, with its emphasis on texture and material, was the perfect counterpart for a show of works using fabric. Examples of this emphasis include the embossed cover, the variety of colorful, textured stock and the ribbon of fabric that surrounds the book."

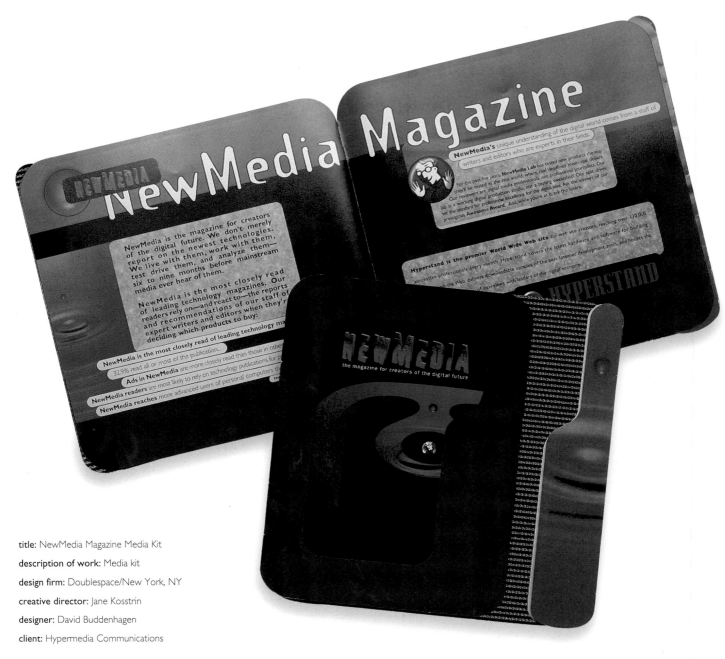

title: NewMedia Magazine Media Kit

description of work: Media kit

design firm: Doublespace/New York, NY

creative director: Jane Kosstrin

designer: David Buddenhagen

client: Hypermedia Communications

Patterns: Patterns are used to express the digital age. Black and white patterns created by typographic elements are juxtaposed with brightly colored illusory patterns suggesting water and fire.

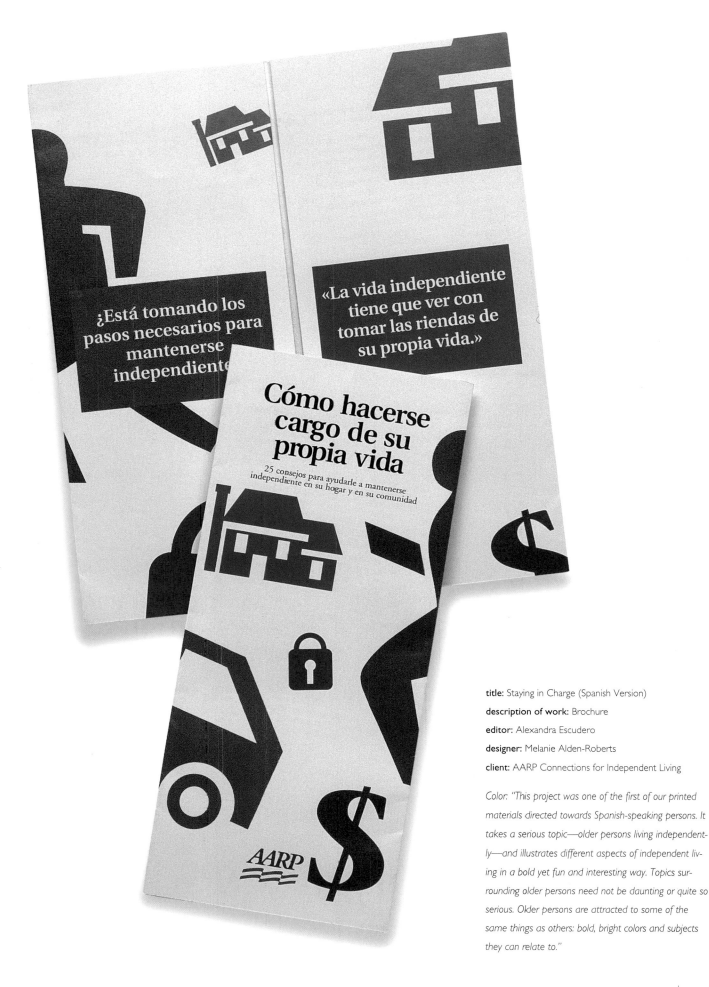

¿Está tomando los pasos necesarios para mantenerse independiente

«La vida independiente tiene que ver con tomar las riendas de su propia vida.»

Cómo hacerse cargo de su propia vida

25 consejos para ayudarle a mantenerse independiente en su hogar y en su comunidad

AARP

title: Staying in Charge (Spanish Version)

description of work: Brochure

editor: Alexandra Escudero

designer: Melanie Alden-Roberts

client: AARP Connections for Independent Living

Color: "This project was one of the first of our printed materials directed towards Spanish-speaking persons. It takes a serious topic—older persons living independent-ly—and illustrates different aspects of independent living in a bold yet fun and interesting way. Topics surrounding older persons need not be daunting or quite so serious. Older persons are attracted to some of the same things as others: bold, bright colors and subjects they can relate to."

title: *A Perspective on Design* Poster

description of work: Poster for design exhibition

design firm: Matsumoto Incorporated/New York, NY

art director/designer: Takaaki Matsumoto

client: Montreal Museum of Decorative Art

Balance: "This poster plays with the exhibit's title by offering two perspectives on the design of the poster. The visual trick works twice as well due to the fact that the poster needed to be printed in two different languages—English and French."

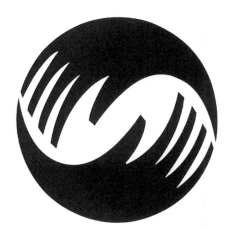

title: Agassi Fusion Logo

description of work: Logo

design firm: Mires Design/San Diego, CA

art director/designer: Jose A. Serrano

client: Agassi Enterprises

Figure/Ground: The negative shape created between the hands becomes an active, interesting shape. The overlapping hands coming together help emphasize the name of the product.

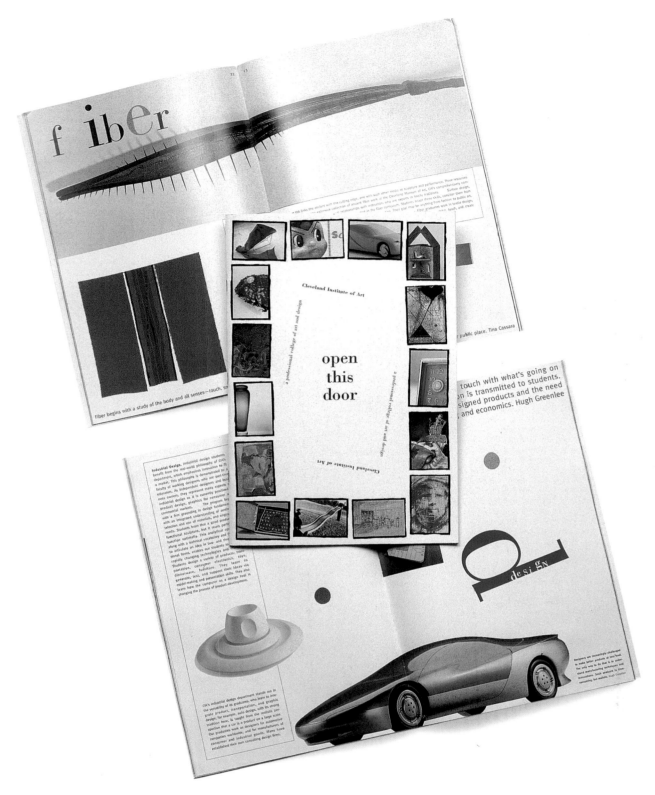

Title: Cleveland Institute of Art Catalog 1996–97

description of work: Catalog

design firm: Nesnadny + Schwartz/Cleveland, OH

copywriter: Anne Brooks Ranallo

creative directors: Joyce Nesnadny, Mark Schwartz

designers: Joyce Nesnadny, Brian Lavy

photographers: Mark Schwartz, Robert A. Muller

client: Cleveland Institute of Art

Format/Layout: In one spread, parallels are made to the elongated rectangular shape of the open catalog; the art objects and copy echo the width of the spread. In another spread, art objects and type are carefully positioned to relate to the edges of the format.

"Nesnadny + Schwartz conceived the design and structure of the catalog to articulate the scope of CIA's unique and diverse programs. The brochure showcases the creative energy, challenge and excitement that are the hallmarks of a CIA education."

Typography

One advantage of visual communication—graphic design, illustration and advertising—is that it combines visuals with words to convey a message. The two together relay a message greater than either one could do alone. Some designers call it synergy. Some simply call it good design. There are times when the typography is the visual, as in Shin Matsunaga's *91 Objects by 91 Designers*. What the designer does with the type becomes both verbal and visual message, like Harp and Company's witty identity for a landscaping business.

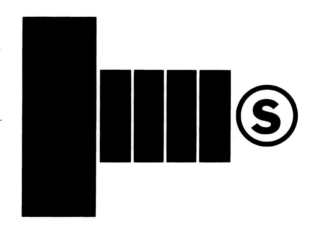

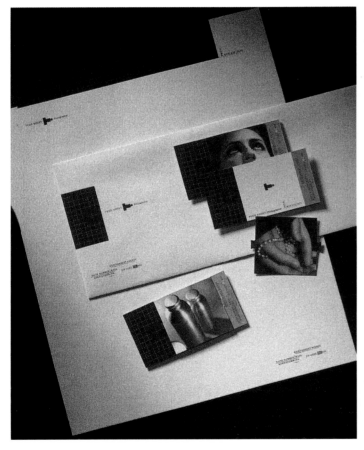

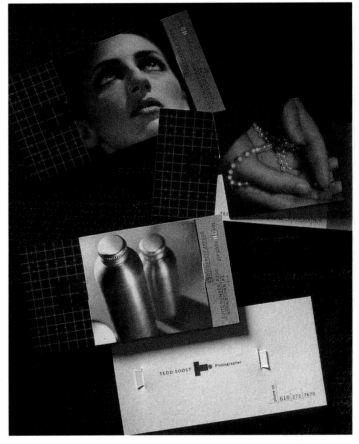

title: Tedd Soost Logo and Identity System

description of work: Logo and identity system

design firm: DeMartino Design (Studio d)/Minneapolis, MN

art director/designer: Laurie DeMartino

photographer: Tedd Soost, Philadelphia, PA

client: Tedd Soost Photography

"The photographer's initials form the tool of his trade. This flexible identity system can be tailored to individual clients. Various die-cut photo inserts represent the photographer's diversity."

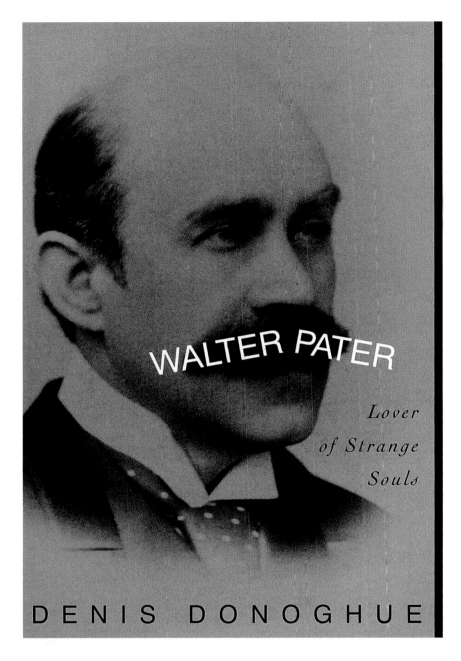

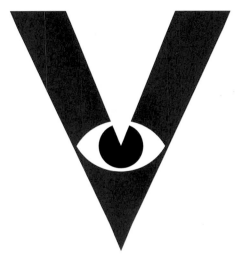

title: Visual Logic Logo

description of work: Logo

design firm: Harris Design, Inc./Hockessin, DE

designer: Jack Harris

client: Visual Logic

"The redesign of a more complex logo that incorporated an eye, this logo is an exercise in graphic economy. Utilizing an eye, or the graphic representation of an eye, was essential to maintain continuity with the old logo."

title: *Walter Pater: Lover of Strange Souls* Book Cover

author: Denis Donoghue

description of work: Book cover

designer: Barbara deWilde

client: Alfred A. Knopf

"Walter Pater was an anomaly among his peers. His appearance became a flag for his very different thinking. His mustache especially was memorable, so I placed some very modern—Helvetica—type on it as a signal of his eccentricity."

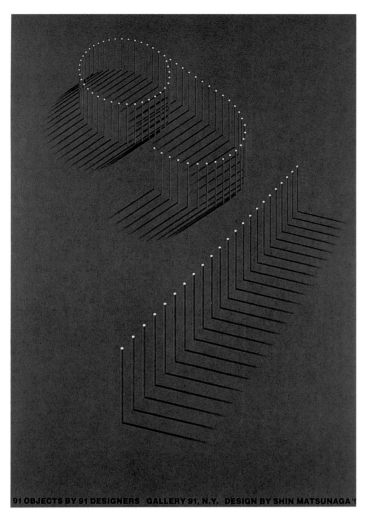

title: *91 Objects by 91 Designers*

description of work: Exhibition poster

design firm: Shin Matsunaga Design, Inc./Tokyo, Japan

art director/designer: Shin Matsunaga

client: Gallery 91, New York

The number 91 becomes a three-dimensional object suggesting sculpture.

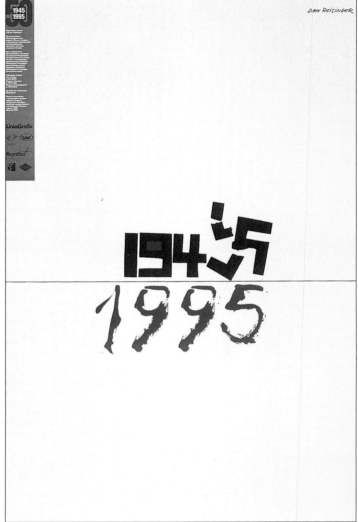

title: *1945*

description of work: Poster

design firm: Studio Reisinger/Tel Aviv, Israel

designer: Dan Reisinger

A swastika replaces the 5 in 1945 for a poster marking fifty years since the fall of Nazi Germany.

hubert de givenchy

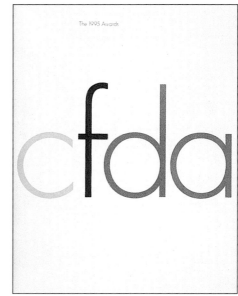

The 1995 Awards

cfda

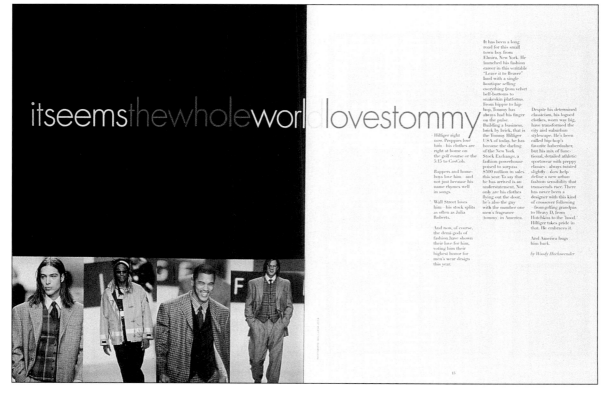

itseems the whole worl d lovestommy

It has been a long road for this small town boy from Elmira, New York. He launched his fashion career in this veritable "Leave it to Beaver" land with a single boutique selling everything from velvet bell-bottoms to snakeskin platforms. From hippie to hip-hop, Tommy has always had his finger on the pulse. Building a business, brick by brick, that is the Tommy Hilfiger USA of today, he has become the darling of the New York Stock Exchange, a fashion powerhouse poised to surpass $500 million in sales this year. To say that he has arrived is an understatement. Not only are his clothes flying out the door, he's also the guy with the number one men's fragrance (tommy) in America.

Hilfiger right now, Preppies love him - his clothes are right at home on the golf course or the 5:15 to CosCob.

Rappers and home-boys love him - and not just because his name rhymes well in songs.

Wall Street loves him - his stock splits as often as Julia Roberts.

And now, of course, the demi-gods of fashion have shown their love for him, voting him their highest honor for men's wear design this year.

Despite his determined classicism, his logoed clothes, worn way big, have transformed the city and suburban stylescape. He's been called hip-hop's favorite haberdasher, but his mix of functional, detailed athletic sportswear with preppy classics - always twisted slightly - now help define a new urban fashion sensibility that transcends race. There has never been a designer with this kind of crossover following - from golfing grandpas to Heavy D, from Hotchkiss to the 'hood.' Hilfiger takes pride in that. He embraces it.

And America hugs him back.

by Woody Hochswender

title: CFDA Awards Journal

description of work: Awards program

design firm: Pentagram Design/New York, NY

partner/designer: Michael Bierut

designer: Lisa Anderson

client: Council of Fashion Designers of America

The typography is designed as structural architecture for the layout.

"The Oscars of fashion, the Council of Fashion Designers of America's annual Awards Gala is the industry's biggest evening. The program for the event features the predetermined winners of various awards and serves as a souvenir of the big night."

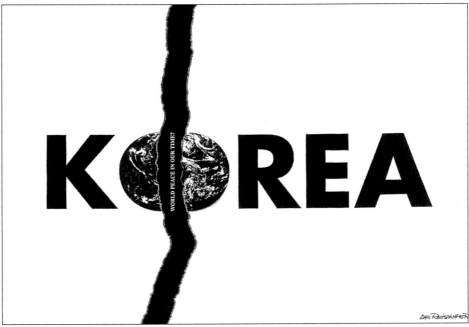

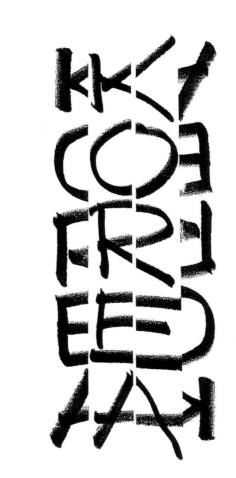

PEACEFUL UNIFICATION OF KOREA

title: *Unification of Korea*

description of work: Poster series (3)

design firm: Studio Reisinger/Tel Aviv, Israel

designer: Dan Reisinger

With three different concepts, Reisinger communicates, through his typographic design, the idea of the existing separation and the hope for unification.

FERRATELLA'S LAWN GROOMING

title: Ferratella's Lawn Grooming

description of work: Identity for landscaping business

design firm: Harp and Company/Hanover, NH

designers: Douglas G. Harp, Linda E. Wagner, Scott McFarland

client: Joseph Ferratella

"This incredibly simple solution seemed so obvious to us. What better way to describe a lawn mowing business than to use an extended typeface, all caps, with some of the tops of the letters sliced off? We experimented with legibility, and pushed it to the edge. For those clients who still don't get it, they can read the business name in the stationery address block. Simple, amusing, memorable, and presumably a standout solution among Joseph Ferratella's competition."

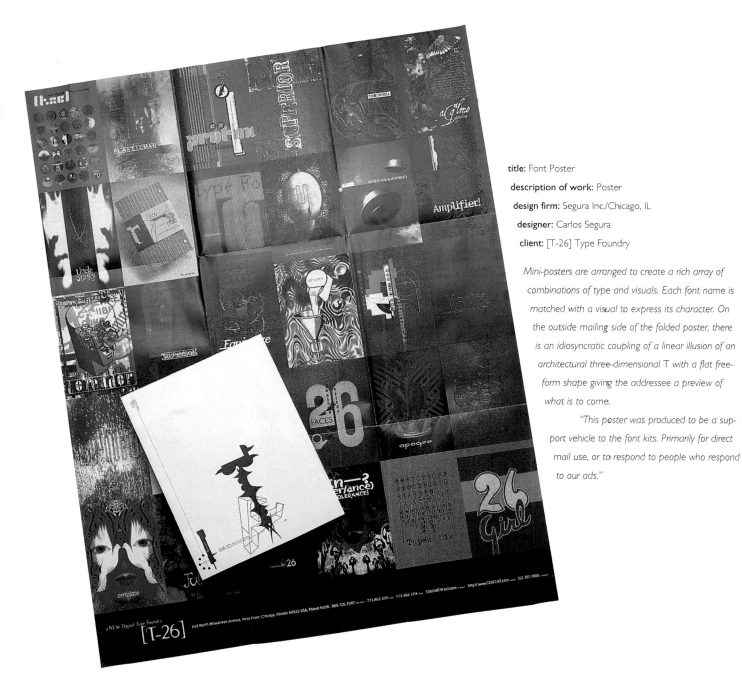

title: Font Poster

description of work: Poster

design firm: Segura Inc./Chicago, IL

designer: Carlos Segura

client: [T-26] Type Foundry

Mini-posters are arranged to create a rich array of combinations of type and visuals. Each font name is matched with a visual to express its character. On the outside mailing side of the folded poster, there is an idiosyncratic coupling of a linear illusion of an architectural three-dimensional T with a flat free-form shape giving the addressee a preview of what is to come.

"This poster was produced to be a support vehicle to the font kits. Primarily for direct mail use, or to respond to people who respond to our ads."

Illusion and Sound

Since ancient Roman times, artists have delighted in amazing their audiences with the illusion of three-dimensional space on a two-dimensional surface. Illusions that delight us range from trompe l'oeil to visual textures. Illusion engages us by toying with our perception of space and reality. We ask, "What is real?" as you'll see in Gunter Rambow's posters.

The illusion of sound in a still and silent medium engages another sense, thereby capturing our attention. With illusion, art imitates life in a most interesting way.

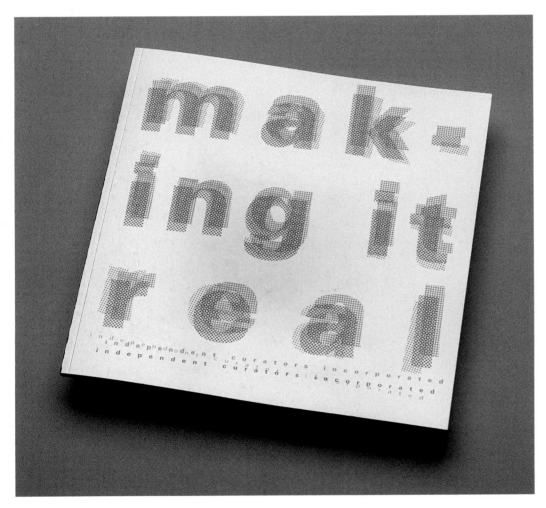

title: *Making It Real* Catalog

description of work: Catalog for a photography exhibit

design firm: Matsumoto Incorporated/New York, NY

art director/designer: Takaaki Matsumoto

client: Independent Curators Incorporated

"The cover of this catalog suggests its content by emphasizing the flawed or altered reality involved in the art of photography. The photo work inside emphasizes the fact that photography can make something that is not real seem real. The cover raises questions of what is real and what is not by the use of a reflective surface and the breaking up of the type to show the process involved (four-color) in both photographic and offset printing."

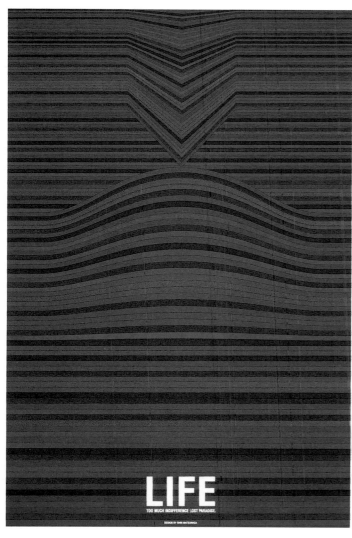

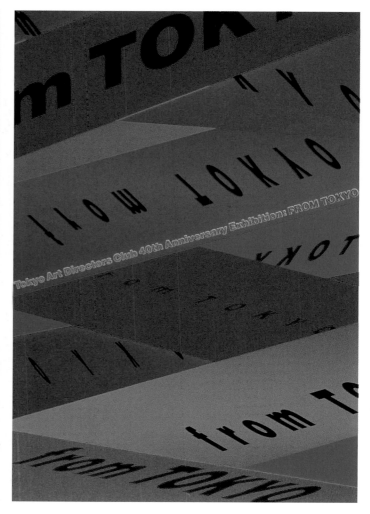

title: *Life*

description of work: Poster

design firm: Shin Matsunaga Design Inc./Tokyo, Japan

art director/designer: Shin Matsunaga

client: *Creative Review* (London)

The specific nature of this optical illusion—an undulation of the surface and the bending of lines—connotes the energy of Life.

title: *From Tokyo*

description of work: Poster for exhibition

design firm: Shin Matsunaga Design, Inc./Tokyo, Japan

art director/designer: Shin Matsunaga

client: Tokyo Art Directors Club

Using dynamic diagonal bands of color, Matsunaga creates the illusion of great depth on a flat surface. The angles, the typography and the italics repeat the diagonals and enhance the illusion.

"The sight of Tokyo is different with time, places and the people I see. I expressed the chaos of this intangible, huge metropolis, Tokyo, with vivid colors."

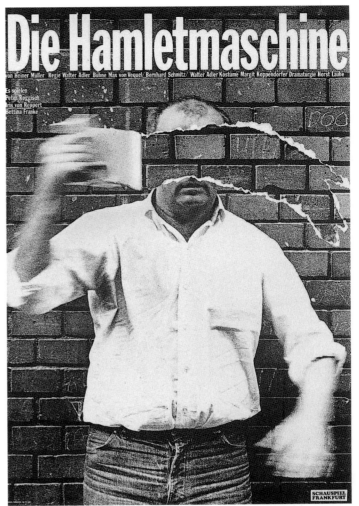

title: *The Hamlet Machine*

description of work: Poster

designer: Gunter Rambow

An actor stands against a wall and rips his face off. What does this trompe l'oeil illusion say about the play's content? Rambow gives us something visual that cannot actually be performed in the play.

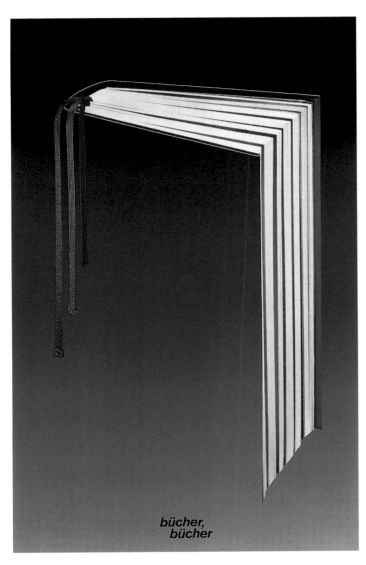

title: *bücher, bücher (books, books)*

description of work: Poster for a TV program

designer: Gunter Rambow

photographer: van de Sand

Is the image flat? Is the image three-dimensional? Does it begin with the picture plane? Is it in front of the picture plane? A book is real, concrete. A television broadcast is illusory; it is a projected electronic moving image. Perhaps this illusion is a merge of the two, resulting in a newly-constructed symbol.

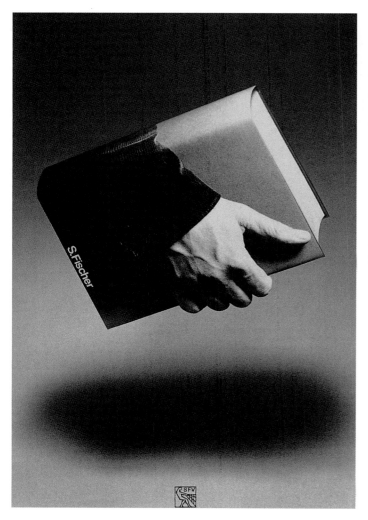

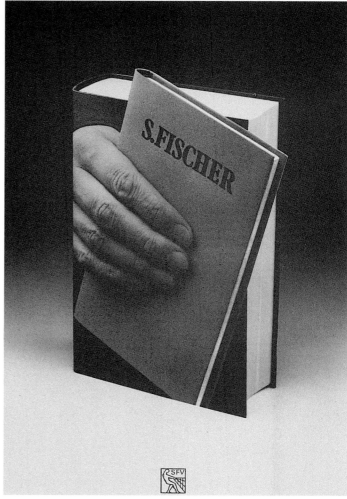

title: *S. Fischer*

description of work: Posters for a publisher

designer: Gunter Rambow

collaborator: Lienemeyer

photographer: van de Sand

client: S. Fischer

Rambow creates poetic humor with his illusions for these posters. Utilizing an everyday image—a hand holding a book—he plays with the viewer's sense of what is real.

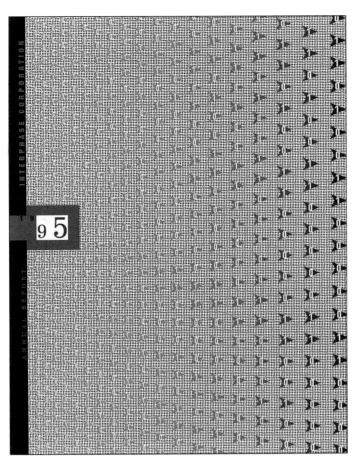

title: Interphase Annual Report

description of work: Annual report

design firm: SullivanPerkins/Dallas, TX

copywriter: Meltzer & Martin

art director/designer/illustrator: Kevin Bailey

photographer: Jeff Ott

client: Interphase Corporation

"This annual needed to contain restraint and be inviting to read, and it needed to communicate on several different levels. I wanted an edgy but minimalist approach to the design, particularly typographically, to allow for a quick comprehension of the company and to promote the company's progressive, forward-thinking approach to doing business. Some of this edginess was accomplished through the use of fluorescent colors and linear type treatments. I considered it a visual challenge to design something that, although progressive, wasn't a layered 'in your face' solution, often seen in current vernacular, and still maintain a progressive feel."

➤ In 1994, Interphase became one of the first companies to begin shipping ATM adapter cards, and we have continued to promote our leadership role by spearheading the interoperability of ATM products throughout the industry. Another emerging technology,

WE WILL MAINTAIN OUR LEADERSHIP WITH A CONTINUED FOCUS ON CREATING TECHNOLOGICALLY ADVANCED PRODUCTS, ESTABLISHING FAR-REACHING DISTRIBUTION CHANNELS, AND ALIGNING OURSELVES WITH THE LEADING NAMES IN THE TECHNOLOGY ARENA.

Fibre Channel, is regarded by many in the industry as the next generation of mass storage technology, providing connectivity and data transfer at tremendous speeds. Interphase will introduce our first adapter products based on Fibre Channel technology in 1996. ➤ Throughout the computer industry and throughout the world, Interphase products have created a standard of excellence for networking and mass storage connectivity. Our products have been selected as the preferred solutions by industry leaders such as Motorola and Hewlett-Packard. And our company has forged worldwide distribution channels to ensure that Interphase products are included in the latest applications of networking technology. ➤ Interphase Corporation is firmly established as a market leader. And we will maintain this position of leadership with a continued focus on creating technologically advanced products, establishing far-reaching distribution channels, and aligning ourselves with the leading names in the technology arena.

FINANCIAL REVIEW

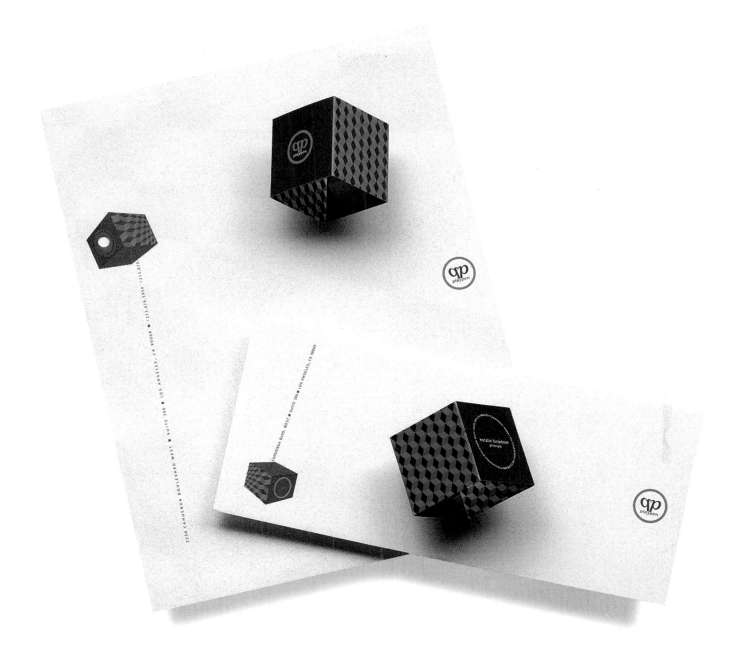

title: Playpen Stationery

description of work: Stationery system for a company that produces on-air
 entertainment graphics

design firm: Vrontikis Design Office/Los Angeles, CA

art director: Petrula Vrontikis

designer: Kim Sage

client: Natalie Kirshner, David Byrnes at Playpen

*"Playpen is a fun place where creativity happens. This system is based on creating this
three-dimensional space within their printed materials. The innovative, interactive busi-
ness card left an unforgettable impression with prospective clients and associates.
Escher-like patterns play with one's notions of perspective and dimension. This
program was so successful that the client gave it to their architect to design their
space using the same elements. The result was a highly creative and cohesive look for
the company."*

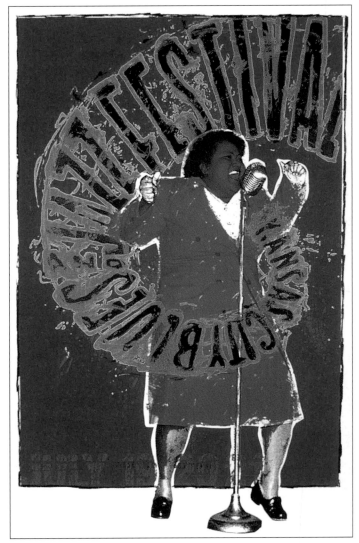

title: *Some People*

description of work: Poster

design firm: Pentagram Design/New York, NY

partner/designer: Paula Scher

designers: Ron Louie, Lisa Mazur, Jane Mella

client: The Public Theater

An arm is extended towards us, the audience, creating the illusion of three dimensions. Also, it breaks the "flat" picture plane and extends into our space. Danny Hoch portrayed multiple personalities in Some People.

title: Kansas City Blues and Jazz Poster

description of work: Poster

design firm: Muller + Company/Kansas City, MO

executive creative director/designer: John Muller

designer: Jon Simonsen

client: Kansas City Blues and Jazz Festival

"A contemporary flair to a traditional medium. That's what we wanted to communicate with the 1996 Kansas City Blues and Jazz poster. The poster takes a creative leap because it perfectly balances today's design with a traditional view of blues and jazz. The splattered paint and the mismatched printing communicate the excitement and the spontaneity of the festival while the image of the woman communicates a more classical feel in regards to blues and jazz."

title: San Francisco International Film Festival Bus Shelter Poster

description of work: Bus shelter poster

design firm: Primo Angeli Inc./San Francisco, CA

creative director/art director/designer: Primo Angeli

computer illustrator: Marcelo De Freitas

client: San Francisco Film Society

Through this sharp and dynamic imagery, the viewer can virtually hear the snap of the clapboard as the director shouts "Action!"

"The logo is a pictogram that portrays the director in motion at the center of the filmmaking process. In this year's poster, the director lunges through an open clapboard; the word FILM is blacked out at a diagonal against the director's body, the final M forming the director's open mouth as he or she barks commands into the megaphone."

Movement

By employing various graphic principles, a designer can attempt to control the order in which the viewer sees the various elements in a design. This is usually achieved with visual hierarchy. And a designer can create movement. The rhythmic structure of a composition can create movement up and down or across a surface. In essence, movement is a type of illusion—obviously, since graphic design is a still medium. This illusion of movement can win and hold the viewer's attention, as in Kerry Leimer's annual report design communicating the theme of speed.

title: InStep Packaging

description of work: Packaging for InStep software

design firm: DeMartino Design (Studio d)/Minneapolis, MN

art director: Laurie DeMartino

designers: Laurie DeMartino, Mary Jo Ames

client: Concierge Software Company

Arrows and outlines of footsteps indicate motion and direction. Interestingly, time is also implied by these linear elements—we assume past movements and present action.

title: *Where The Road Bottoms Out: A Collection of Stories*

author: Victoria Redel

description of work: Book jacket

art director/designer: Barbara deWilde

client: Alfred A. Knopf

The cover echoes the theme of the title story: a painful walk down a road with the narrator's mother, who has a disability. The yellow type descending on a black background suggests the dividing line on a road.

title: Rollerblade Media Kit

description of work: Media kit

design firm: Doublespace/New York, NY

designer: Yuno Sakarai

photographer: Elise Exerm

Blurred imagery implies speed and movement on the front and back cover of this media kit. Inside spreads also conjure up motion, repeating horizontal bands of blurred imagery coupled with linear arcs and italic typography.

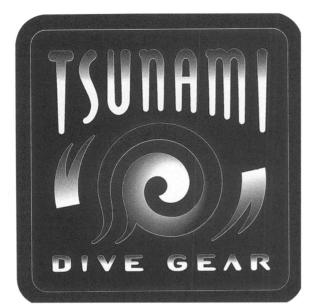

title: Tsunami Logo

description of work: Logo

design firm: Mires Design/San Diego, CA

art director: John Ball

designers: John Ball, Deborah Hom

client: Tsunami Dive Gear

"Tsunami makes products that allow divers to communicate better under water and dive more safely. We represented this with two divers and a large wave, all done with a Japanese flavor."

the most complete range of exciting brands in women's footwear under one umbrella.

title: Nine West Annual Report

description of work: Annual report

design firm: Pentagram Design/New York, NY

partner/creative director: Woody Pirtle

art director/designer/associate: John Klotnia

designers: Ivette Montes de Oca, Seung-il Choi

photographers: John Madere, John Paul Endress, various

copywriter: JoAnn Stone

client: Nine West

An organic current of movement is created by the swirl of type and visuals.

"An oversize publication produced in a striking silver, black and white design, the annual report projects the desired aggressiveness and importance in an elegant, readable form. Corporate portraits and images were commissioned to coordinate with the fashion photography produced for Nine West's advertising campaign. Some advertising photos were reused in the annual report, thereby extending and reinforcing the existing visual equity of the Nine West Group and its brands."

title: *Ecology*

description of work: Poster

design firm: Studio Reisinger/Tel Aviv, Israel

designer: Dan Reisinger

client: Israeli Advertising Association

The movement of the earth towards the green rectangle communicates the need for ecological awareness.

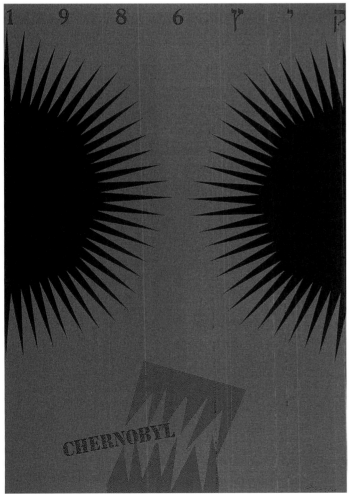

title: *Chernobyl '86*

description of work: Poster

design firm: Studio Reisinger/Tel Aviv, Israel

designer: Dan Reisinger

client: Self-initiated

The tragedy of the Chernobyl nuclear accident is communicated through abstract shapes that express a blast and its consequences.

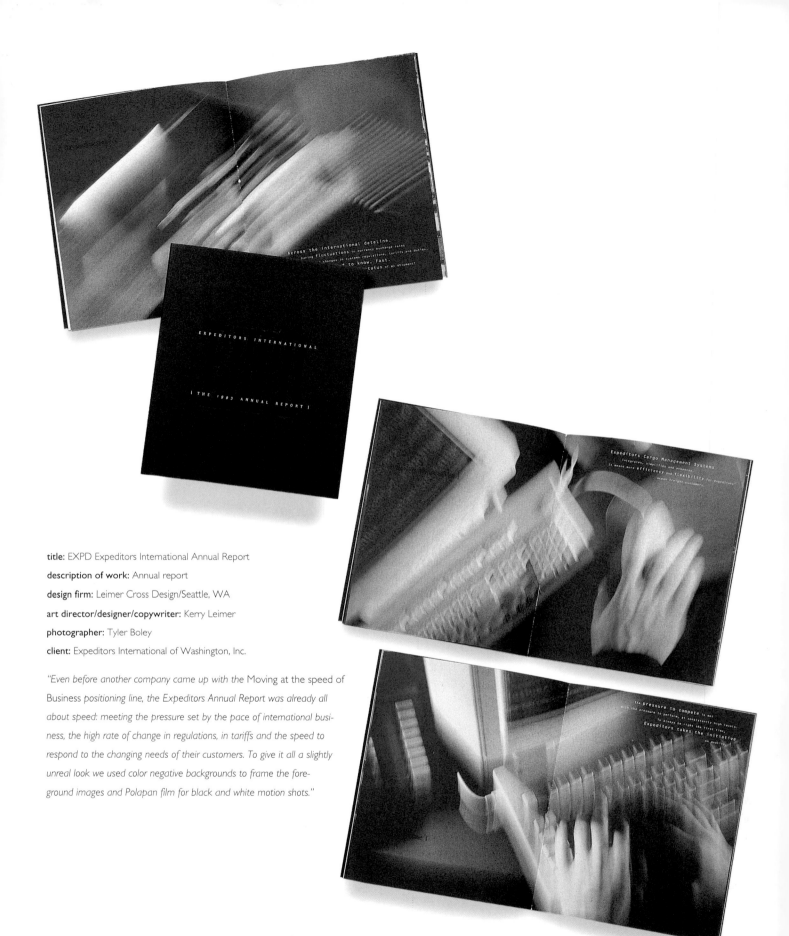

title: EXPD Expeditors International Annual Report

description of work: Annual report

design firm: Leimer Cross Design/Seattle, WA

art director/designer/copywriter: Kerry Leimer

photographer: Tyler Boley

client: Expeditors International of Washington, Inc.

"Even before another company came up with the Moving at the speed of Business positioning line, the Expeditors Annual Report was already all about speed: meeting the pressure set by the pace of international business, the high rate of change in regulations, in tariffs and the speed to respond to the changing needs of their customers. To give it all a slightly unreal look we used color negative backgrounds to frame the foreground images and Polapan film for black and white motion shots."

title: Southern California Institute of Architecture (SCI-ARC) Identity

description of work: Logotype, stationery system, "heavy-metal" version on brochure cover, signage, Web image/Web site

design firm: April Greiman/Los Angeles, CA

designer: April Greiman

client: Southern California Institute of Architecture, Michael Rotondi, Mary Jane O'Donnell

"The first architecture school with a total identity program. There are a million applications of the Matrix SCI-ARC logotype on it since we used it in 1989. I used Matrix because it was one of the first Mac typefaces and since I realized that computers were a form of architecture . . . Later I went on and designed a more contemporary version yet of the Matrix logo . . . which I call my first 'heavy-metal' logo, which was manipulated in Photoshop and used on signage, posters, brochures and currently on their Web site."

Scale and Cropping

We expect things to be certain sizes—for example, we all know an apple is smaller than a planet. When a designer plays with size relationships, the irrationality or improbability of it jars our perception. Designers also use point of view in relation to scale, as in Sayles's dynamic poster, to give us a sense of where we are in relation to the things seen. By cropping things so that they seem close to us, a sense of intimacy with the thing seen is established, as in Morla's proximal and sensual exploration of tableware.

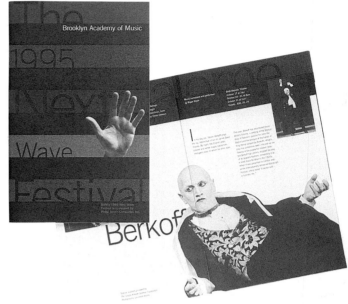

title: BAM Next Wave Festival Posters and Corporate Identity

description of work: Posters and corporate identity

design firm: Pentagram Design/New York, NY

partner/designer: Michael Bierut

designer: Emily Hayes

Photographer: Timothy Greenfield-Sanders (Next Wave Hand)

client: Brooklyn Academy of Music (BAM)

"Pentagram organized layouts for posters, advertisements, invitations, programs and brochures around a motif of wide stripes. Type is partially concealed by the stripes to suggest something 'coming over the horizon,' a visual metaphor for the Next Wave Festival's focus on emerging talent. Subsequent projects will extend and coordinate graphic identity elements throughout stationery, printed materials for upcoming seasons and building signage."

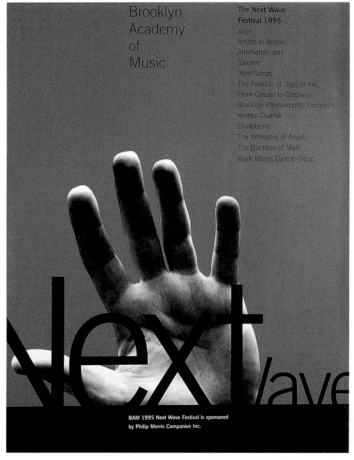

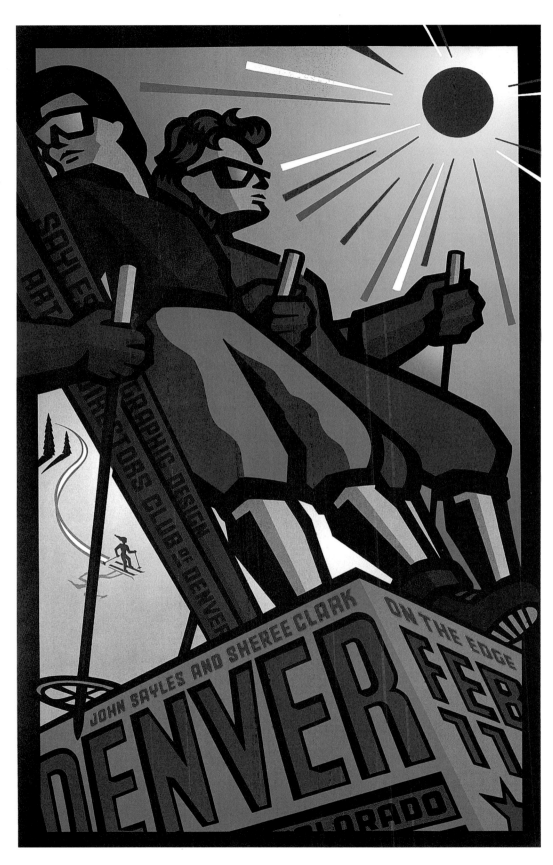

title: *John Sayles and Sheree Clark On the Edge*

description of work: Poster

design firm: Sayles Graphic Design/Des Moines, IA

art director: John Sayles

designers: John Sayles, Jennifer Elliott

client: Art Directors Club of Denver

We look up at two huge figures anchored by enormous type. The point of view and foreshortening add drama to this interesting use of scale.

Sayles Graphic Design principals John Sayles and Sheree Clark spoke on the topic of creativity to the Art Directors Club of Denver, and the promotional piece Sayles developed for the event had recipients on the edge of their seats. The designer's dramatic original illustration of two skiers on a mountain top and the theme "On The Edge" are offset-printed in four-color process on an iceberg-white stock. The two sides of the poster each have a unique identity; Sayles's hand-rendered type complements his illustration on the front, while computer-set type accents the reverse.

Sayles says, "We do like to do work that's 'on the edge,' and events like this one are fun to promote and take part in."

title: *The Line* Covers

description of work: Magazine covers

design firm: Muller + Company/Kansas City, MO

art director: John Muller

art director/designer: Angela Coleman

photographer: Mike Regnier

client: Sportscar Vintage Racing Association

"The creative leap of these pieces lies in their simplicity. The single image of the car is cropped and not only demands attention, but also captures the elegance and tradition of vintage racing and the passion that the Association has for it."

title: Tableaux Lounge Materials

description of work: Stationery, menu, and opening night party invitation for a jazz,
wine and cigar club in Tokyo

design firm: Vrontikis Design Office/Los Angeles, CA

art director: Petrula Vrontikis

designer: Peggy Woo

client: Global Dining, Inc.

*"Images were enlarged and used boldly on these pieces. This cigar, wine and jazz club
in Tokyo needed a warm, elegant and progressive feel. The typography on the sta-
tionery echoes the pattern created by the lined-up cigars. Using two languages is
always a challenge, but worked to make the type more interesting an all pieces. We
specifically used an off-white paper for the warm feeling it creates, especially using this
color palette."*

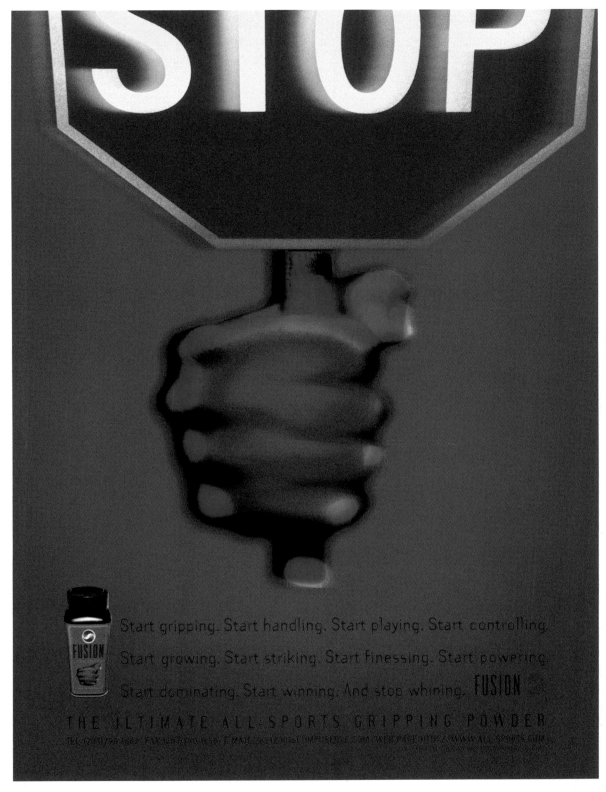

Start gripping. Start handling. Start playing. Start controlling. Start growing. Start striking. Start finessing. Start powering. Start dominating. Start winning. And stop whining. FUSION

THE ULTIMATE ALL-SPORTS GRIPPING POWDER

title: Agassi Fusion Stop Sign Advertisement

description of work: Advertisement

design firm: Mires Design/San Diego, CA

art director/designer: Jose A. Serrano

copywriter: John Kuraoka

photographer: Carl Vandershuit

client: Agassi Enterprises

The advertisement uses bold imagery to convey the nature of the product. Cropping the stop sign brings the audience closer to the visual, creating greater impact and sending a faster message. It's almost "in your face."

title: *Linens: Elements of the Table*

description of work: Book

design firm: Morla Design/San Francisco, CA

designers: Jennifer Morla, Petra Geiger

client: Sara Slavin

"*Linens* was designed to have both an intimate and individual style, as well as the flexibility to incorporate other titles into a series. Both the typography and the images have been pared down to essential elements to create a very light, clean, modern feeling. We also looked for a way to ensure that the photography led the narrative."

Period and Historical Influences

Retro graphic design depends upon an audience's interest in and longing for an idealized past. There is a soft spot in people's hearts for television programs, commercials and fashion and graphic design of days gone by. Paying homage to history or a period or another culture is a way to employ the aesthetics of another time and explore the exotic. It's graphic time travel. Muller + Company brings us back to the 1920s; Hornall Anderson Design Works takes us to the city of Mazagran.

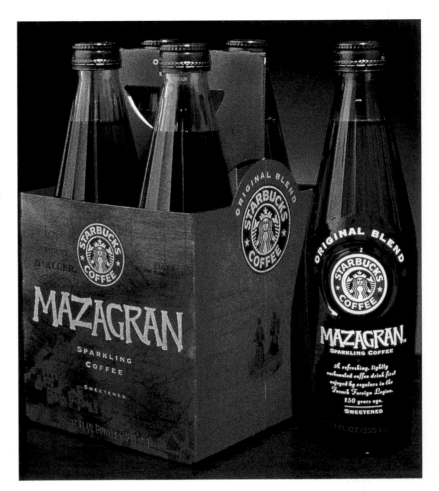

title: Industry Pictures Logo

description of work: Logo

design firm: Mires Design/San Diego, CA

art director: Jose A. Serrano

designer: Deborah Hom, Jose A. Serrano

Illustrator: Tracy Sabin

client: Industry Pictures

This is a strong, historical visual that helps reinforce the name of the company.

title: Starbucks Mazagran Four-Pack and Bottle Packaging

description of work: Packaging for coffee drink

design firm: Hornall Anderson Design Works, Inc./Seattle, WA

art director: Jack Anderson

designers: Jack Anderson, Julie Lock, Julie Keenan

client: Starbucks Coffee Company

"The name, as well as the concept of combining sparkling water with coffee, originated 150 years ago in the French Foreign Legion fort city of Mazagran, located in North Africa. Weary soldiers, returning from battle, would mix sparkling water with coffee to create a thirst-quenching, refreshing beverage.

"The four-pack basket container depicts a watercolor map of ancient Algeria, customized hand-lettering, and archived illustrations of the legionnaires extracted from history books. Currently, there are three flavors of Mazagran, each having a distinct color palette within the package design. These flavors are further differentiated with green, gold and black metal caps."

title: Greenhood and Company Stationery

description of work: Stationery for a new-media technology consulting company

design firm: Vrontikis Design Office/Los Angeles, CA

art director: Petrula Vrontikis

designer: Samuel Lising

client: Robert Greenhood/Greenhood and Company

"Our client is fond of Russian Constructivism, so we chose to let that influence this progressive, yet retro, solution. The challenge was to create a stationery package that would be very flexible, because the company was expecting to move to two to three different locations within the next two years. We decided that we should use the easily accessible tools of laser printing and rubber stamps to produce the system. The creative color palette in the Durotone line by French Paper Company was the perfect choice of paper."

title: Des Moines Plumbing Letterhead

description of work: Letterhead

design firm: Sayles Graphic Design/Des Moines, IA

art director/designer: John Sayles

client: Des Moines Plumbing

"The company name is enclosed in a retro, 1950s-style shape. Stylized graphics are different on each stationery component and include faucet handles, a bathtub and a sink, connected by graphic 'pipes.' The logo and illustrated visuals are also found on the streets of central Iowa—on Des Moines Plumbing vans."

title: Neo-Dada Poster

description of work: Poster for a gallery exhibit

design firm: Matsumoto Incorporated/New York, NY

art director/designer: Takaaki Matsumoto

client: The Equitable Gallery

"The design of this poster suggests the Dada period with its almost-haphazard nature and suggestion of wood-block lettering."

title: Dix Productions Logo

description of work: Logo

design firm: Muller + Company/Kansas City, MO

art director/illustrator: Dave Swearingen

client: Dix Productions

"The Dix logo assignment was to take a strictly type logo and give Dix Productions a more noticeable, likely identity. We went with a 1920s approach in the shape and style of the logo. The illustration style used in the camera gives the logo energy and results in a creative, fun, yet sophisticated logo to represent this successful film studio."

Image Manipulation

A change or distortion in appearance can disrupt or amuse the viewer. Whether a designer elongates, flattens, stretches, inflates or scratches a photograph, object or representation, it changes the quality of the original. This makes us see the thing anew and communicates meaning, like Steven Brower's cleverly bent guitar.

title: *The Classic Rock Quiz Book*

description of work: Book cover

design firm: Steven Brower Design/New York, NY

art director: Gregory Wilkin

designer/illustrator: Steven Brower

client: Carol Publishing Group

"The image of a bent guitar sums up the title in an unexpected way."

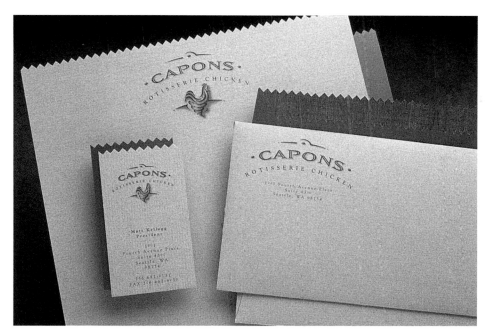

title: Capons Rotisserie Chicken Stationery Program

description of work: Stationery program for restaurant chain

design firm: Hornall Anderson Design Works, Inc./Seattle, WA

art director: Jack Anderson

designers: Jack Anderson, David Bates

client: Capons Rotisserie Chicken

"Capons Rotisserie Chicken, a take-out restaurant, wanted an identity that would portray the metamorphosis between a chicken and a quick 'spinning' motion. A spinning tornado design is used in the body of the chicken to depict a quick, take-out mentality. This 'chicken with an attitude' illustration is applied to the restaurant logo and take-out bags, as well as the stationery program."

title: *Loved* Poster

description of work: A movie poster for a new release starring William Hurt and Robin Wright-Penn

design firm: Vrontikis Design Office/Los Angeles, CA

art director/designer: Petrula Vrontikis

client: David Haynes/MDP Worldwide

"We were chosen to bring a different look to a very different film. Typical Hollywood movie poster work was absolutely inappropriate for this film, so our client asked us to rethink the way the poster medium can work. We had very little to work with as far as images. The only available images were from 35mm color negatives. The creative way we used them made their inferior quality much less noticeable."

1

2

3

4

5

6

7

8

9

10

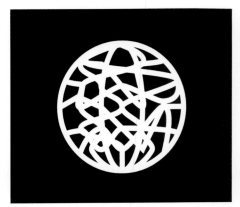

11

title: *New Order* Booklet

description of work: Booklet accompanying an exhibit

design firm: Matsumoto Incorporated/New York, NY

art director/designer: Takaaki Matsumoto

client: Gallery 91

"This booklet takes a simple, common visual image—that of a globe with latitudinal and longitudinal lines—and runs it through several transformations to suggest a feeling of disorder in world events."

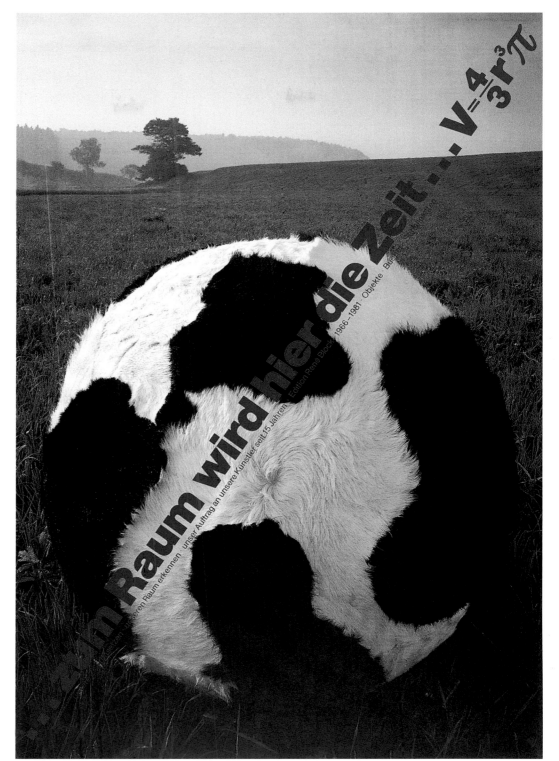

title: *. . . zum Raum wird hier die Zeit . . . (time becomes space)*

description of work: Poster

designer/photographer: Gunter Rambow

collaborators: Lienemeyer, van de Sand

The body of a cow becomes a ball. However, it retains its "cow" essence because of the texture and placement in a pasture.

Synthesis

Putting together separate elements to form a new, more complex whole produces an original visual. The combination of related or disparate elements—photographs with flat shapes, abstract elements with representational elements—can result in a startling, rich entity. Of course, one must always strive for coherence when synthesizing elements, as in NAGAI's imaginative paper samples.

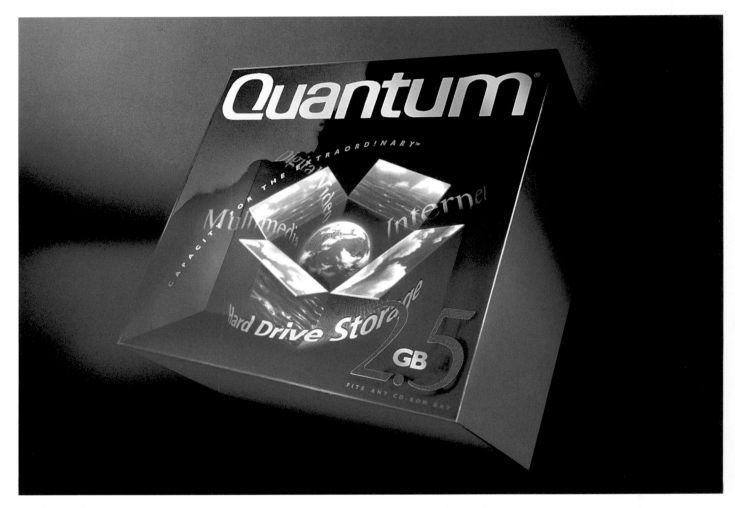

title: Quantum Packaging

description of work: Packaging

design firm: Primo Angeli Inc./San Francisco, CA

creative director: Primo Angeli

art directors: Brody Hartman, Richard Scheve

designers: Philippe Becker, Nina Dietzel

illustrator: Mathew Holmes

client: Quantum

A visual dialectic is created by combining the globe, as object, with an illusory reflection of it, into a coherent synthesis. The illustration conveys the idea that data storage is "a dynamic rather than static process."

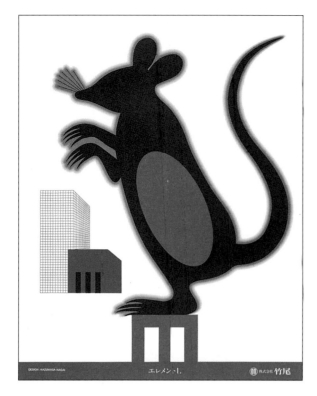

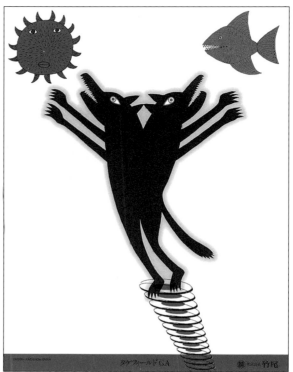

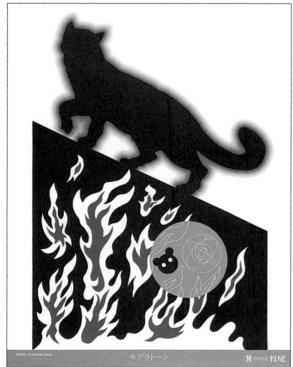

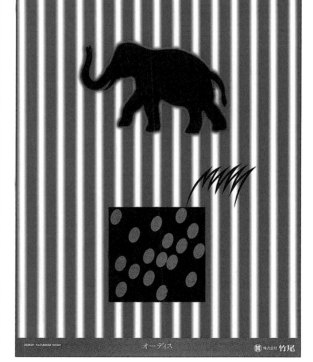

titles: Element Line (top left), Take Field GA (top right), Moderatone (bottom left), Fau douce (bottom right)

description of work: Paper samples for the paper trading company (series of 10)

design firm: Nippon Design Center/Tokyo, Japan

designer: Kazumasa NAGAI

client: Takeo Co., Ltd.

NAGAI's interest in living creatures, ecology and the destruction of the ecosystem is evident in this theme for paper samples.

By combining different animals with abstract and recognizable shapes in powerful compositions, NAGAI conveys the message that this planet belongs not only to us, but to any living form, an idea which is found in Asian culture and thought.

title: *Darkest England*

description of work: Book jacket for novel

design firm: Steven Brower Design/New York, NY

art director: Debra Morton Hoyt

designer: Steven Brower

client: W.W. Norton, New York

"This is a novel about an African tribesman who is sent to England to try to meet with Queen Elizabeth, who is recognized as the head of his tribe. I decided to juxtapose images of the two cultures in a way that is at once provocative and humorous, belying the nature of the book."

title: AIGA Stationery

description of work: Conference letterhead, envelope, second sheet

design firm: Rick Eiber Design (RED)/Preston, WA

designer: Rick Eiber

client: AIGA National

"The stationery breaks new ground in that it needed to include symbols by four different designers with accompanying theme statements for the AIGA Conference, be functional and still appeal to a 'designer' audience. I chose to use one symbol as dominant in the background as a unifier. This was reduced in intensity through density reduction of the four-color file to permit laser copying over it without compromising legibility. A variant of this same symbol was used on the envelope (note eye color change) without the water background to relate better with the other symbols. This spaced arrangement was then used on the mailing surface for two additional pieces."

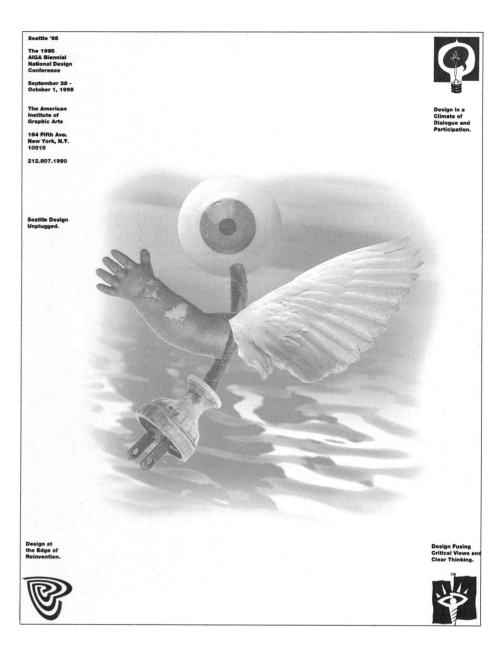

Merge

It is said that the best way to create something new is to bring two existing things together. By merging two things into one, whether the things are opposite, similar or unrelated, designers form a unique whole that makes us rethink the original elements. This is a particularly effective and important graphic device, which can range from Miller's humorous Book Head logo to Reisinger's inspirational symbols.

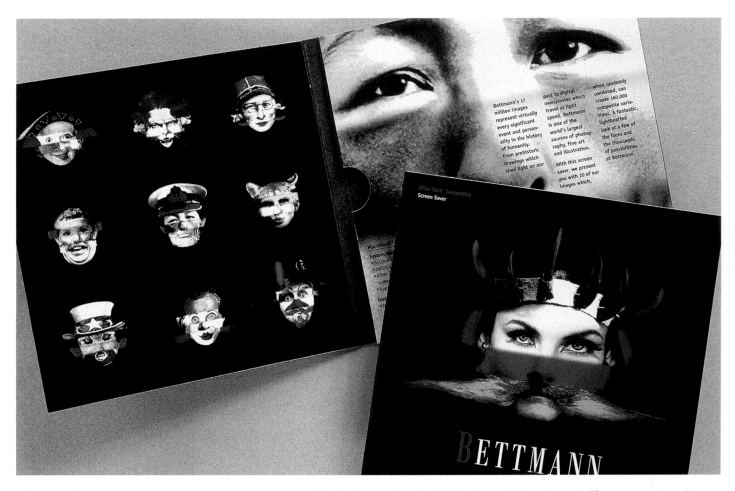

title: Bettman Screensaver

description of work: Screensaver

design firm: Carbone Smolan Associates/New York, NY

creative director: Ken Carbone

art director/designer: Justin Peters

client: Bettman Archives

"Dr. Otto Bettman began lending his photographic chronicles nearly fifty years ago and proudly merchandised the collection as a "complete history of civilization." Recently, Microsoft chairman Bill Gates acquired the expansive collection of documentary images that range from prehistoric drawings to modern-day news photos. Through his privately-owned company, Corbis, Gates will digitize the more than sixteen million images. As it was Bettman's mission to make his original pictures available to the masses, Gates possesses the same intention. Ultimately, the images will be retrievable from home and office via on-line services, CD-ROM and other unexplored media.

"This screensaver is a dynamic digital collage utilizing twenty faces from the archives. When the facial components are randomly combined, they can create 160,000 comedic and bizarre compositions. The screensaver represents the fresh identity of Bettman and a world of options available to the viewer."

 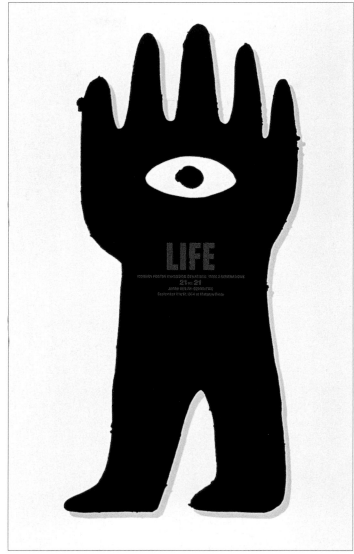

title: *Life*

description of work: Two posters for a design magazine

design firm: Shin Matsunaga Design, Inc./Tokyo, Japan

art director/designer: Shin Matsunaga

client: Japan Design Committee

Matsunaga sees the poster as a comprehensive tool. The poster format allows him to be expressive and communicate a message at the same time. These posters utilize merges; Matsunaga combines things—a body part, the hand and the lower torso, a tree and a person—to create meaningful expressions of the word Life.

"I express nature with organic curved lines and man-made objects with acute lines. We have been destroying forests and polluting seas, rivers and lakes in order to have a convenient and comfortable life. The natural world is delicately balanced. We cannot forget that human beings are only one tiny living thing in the vastness of nature."

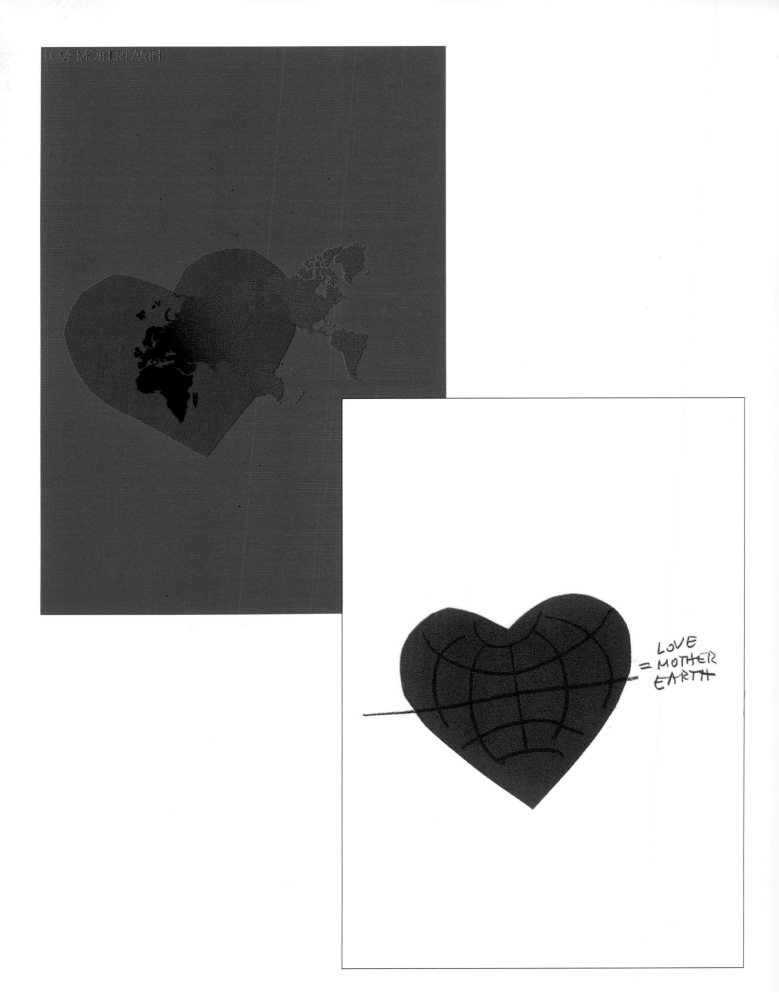

thinking creatively: new ways to unlock your visual imagination

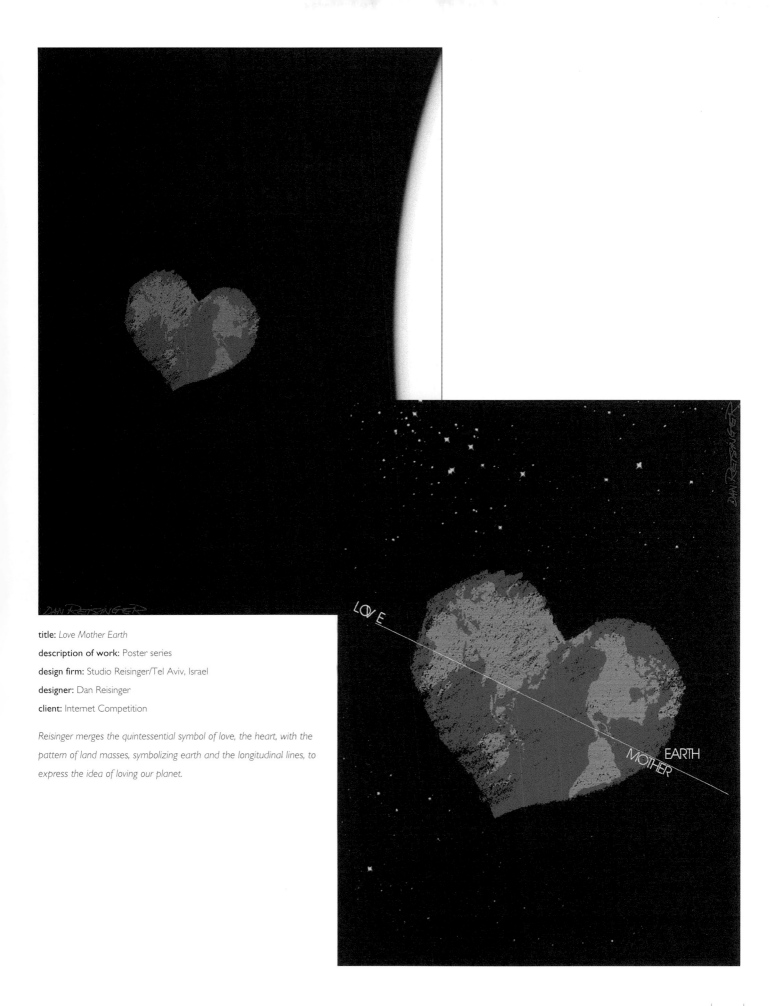

title: *Love Mother Earth*

description of work: Poster series

design firm: Studio Reisinger/Tel Aviv, Israel

designer: Dan Reisinger

client: Internet Competition

Reisinger merges the quintessential symbol of love, the heart, with the pattern of land masses, symbolizing earth and the longitudinal lines, to express the idea of loving our planet.

title: Colorado Brewery & Trading Company Logo

description of work: Logo for a brewery and restaurant

design firm: Hirschmann Design

art director: Richard Foy

designer/illustrator: Karl Hirschmann

client: Tim Foster, Semitorr Associates

"The similarities between the woolly head of a buffalo and the head of foam on a glass of beer were irresistible."

title: Book Head Logo

description of work: Logo

design firm: Muller + Company/Kansas City, MO

art director/designer/illustrator: Jeff Miller

client: Kansas City Book Festival

"This logo was developed for a local book festival. I began to sketch out ideas of incorporating a visual for a book and a feel for the festival. I decided on hand drawing normal, icon elements of a book and a man's head and combining them. The result was not an obvious, clichéd logo, but because of their combination, created a twist on the words book and festival and became an appropriate symbol for the book festival."

title: Station Store

description of work: Logo

design firm: The Knape Group/Dallas, TX

designer: Les Kerr

client: Station Store

"Our assignment: Create a symbol that says high-quality television programming and is as convenient as a product at your neighborhood grocery store."

title: Magic Carpet Logo

description of work: Logo

design firm: Mires Design/San Diego, CA

art director: Jose A. Serrano

illustrator: Tracy Sabin

client: Magic Carpet Books

"The unique mark blends the name with the visual . . . the book becomes the carpet."

The Unexpected

We don't want to know how a movie or novel is going to end because we want to be surprised. And that's just what this approach is all about—a twist, a surprise, something unforeseen. When something is unanticipated, it is more likely to be attractive, like Nakamura's eye-opening interpretation of medical material or deWilde's choice of file folders for the Didion book jacket.

title: Digital Stock "Deep Thoughts"

description of work: Advertisement announcing a new collection of stock photography published on CD-ROM

ad agency: Big Bang Idea Engineering/Carlsbad, CA

creative directors: Rob Bagot, Wade Koniakowsky

art director: Wade Koniakowsky

copywriter: Kirt Gentry

photographer: Digital Stock

client: Digital Stock

"Digital Stock is a publisher of stock photography on CD-ROM. This piece carried the cover headline 'Deep thoughts for creative people to ponder during moments of quiet reflection when you really should be working.' The market is creative people whose work is produced via desktop publishing. They've all seen stock photography (more than they'd care to remember). Most stock these days is advertised with that 'We get it' tone. But creative people are among the most jaded on the planet. You can't try too hard. Entertain first, provide just enough information, and get out."

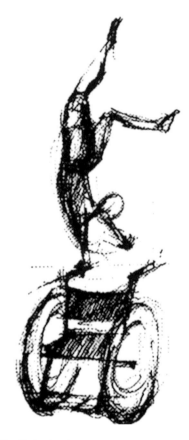

title: Center for Assistive Technology Logo

description of work: Logo

design firm: Muller + Company/Kansas City, MO

art director: Jeff Miller

client: Center for Assistive Technology

"The Center for Assistive Technology is a non-profit group that assists those in need of special equipment. Wheelchairs are in the greatest demand. My first sketches were of an abstract form of 'assisting,' since that was what they did mostly. However, the abstract logos were too 'corporate' and not fun enough. The staff at the center was so friendly I decided to incorporate a human element but still kept the 'assisting' part abstract. The result was a gestural sketch of a human form balancing on a wheelchair. The Center loved the idea because it showed that those with disabilities are not confined to their devices, but are independent through technology."

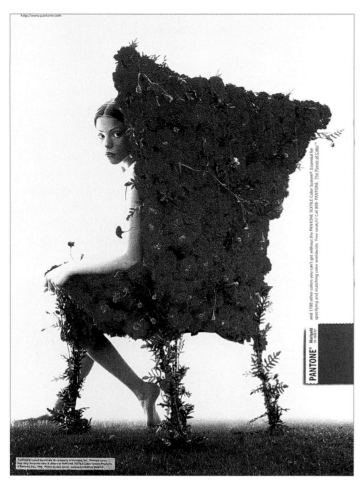

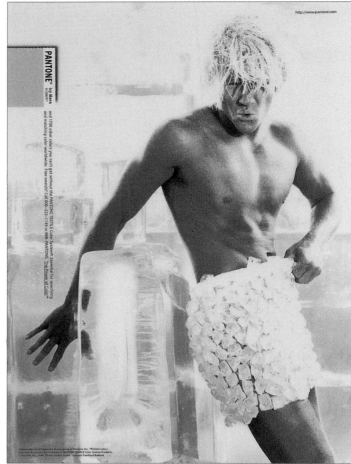

title: Pantone Textile Advertisements

description of work: Series of trade advertisements: *Bubblegum, Marigold* and *Icy Morn*

design firm: Frankfurt Balkind Partners/New York, NY

creative director: Kent Hunter

associate creative director: Kin Yuen

art director: Robert Wong

copywriter: Tom Givone

photographer: Jordan Donner

client: Pantone, Inc.

"Problem: Pantone is known to printers and graphic designers, but relatively unknown to designers in the fashion and textile industries. If they do know Pantone, the perception is of a limited color palette that isn't hip or fashion forward.

"Project: Trade advertising campaign to break through media clutter and create awareness of the Pantone Textile Color System, while also changing the image of the brand.

"Solution: We took advantage of the industry's practice of assigning silly names to color by creating literal photographic interpretations of colors such as Bubblegum, Marigold and Icy Morn. The arresting images looked more at home in a fashion magazine than a traditional trade publication."

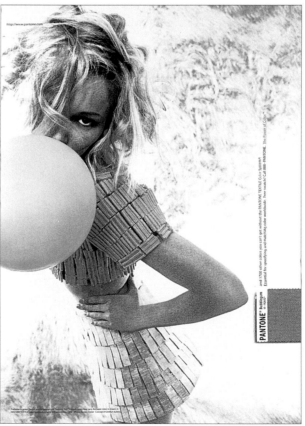

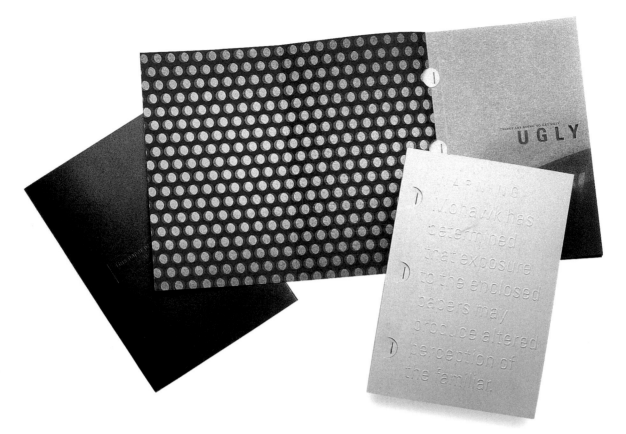

title: *Things Are Going to Get Ugly*

description of work: Paper promotion

design firm: Concrete/Chicago, IL

copywriter: Deborah Barron

designers: Jilly Simons, Cindy Chang

photograms: Jilly Simons, David Robson

photographer: Francois Robert

client: Mohawk Paper Mills, Inc.

"This promotion for unique imported papers alerts designers to expect the unexpected and warns that their perception may be altered. The deliberately ironic interplay of familiar industrial landscapes as precious miniatures, 'ugly' text and printing technique demonstrates the exquisite beauty in the commonplace, while focusing attention on practical virtues as well as the extraordinary beauty of the papers themselves."

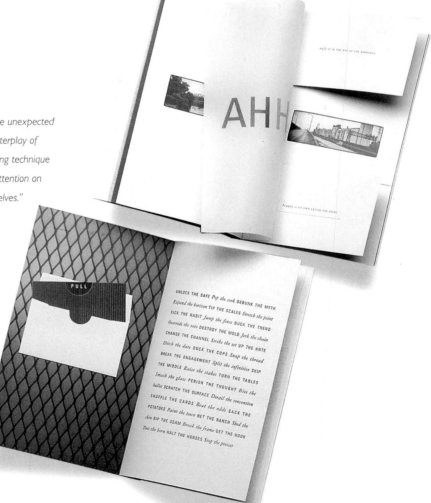

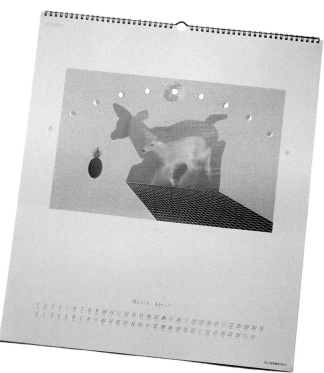

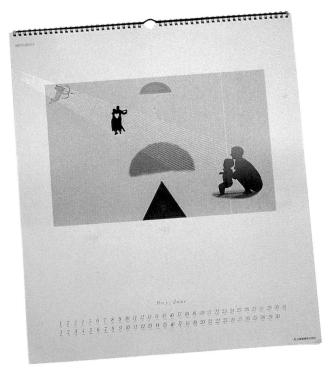

title: *Life*

description of work: Annual calendar with the company image

design firm: Nippon Design Center/Tokyo, Japan

designer: Kazumasa NAGAI

client: Mitsubishi Electric Co., Ltd.

We don't expect three-dimensional objects to exist in two-dimensional spaces. We don't expect the illusion of depth to be created by a single element on a flat surface. Nor do we expect to see flat shapes, snippets of illusory drawings and photographs compositionally working together.

NAGAI takes one out of one's experience and brings one into the world of the unexpected.

title: Kelley Baseball Glove Catalog

description of work: Direct mail catalog

design firm: The Knape Group/Dallas, TX

creative director: Les Kerr

associate creative director/copywriter: Paul Brandenburger

art director: Dan Streety

photographer: Dick Patrick, Dick Patrick Studios

client: Kelley Baseball Co.

"The Kelley Baseball company is an energetic rookie in a field of established old-timers. While the NBA and the NFL tend to update their image with the times, baseball pretty much sticks to its roots. So we chose to draw a contrast with tradition by creating a decidedly non-traditional catalog. We hired a great photographer, cranked up the lime green and fireball yellow (flame graphics included) and created a catalog that showcases Kelley's innovative gloves with a whole new attitude for a whole new generation of ball players."

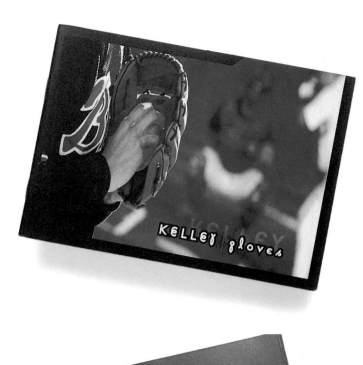

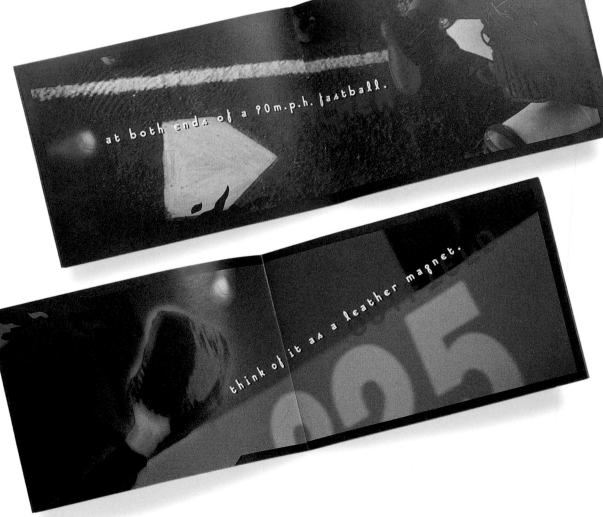

title: *The Last Thing He Wanted*

author: Joan Didion

description of work: Book jacket

art director/designer: Barbara deWilde

client: Alfred A. Knopf

"This is a minimalist, cryptic piece of writing which comes in case-file language. All the facts eventually accumulate to put together the motivation behind an average citizen's eventual entanglement in an arms-to-Contras deal. I wanted to use the file folders instead of the usual Washington/LA imagery associated with Didion's writing."

title: COR Annual Report

description of work: Illustration for annual report

media: Acrylic on archival paper, 20" x 30" (51cm x 76cm)

art directors: Bob Dinetz, Bill Cahan

Illustrator: Joel Nakamura/Santa Fe, NM

client: COR

"Bill Cahan came to me with this project. The idea was to illustrate the long process in which a new drug must pass through in order to come to market. Bill wanted to create a chart for a fold-out poster in the annual report so the stock holder would have a tool to better comprehend the material. Nothing like this had ever been done before. The biggest challenge was in trying to interpret this pile of medical material into some kind of visual. The next challenge was to place the process involved in a sequential order. Then Bill had to sell this to the client. The poster was a hit. I have never thought about my prescriptions the same way since."

title: New England Marionette Opera Web Site

description of work: Web site

design firm: PointInfinity/Sciasconset, MA

webmaster: Larry Coffin

art director: Rose Gonnella

hand lettering: Martin Holloway

client: New England Marionette Opera

For jaded Web surfers blasted with a consistent cacophony of type and images, seeing a beautifully lyrical handmade piece of lettering come across the screen is a warm and friendly sensation—totally unexpected in the cold brightness and density of the Internet. Surprise! Ancient traditions meet at the edge of cyberspace—melding the centuries to produce good design. And the design never loses sight of maintaining a visually appropriate look for an old world client—Marionette Opera.

title: CoopHimmelblau Architects/Los Angeles and Vienna

description of work: Logotype and stationery system for both locations

design firm: April Greiman/Los Angeles, CA

designer: April Greiman

photographic images: April Greiman

client: Wolf Prix/CoopHimmelblau

"The name of Europe's premier young architecture firm means 'cooperative [coop] blue sky [Himmelblau]'—hence the obvious, but not radical, use of a sky image and a logo 'block' for architecture. To be less obvious, I used the blue(s) for the typographic logo instead of the sky. After a while Coop got the idea to modify their name from Himmelblau to Himmelbau (dropping the l in blau, which then means 'sky building' instead of 'sky-blue'). I came up with literally lowering the l so you have both names in one logotype. Otherwise, everything that has been done since uses really interesting skies and clouds and various iterations of the graphical-boxed logotype. The supportive type is meant to represent the landscape."

Signs and Symbols

Signs, symbols, archetypes and icons can convey powerful meaning—both positive and negative. A cross. A hammer and sickle. A skull and crossbones. The meaning of a singular image or representation can be employed, enhanced, maximized, diminished, shattered or violated. How we use these things can actually stir audience emotion or improve lives, as in Robbins's TalkChart.

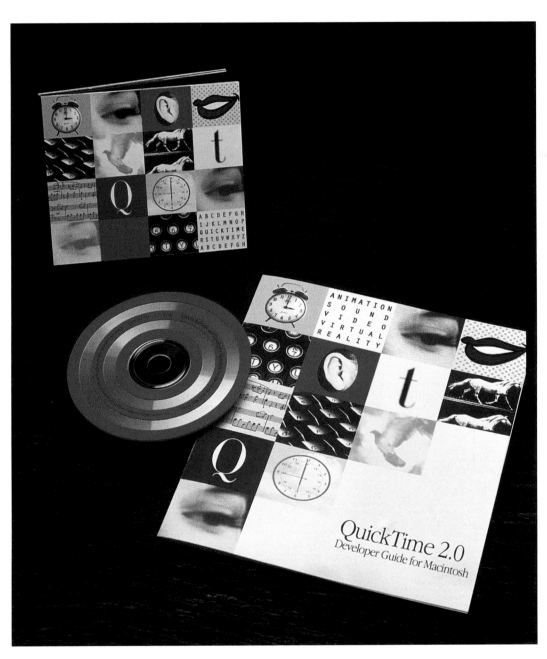

title: Apple QuickTime CD Digipak
description of work: CD packaging
design firm: Morla Design, Inc./San
 Francisco, CA
designers: Jennifer Morla, Craig Bailey
client: Apple Computer

"Apple Computer called upon us to design the packaging identity system for QuickTime, system software that allows for the integration of video, sound, text and animation for computer multimedia. Apple was looking for a fresh design solution that diverged from typical software and computer technology packaging. The imagery Morla Design used is representative of all the facets of QuickTime, showing the integration of motion, technology and animation. The CD was distributed to software developers to promote the use of QuickTime in their programs and the design project has since been expanded to include QuickTime VR and instruction manuals for retail distribution."

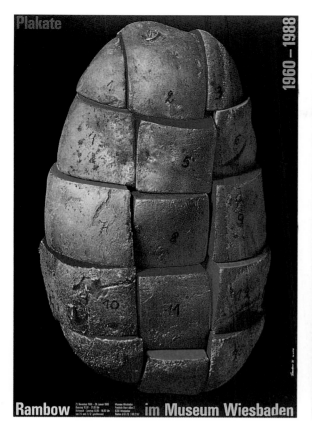

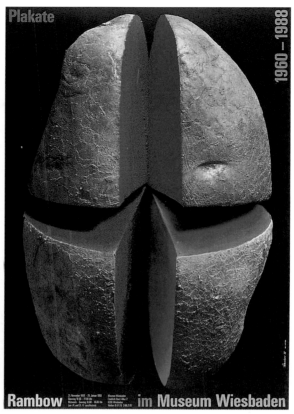

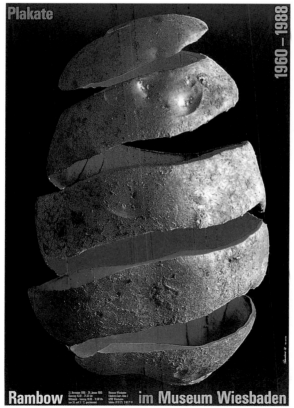

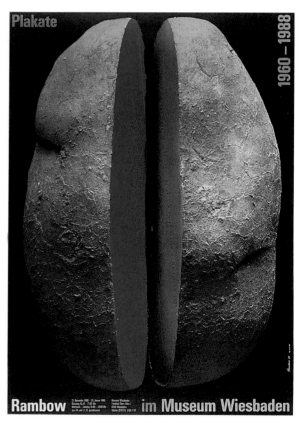

title: *Rambow im Museum Wiesbaden*

description of work: Poster series

designer: Gunter Rambow

photography: Rambow and van de Sand

client: Museum Wiesbaden

Rambow uses the potato, the archetypal German food, to create a memorable object-symbol. He takes an ordinary object and infuses it with creative energy.

title: *Again?*

description of work: Poster

design firm: Studio Reisinger/Tel Aviv, Israel

designer: Dan Reisinger

client: Internet Competition

The swastika, a still frightening (for many) and powerful symbol on its own, creates a "crack" in the red star, a symbol of fascism. The poster was designed to promote awareness of emerging fascism in the territories of the former Soviet Empire.

title: *Let My People Go*

description of work: Poster

design firm: Studio Reisinger/Tel Aviv, Israel

designer: Dan Reisinger

client: Self-initiated

The hammer and sickle, a symbol of the former Soviet Union, replaces the G in Go to denote who should let the Jews leave the country.

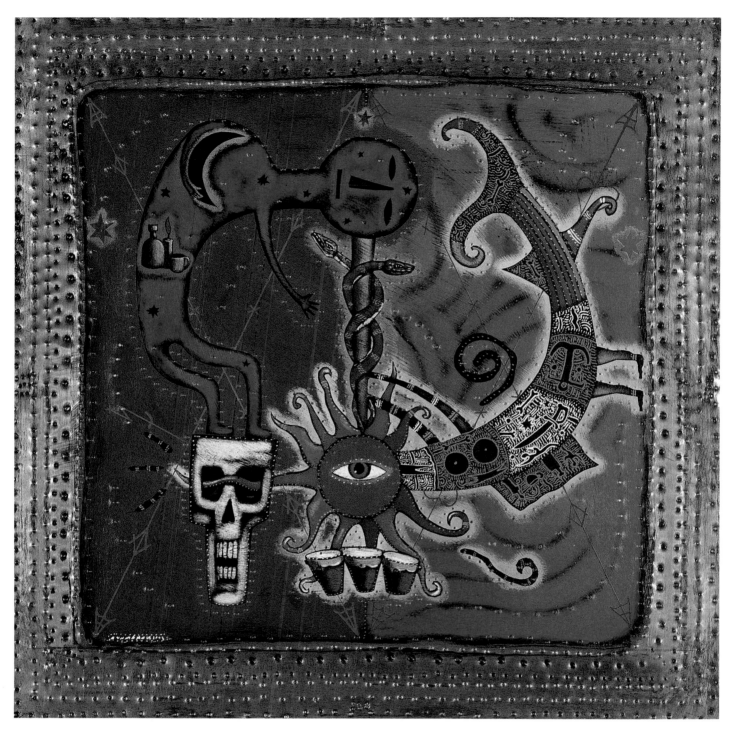

title: Boukman Eksperyans

description of work: Illustration for record cover

media: Acrylic and oil on tooled tin, 14" x 14"
 (36cm x 36cm)

art director: Satoru Igarashi

illustrator: Joel Nakamura/Santa Fe, NM

client: Boukman Eksperyans

"Boukman Eksperyans is a Voodoo band from Haiti. There are very specific elements of the Voodoo religion that needed to be placed in the illustration in very specific places. I also wanted to create a very folk-art-looking piece. I did not want this to feel like a commercial illustration, but rather an old relic depicting folklore. The elements: Loa, or spirits of the dead; stick with two snakes, placed in the middle of the composition; sun and moon; bottle, candle and cup, all together; siren Mermaid (Haiti is surrounded on three sides by water); diagrams; skull and eye; red and blue.

"I used Haitian folk art as inspiration, as well as some books on the Voodoo practice. I had to get this right so the Boukman Eksperyans would not cast a spell on me! In the end, everyone was very happy with the art, and it has gone on to win many awards."

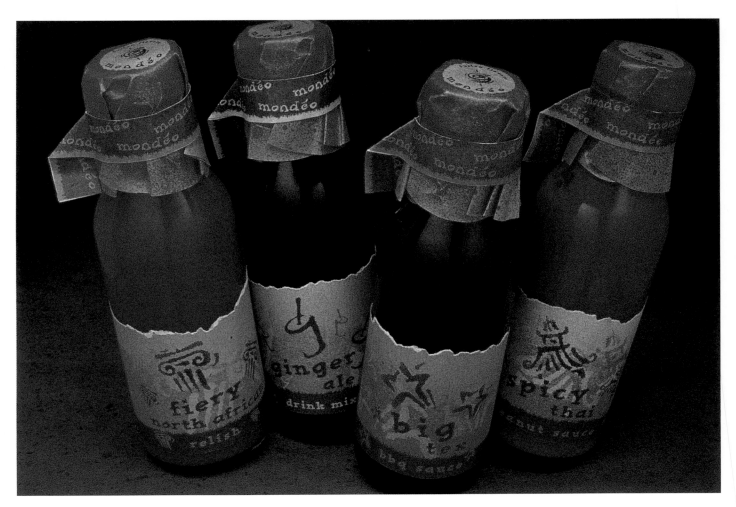

title: Mondeo Gourmet Packaging

description of work: Packaging for a line of sauces and mixes

design firm: Hornall Anderson Design Works, Inc./Seattle, WA

art director: Jack Anderson

designers: Jack Anderson, David Bates, Sonja Max

client: CW Gourmet

"Mondeo was designed as the identity for a restaurant concept bringing together excit-
ing, authentic flavors from around the world and delivering them in a fresh and fast
manner. The identity continues the global theme through the use of type treatment
(also depicted on the bottle labels) reflecting an earthy, old-world feel. Each label illus-
trates the bottle's contents with an icon representation. These include: a pagoda for
Asia (spicy Thai peanut sauce), a column for the Mediterranean (fiery North African
relish), stars for the Americas (big Texas BBQ sauce) and a cup icon that represents a
ginger-ale mix (the only icon/packaging that doesn't represent a corner of the world).
These bottles are only sold in the restaurant and are also environmentally conscious
through their use of labels on recycled paper."

title: Southwest Records Logo

description of work: Logo for a record company specializing in record-
ings of artists from the American Southwest

design firm: Hirschmann Design/Boulder, CO

art director: Janet Martin

designer/illustrator: Karl Hirschmann

client: Sandy Jones

"Combining the sun petroglyph with a record seemed to be the obvious
and best solution for the problem."

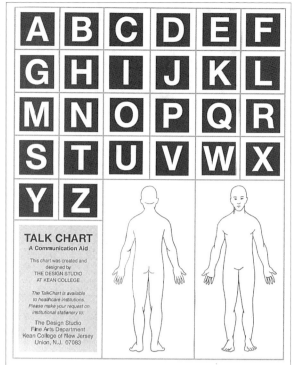

title: The TalkChart

description of work: A communication device utilizing icons

creative director: Alan Robbins/The Design Studio, Kean College of New Jersey

designers: Various dedicated students

client: Self-initiated

"The TalkChart is a communication device for patients in hospitals and nursing homes. Using the 8 ½" x 11" laminated chart, healthcare patients with aphasia, throat tubes or other impairments to their speech can now make their needs known to family and staff by pointing to the graphic symbols or letters of the alphabet that appear on the chart. The graphic symbols represent fifteen basic patient needs and figures of the human body for pinpointing problems.

"The TalkChart was created and designed by college students in The Design Studio at Kean College under the direction of Professor Alan Robbins and donated to local hospitals. Thanks to articles about the project in The Newark Star Ledger and The New York Times, many hospitals throughout the state of New Jersey are currently using this helpful device."

title: TrukkE Boot Icons

description of work: Icons

design firm: Tharp Did It/Los Gatos, CA

designer: Rick Tharp

illustrators: Rick Tharp, Susan Jaekel

client: TrukkE Winter Sports Boot Company

These icons were created by Rick Tharp to represent the various winter sports a line of boots are designed for. They represent walking, working, hunting, camping, fishing, snowshoeing, playing, climbing and generally goofing-off-in-the-snow. The Ansel Adams–like figure was illustrated by Rick to represent "hunting." According to Tharp, "I'm not a strong supporter of sport hunting. We mentioned to the client that there is a difference between hunting, shooting and killing. One can hunt animals without a weapon and one can shoot them without one too." The icons were used in advertising, point-of-sale and trade show applications.

Even with a strong background in drawing, Rick still takes Polaroid photos when designing with the human figure. "It's important to explore all the angles. The 'goofing-off' icon was the easiest one, but we took many photos to get it just right."

Humor

Who doesn't want to be amused or enjoy a good chuckle? We all enjoy humor, and in visual form it captures our attention like nothing else. A sense of humor manifested in visual form and at the service of a design concept or message is priceless, like the use of scale in Big Bang Idea Engineering's Taco Del Mar poster, "Do not drop it."

title: Plaza Hair Poster
description of work: Poster
design firm: Muller + Company/Kansas City, MO
art director: John Muller
designer: Dave Swearingen
client: Plaza West Hair

"We took the project of a simple We're moving poster for Plaza West Hair and gave it a creative twist. The poster gained more recognition and got the point across by catching people's eyes and drawing them in. The concept is clever and the graphic is a play on the simple concept behind a moving reminder."

Our vet will be back shortly. Sit. Stay.

SHOTS, SPAYS, NEUTERS AND GREAT VETERINARIANS ARE JUST NEXT DOOR.

title: *Sit, Stay*

description of work: Poster that hangs in the lobby of the Humane Society

ad agency: EvansGroup/Salt Lake City, UT

creative director: Bryan DeYoung

art director: Dick Brown

writer: Dick Brown

client: Humane Society of Utah

Self-cleaning Cats Now In Stock.

PET ADOPTIONS AND SHELTER.

Our pups runneth over.

PET ADOPTION AND SHELTER.

If you see a lost dog: retriever.

PET ADOPTION AND SHELTER.

title: Outdoor Boards for Humane Society

description of work: Two-sided billboard

ad agency: EvansGroup/Salt Lake City, UT

creative director: Bryan DeYoung

art director: Dick Brown

writers: Gage Glegg, Dick Brown

client: Humane Society of Utah

"Since the Society is funded from donations, the budget is practically nonexistent for advertising. They do, however, have a small billboard on their property that is very visible from the freeway by both northbound and southbound traffic. Our purpose was to create a design that was very easy to read and inexpensive to paint and that, most importantly, would relate the message of the Humane Society. The main message is getting people to adopt pets from them; a secondary one has been to tell the public about the spay-and-neuter clinic available on site.

"The cat and dog theme is one that lends itself to lots of word plays and innuendos. Our messages have been both short and lighthearted, and as a result the adoptions are doing very well, as is the Humane Society of Utah in general.

"We have a great relationship with them, and they enjoy our sense of humor and willingness to help them."

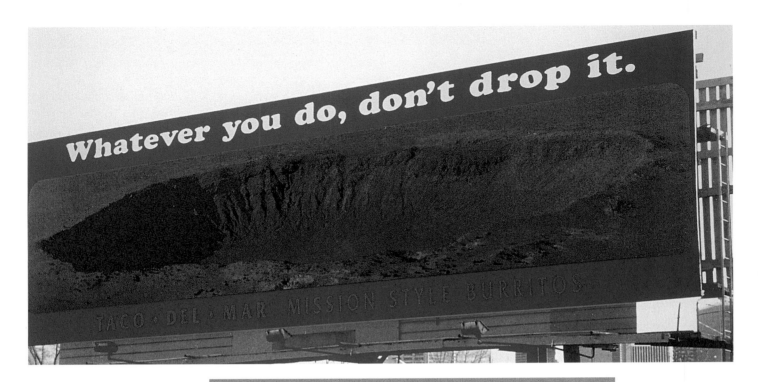

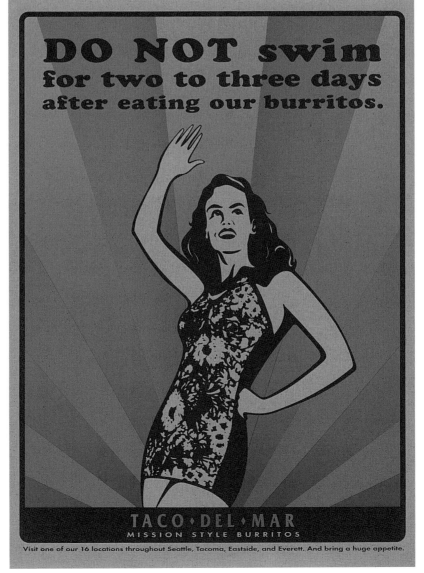

thinking creatively: new ways to unlock your visual imagination

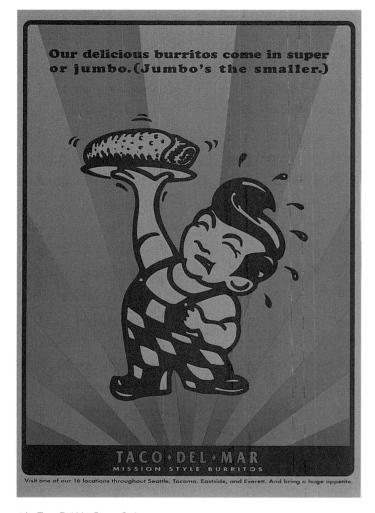

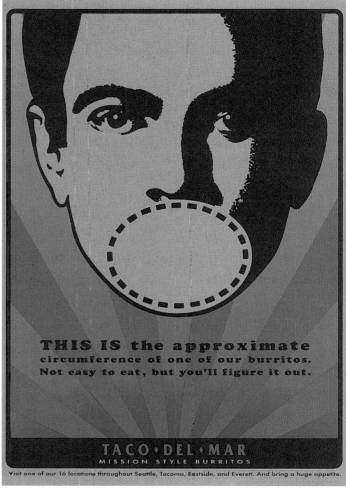

title: Taco Del Mar Poster Series

description of work: Point of sale posters and painted outdoor
 bulletin

ad agency: Big Bang Idea Engineering/Carlsbad, CA

creative directors: Rob Bagot, Wade Koniakowsky

art director/illustrator: Wade Koniakowsky

copywriter: Rob Bagot

client: Taco Del Mar

"When they came to us, Taco Del Mar had three stores and a somewhat lofty view of their product. After talking to consumers, we discovered that while the burritos were tasty, it was their girth that kept their fifteen- to thirty-year-old customers coming back. Unlike many clients who resist truth in favor of a romantic ideal of their product, Taco Del Mar embraced the quantity strategy and every piece of communication since then has been based on that simple premise. This is extremely freeing for the agency."

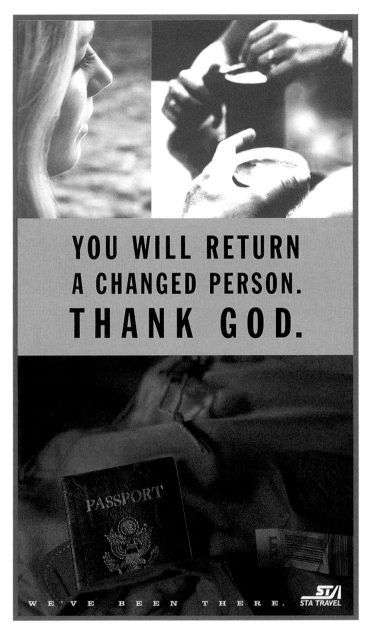

thinking creatively: new ways to unlock your visual imagination

NOW THAT YOU'VE ACCRUED
THOUSANDS IN STUDENT DEBT,
IT'S TIME TO FLEE THE COUNTRY.

EXPERIENCE THE WONDERS
OF FOREIGN CULTURES
BEFORE THEY IMPORT OURS.

title: STA Travel Point-of-Sale Posters

description of work: Point-of-sale posters used to brand STA in their retail outlets
across the U.S.

ad agency: Big Bang Idea Engineering/Carlsbad, CA

creative directors: Rob Bagot, Wade Koniakowsky

art director: Wade Koniakowsky

copywriters: Rob Bagot, Kirt Gentry

photographer: Paul Beauchamp

client: STA Travel

*"STA (originally Student Travel Australia, until they went international) is the world's
largest student travel organization. Their marketing position is simple. 'We know stu-
dent travel better than anyone.' Large point-of-sale pieces like this decorate their
offices. When students come in, instead of seeing posters of women lying on the
beach in the Bahamas, they get the feeling that somebody understands their unique
travel needs."*

Juxtaposition

When a designer places dissimilar elements side by side, very exciting things can happen. Too often we combine like elements and don't think to establish contrasts. Juxtapositions can teach, inform and jolt us. Sometimes we need to compare things in order to understand their range, as in Mires Design's Nextec logo.

title: *The Burial Brothers*

description of work: Book jacket for novel

design firm: Steven Brower Design/New York, NY

art director: John Gall

designer/illustrator: Steven Brower

client: Grove/Atlantic Press

"This irreverent jacket reflects the tone of this novel, as the two main characters journey in a hearse to South America, with much good and evil along the way."

title: Nextec Logos

description of work: Logo

design firm: Mires Design/San Diego, CA

art director: John Ball

designers: Kathy Carpentier-Moore, John Ball

photographers: Various

client: Nextec Applications, Inc.

"Photographic opposites reinforce the message of this manufacturer of weather-resistant fabric."

title: *NEO* Magazine

description of Work: Magazine

design firm: Carbone Smolan Associates/New York, NY

creative directors: Ken Carbone, Leslie Smolan

art director: Jen Domer

designer: Lesley Feldman

client: The Simpson Paper Company

"Simpson's NEO premiered five years
ago with a two-fold purpose: to highlight
and then discuss a few truly unique
people, places and things — from a
variety of disciplines—that have recently
appeared on the stage of contemporary
culture. These writings and images, which
praise the "New," have been juxtaposed
with voices and ideas that are part
of our heritage and are worthy of re-
examination and more accolades.

"In CSA's design, the dialogue between
novelty/alteration and preservation is carried by
a striking selection of spokespeople and land-
marks. Laurie Anderson, performance artist
extraordinaire, meets Pierre Chareau's Maison
de Verre. CSA strategically chose Anderson's
art, which upholds NEO's theme: She harness-
es technology and her memories. Similarly, the
Maison de Verre was built decades ago, but still
captures the minds of contemporary designers
and architects. CSA's design possesses energy
and intelligence: It moves from past to present
and vice versa in an informative and engaging
manner."

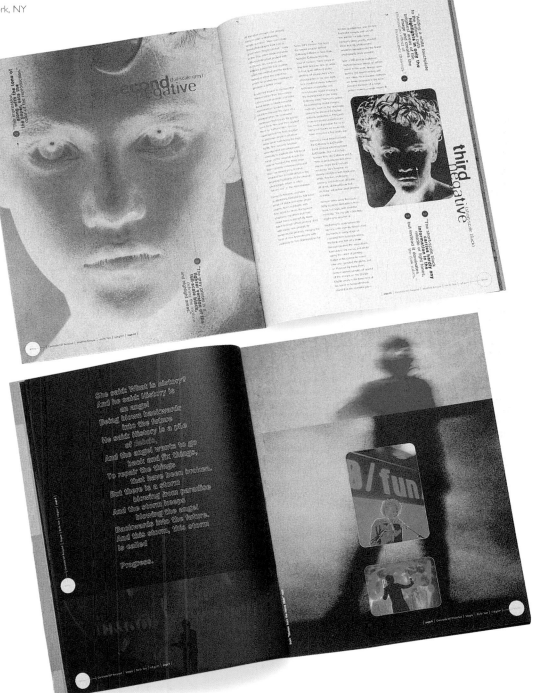

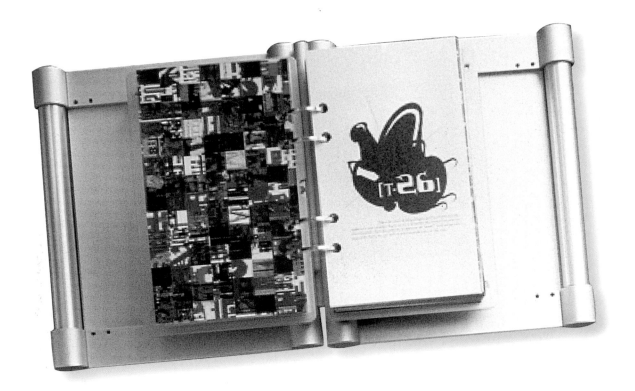

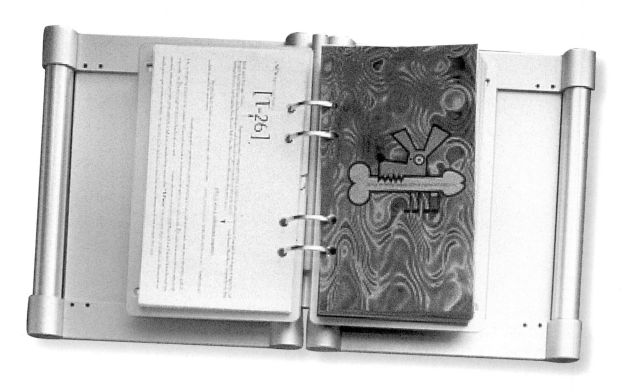

title: *Metal Type Book*

description of work: Font catalog for reps

design firm: Segura Inc./Chicago, IL

designer: Carlos Segura

client: [T-26] Type Foundry

Type is juxtaposed against full-page pattern-oriented illustrations, which creates an interesting interplay between the shapes of type and the shapes in the illustrations.

"When [T-26] first started, we hired reps and produced these books to have them 'walked' to local agencies and design firms."

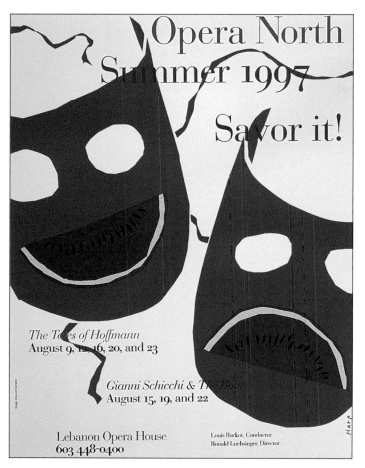

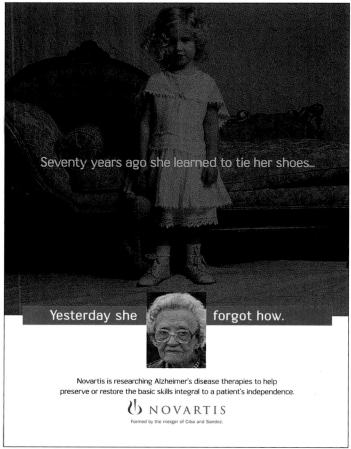

title: Opera North Summer

description of work: Promotional poster for regional opera company

design firm: Harp and Company/Hanover, NH

designers: Douglas G. Harp, Susan C. Harp, Robert C. Yasharian

client: Opera North

"The primary goal of this poster is to reach out to as broad an audience as possible and to portray opera in a different light: as something fun and accessible to all. The concept is simple. It would have been far too busy and complex to attempt to capture something about each of the three operas in one poster. Instead, by adding a bright, summery twist to the age-old comedy/tragedy cliché, we have created an overall impression about a summer of opera. The juxtaposition of these disparate elements— watermelon slices (modified by the words Savor it!) and the theater masks—delivers a colorful, eye-catching, witty solution that invites the viewer to think, discover and pick up the phone."

title: Novartis Advertisement

description of work: Medical advertising

ad agency: Harrison Wilson & Associates/Parsippany, NJ

creative director: Hector Padron

creatives: Hector Padron, Paul O'Neil, Kelly Fletcher

copywriter: Fran Dyller O'Neil

digital artist: Phil Donaldson

photographers: Bob Walsh, Eileen Vincent-Smith

client: Novartis Pharmaceutical, Mark Frank

"The visual and headline present the contrasting differences of functionality, in regard to what is learned and forgotten, due to Alzheimer's Disease.

"The objective of this advertisement is to generate awareness of the entry of Novartis into the area of Alzheimer's Disease. This ad is not a 'Coming Soon' ad, but one that indicates that Novartis has a therapy coming down the pike, but not in the immediate future."

Abstraction

A designer can refer to a concrete object without representation-
ally depicting it. At times, we get a greater sense of a thing's
essence from abstraction; a reference or context can epitomize
something, like Primo Angeli's delicious packaging for chocolates
or Segura's sleek snowboard designs.

title: Harden & Huyse Chocolates

description of work: Packaging

design firm: Primo Angeli, Inc./San Francisco, CA

art directors: Carlo Pagoda, Primo Angeli

designer: Philippe Becker

client: Harden & Huyse

"When Harden & Huyse approached Primo Angeli Inc. to develop new packaging for its exquisite, high-end chocolates, we knew the graphics had to reflect the luxury and sophistication of the product, which uses only the finest ingredients. We created an abstract, fluid, swirling pattern in gradations of rich color, suggesting a delectable melting of cream and chocolate. The logotype, printed in gold and surrounded by an embossed rectangle, gives the impression of a sovereign seal securing a tissue or wrapping paper of extraordinary quality. We intentionally kept the graphics devoid of any mainstream product-photograph taste appeal, creating a package that could hold something precious: perhaps chocolate, perhaps fine Italian silk stockings. How would one immediately know? This desirable ambiguity is effective within the context of the confectionery shelf sales environment, where the product gains its identity from the other products that surround and compete with it."

title: *Post War Energy*

description of work: Poster for peace and environmental campaign

design firm: Shin Matsunaga Design, Inc./Tokyo, Japan

art director/designer: Shin Matsunaga

client: Japan Graphic Designers Association, Inc.

"The five circles represent the growth of the world in the five decades after the end of World War II. We lost everything in the war, but rose like a phoenix from the ashes to build a new world. Those fifty years nearly correspond to my age. The red flames symbolize the enormous energy of that time. In a way, they look like war flames that have never ceased to burn on the earth after the war. Definitely, they are not the flames of hell. They are the flames of the people's zeal to take on challenges and solve the earth's difficult problems."

title: *Vision of Water*

description of work: Poster for an exhibition against water pollution entitled "Water"

design firm: Shin Matsunaga Design, Inc./Tokyo, Japan

art director/designer: Shin Matsunaga

client: Japan Graphic Designers Association, Inc.

Matsunaga communicates the idea of water in three basic ways: the color blue, horizontal layers and the "sinking" of the typography. Usually, water is symbolized by waves rather than horizontal bands or layers. By making the horizontal layers gradations of blue, we understand the visual.

title: Snowboards

description of work: Three snowboards

design firm: Segura Inc./Chicago, IL

designer: Carlos Segura

client: XXX Snowboards

The colors and movement of these abstract designs are appropriate for a sport which is about speed and skill.

"We did over forty boards in all for XXX, who used to be a snowboard wax company and then wanted to enter the board segment of the market."

title: "The Great Cosmos"

description of work: Annual calendar with company image

design firm: Nippon Design Center, Inc./Tokyo, Japan

designer: Kazumasa NAGAI

client: Mitsubishi Electric Co., Ltd.

Design does not have to depend upon narrative content or pictorial representation to communicate and affect an audience. NAGAI's calendar is an example of intrinsic forms that communicate clearly and that are deeply effective.

Borrowing From Language

Who said language has to be verbal or written? Designers can visualize metaphors, personifications, onomatopoeias, similes, puns, malapropisms, pleonasms and oxymorons. We can use one thing to designate something else. Visuals can have double meanings or be connotative or be symbolic of more than one thing. We can make visual comparisons. We can design type to imitate sound, like Ciccolella's paper show invitation, or create visual metaphors, as in Frankfurt Balkind's annual report for NCR.

title: Paper Show Invitation

description of work: Invitation

design firm: Marty Anderson Design Associates, Inc./Alexandria, VA

designer: Tony Ciccolella

client: The Production Club of Greater Washington

Ciccolella's design is an example of onomatopoeia.

"This invitation was designed to get people excited about this annual event. The name of the event is revealed once the invitation is opened full width. The letters of the event name are used to provide the details of the event."

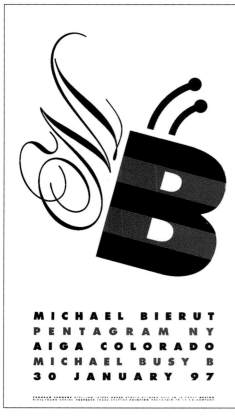

title: Michael Bierut Invitation

description of work: Invitation to speaker presentation by Michael Bierut of Pentagram

design firm: Hirschmann Design/Boulder, CO

art director/designer/illustrator: Karl Hirschmann

client: Colorado Chapter of the American Institute of Graphic Arts

"As chairperson of this program, I experienced some frustration trying to schedule Michael Bierut to come to Denver and give a speech. As a partner of Pentagram, Michael may very well be the busiest designer in the country. At one point, I thought (to myself), 'He really is a busy bee!' Which soon became, He really is a busy B! From there it was a short jump to make wings out of a script M. Michael has a wonderful sense of humor, which made this solution more than appropriate."

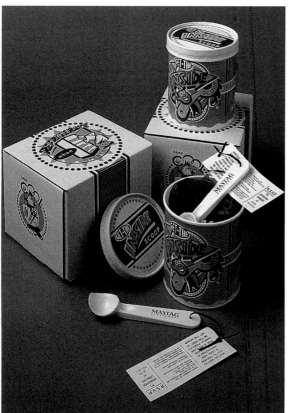

title: *Get the Inside Scoop*

description of work: Invitation

design firm: Sayles Graphic Design/Des Moines, IA

art director: John Sayles

designers: John Sayles, Jennifer Elliott

copywriter: Wendy Lyons

client: Maytag

The appliance manufacturer asked Sayles to develop a mail piece to invite members of the media to a luncheon introducing a new Maytag refrigerator. Sayles responded with a corrugated box printed with illustrations of "chilly" characters—a penguin and Jack Frost. Inside the box, cotton "frost" surrounds an ice cream carton printed with the message Get The Inside Scoop, an imprinted ice cream scoop, details about the luncheon and even a coupon for free ice cream.

"I'll admit we do some 'cool' things, but this project really lived up to that!" laughs Sayles.

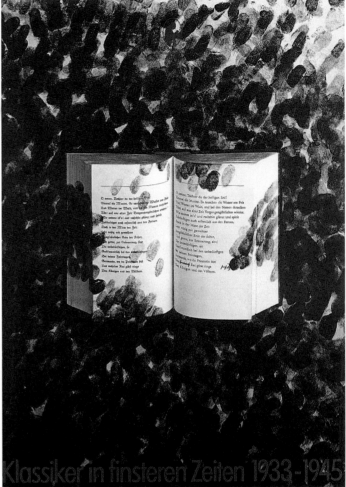

title: *The Undertaking: Life Studies From the Dismal Trade*

author: Thomas Lynch

description of work: Book jacket

art director/designer: Barbara deWilde

client: Alfred A. Knopf

"The profession of undertaking is a dark comedy of manners. Slipping a card from the dark to a client seemed to be a good metaphor for reaching the living on an issue of death."

title: *Classic Literature in the Dark Days 1933–1945*

description of work: Poster for exhibition of classic works of literature

designer: Gunter Rambow

photographer: van de Sand

collaborator: Lienemeyer

Inked fingerprints mar and surround an open book as a metaphor for the "Dark Days."

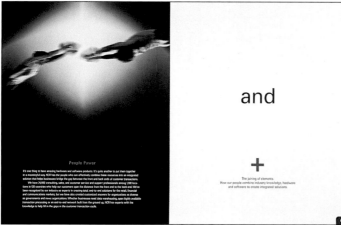

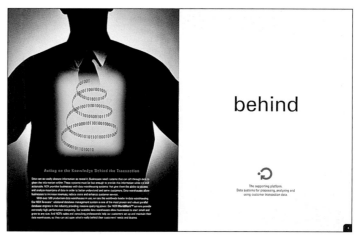

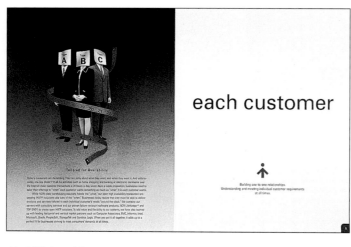

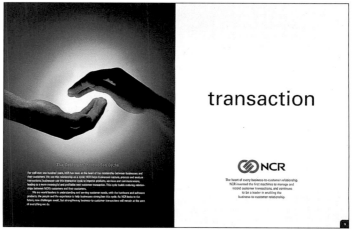

title: NCR Annual Report

description of work: Annual report

design firm: Frankfurt Balkind Partners/New York, NY

creative directors: Aubrey Balkind, Kin Yuen

designers: Kin Yuen, Ji Byol Lee

client: NCR Corporation

"Problem: To convey scope of NCR's business and customer services. To reposition a 113-year-old company known for its cash registers as the authority in customer transactions.

"Solution: We distilled this essence into a phrase, *at and behind each customer transaction.* By visually dissecting this sentence with surreal photo illustrations and icons, we gave the reader a device to absorb and retain the key message of the report."

Technique

The final step of any graphic design project is producing it. Designers have an intimate knowledge of the materials they use, like papers and inks, as well as the printing process, binding and gluing. The physical process of making the art, as in Eiber's logo and stationery, or the selection of atypical materials can make lasting impressions in design solutions.

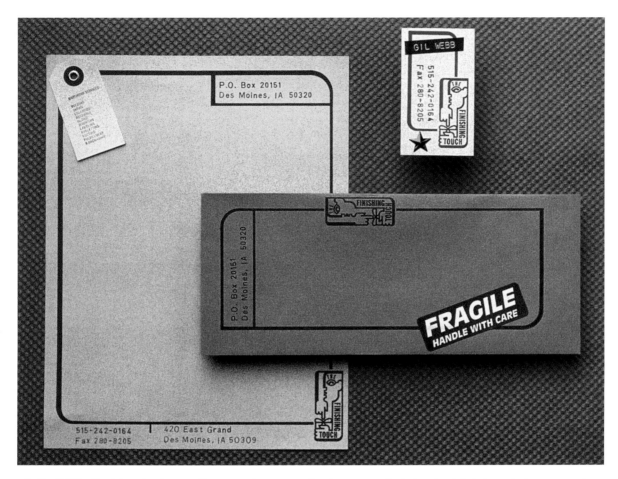

title: The Finishing Touch Letterhead

description of work: Letterhead

design firm: Sayles Graphic Design/Des Moines, IA

art director/designer: John Sayles

client: The Finishing Touch

The company's name served as the inspiration for the letterhead. Sayles's graphic logo consists of two hands putting "the finishing touch" on a box. Individual components of the letterhead system are each on a different paper, with the envelope a standard Kraft paper "policy" envelope and the business cards printed on manila cover stock.

The true nature of The Finishing Touch comes through in the details of the letterhead program. The address on the envelope is rubber stamped in purple, while a "Glass: Handle With Care" label provides an attention-getting feature. In addition to the printed logo and hand-stamped information, the business card includes a hand-made plastic label with the employee's name and a decorative plastic star hand-glued to each card. Similarly, the letterhead includes a miniature shipping tag applied with an eyelet. The tag is rubber stamped with a list of the company's services.

Sayles explains, "Because The Finishing Touch is a small company, I had a lot of freedom to come up with a unique look. Their business is handwork, so they didn't balk when I came up with this rather involved process. The individual parts themselves are economical and readily available; they assemble the components of their letterhead during down times or as needed, so it works very well for them."

title: Michael Regnier Logo

description of work: Logo

design firm: Muller + Company/Kansas City, MO

art director: John Muller

designer/illustrator: Jeff Miller

client: Michael Regnier Photography

"This logo was done for the local photographer Michael Regnier. His work is unconventional and untraditional, to the point of blurring the lines between photography and painting. It was important to know the background, look and feel of his photography before his logo could be executed. We created a circle out of black markers and crystal clear spray to work the marker on the paper. We then scratched the wet marker ink and drew a lowercase r in the circle. I then scanned it in and adjusted the contrast, blurred and re-scratched certain areas and left others alone. What was important with this logo was not relying on the computer to develop the logo, but rather to make it look like there was no computer imaging involved at all. Therefore, by avoiding the computer as much as possible, we created a logo that looks like one of Regnier's photo/paintings."

title: Body Glove Packaging

description of work: Packaging

design firm: Mires Design/San Diego, CA

art director: Jose A. Serrano

designers: Jose A. Serrano, Miguel Perez

photographer: Carl Vanderschuit

client: Voit Sports

"The simple use of color and material—silver on Kraft cardboard—gives it a raw, industrial feel."

1

2

3

4

5

6

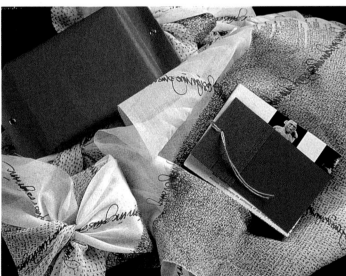

7

title: plus design inc. Moving Announcement

description of work: Announcement

design firm: plus design inc./Boston, MA

design directors: Anita Meyer, Karin Fickett, Dina Zaccagnini, Matthew Monk

designers: Anita Meyer, Karin Fickett, Dina Zaccagnini, Matthew Monk, Jan Baker

hand lettering: Jan Baker

photographer: Joseph Cafferelli

client: plus design inc.

"This pad is made of printers' press sheets and make-ready sheets from various jobs produced for clients of plus design inc. These sheets are a by-product of offset printing. Although the sheets often result in unexpected combinations of words and images, they are normally discarded as waste. We have collected these interesting-but-not-quite-usable pages and transformed them into pads. Because of the way the pads are compiled, each is unique, and may contain some pages too densely printed to serve as note pages. Those pages can be appreciated for their visual interest.

"The cloth wrap is inspired by Japanese furoshiki. The furoshiki is a square piece of fabric traditionally used in the Japanese bath, where it served as a towel, bath mat and wrap. Today furoshiki are used throughout Japan for innumerable purposes such as wrapping and carrying all kinds of packages, gifts and bundles.

"Furoshiki are made of everything from simple pieces of plain cloth to beautiful cotton fabric emblazoned with elaborate stencils. This furoshiki is silk-screened with Jan Baker's lettering documenting our conversations on the process of conceptualizing this announcement."

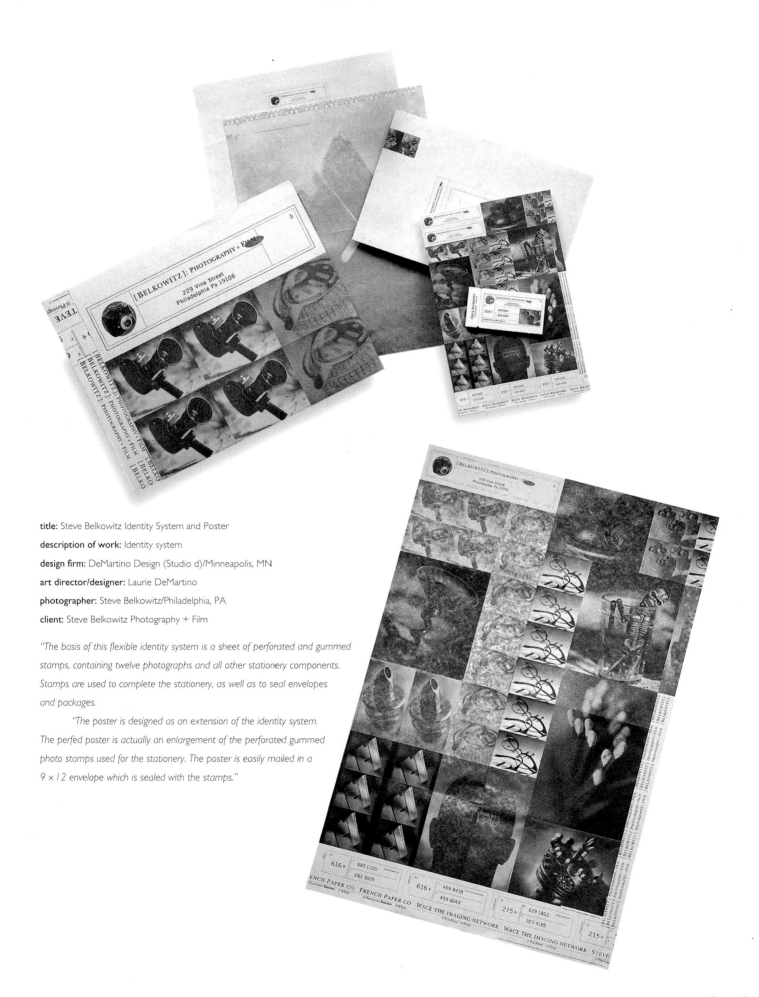

title: Steve Belkowitz Identity System and Poster

description of work: Identity system

design firm: DeMartino Design (Studio d)/Minneapolis, MN

art director/designer: Laurie DeMartino

photographer: Steve Belkowitz/Philadelphia, PA

client: Steve Belkowitz Photography + Film

"The basis of this flexible identity system is a sheet of perforated and gummed stamps, containing twelve photographs and all other stationery components. Stamps are used to complete the stationery, as well as to seal envelopes and packages.

"The poster is designed as an extension of the identity system. The perfed poster is actually an enlargement of the perforated gummed photo stamps used for the stationery. The poster is easily mailed in a 9 × 12 envelope which is sealed with the stamps."

exercises

Utilize any of these exercises for a variety of projects—logos, book jackets, posters, brochures—as long as the exercise is appropriate for and can help express your design concept. Or have fun executing them as a visual workout. Each exercise has two things to help you: "The point of this exercise is . . ." and examples to further clarify the goal. Ninety percent of the examples given are invented, but some are based on real graphic design, fine art and advertising solutions. And scattered throughout this section are "celebrity exercises" inspired by greats in fields outside of the design world, to show that inspiration can come from a wide variety of sources.

It is important to understand the creative process, problem solving and the relationship between form and content before utilizing these exercises. The exercises in the following categories may overlap, or you may think they belong in different categories altogether. That's okay. Mix them up. Let them inspire you to do other things. They're yours now; you can apply them however you like.

how these exercises can apply to real world projects

Here are two examples of how visual thinking exercises and creative approaches can be translated into practical graphic design solutions.

BEING SARCASTIC

Project: Invitation to Whitney Biennial

Problem: Before the last biennial, the Whitney Museum of American Art announced the artists included in the prestigious (yet sanctimonious) show. The resulting pre-show publicity caused the usual criticisms. For the next biennial, the Whitney wants to keep the names of the artists a secret.

Recipe for a Solution: With tongue in cheek and in response to the usual criticism of the Whitney's fashionable choices, the visuals will be of "low art," such as a velvet Elvis painting, a holographic Last Supper or a clown painting.

DOING THE UNEXPECTED

Project: Labels for a new brand of salsa. The flavors are mild and hot.

Problem: Client wants to distinguish its new brand from the competition.

Recipe for a Solution: Use unpredictable visuals to distinguish the brand from competing products that focus on literal representations of salsa, like tomatoes and spices. Use visuals to describe the strength of spice in each flavor by showing what you'll need to extinguish the "flame" on your tongue.

Visuals: A water pistol for mild. A fire hose for hot. Other unique elements include graphics applied directly to the jar rather than on paper labels, and related icons on the lids, like a kid on a tricycle (mild) and a fire truck (hot).

Altering Imagery and Objects

1. EXAGGERATE IT.

Take any visual—a photograph or part of one, a letterform, a drawing, a pattern—and present it larger than it actually is. Overstate it. Enlarge or increase it to an abnormal degree.

The point of this exercise is to find ways to create impact and change an image's conveyed message.

Examples:

• Take a word and exaggerate one syllable by making those letters bigger.

• Take a photograph of a kitten and enlarge the size of its paws.

2. ALTER IT.

Make five copies of the same visual or get five of the same object, such as an illustration, a rubber glove or a ball. Keep one the same, and alter the remaining four in different ways. The alterations should not completely destroy the visual's inherent identity; we should still be able to recognize it. Stretch it. Repeat it. Cut it. Split it. Condense it. Weave it. Distort it. Tilt it. Rearrange it. Change its color.

The point of this exercise is to find ways to vary the meaning of a visual through mutation. You will then have a range of ways to communicate different ideas or feelings.

Examples:

• Make several copies of a photograph. Cut one up and rearrange it on a grid. Crumple one. Distort one on a copier. Cut one in half and shift the two parts.

• Buy six socks. Sew one closed. Shred one. Stuff one. Tie dye one. Stretch one. Shrink one. Lose one in the dryer (just kidding).

3. APPROPRIATE SOMETHING.

Take a visual or typeface and make it your own. The visual may be well-known or a copyright-free image. Alter it in some way to make it exclusively yours.

The point of this exercise is to learn that making a slight adjustment can recreate or reinvent a visual.

Examples:

• Some designers only use three or four typefaces for all their solutions. It's almost like appropriation.

• Find a vernacular artifact, such as a movie ticket or trading card, and make it your own.

4. DESIGN ARROWS.

See how many ways you can design an arrow, a directional symbol. The point of this exercise is to push your "creative envelope" and see just how many variations you can design. This exercise also allows you to see that one symbol can be interpreted in an infinite number of ways.

Examples:

• How many heads can you give an arrow and still use it as a functional symbol of direction?

• Fabricate an arrow from found parts.

5. DESIGN ICONS.

Design icons out of images such as columns, trees and airplanes.

The point of this exercise is to learn to create a simple, memorable and identifiable icon or series of icons.

Examples:

• Take one image, like an airplane, and design a few elemental graphic icons of it.

• Take one image, like a tree, and see how many ways you can create an icon out of it. Try sketching it. Make it a simple, elemental shape. Make it linear.

6. REDO A COMMON IMAGE.

Take something that we see all the time, like a traffic sign, federal monument or well-known logo, and present it (by altering, adding or subtracting, redesigning, etc.) so that we are forced to think about it in a new way.

The point of this exercise is to make us see something as if we were seeing it for the first time.

Examples:

• Redesign a coin to make a personal statement about your feeling regarding the economy.

• Take a famous work of art, one we've seen two million times, and rekindle our interest in it.

• Change the colors of a famous logo or package design, thereby altering its original spirit or personality. ■

celebrity exercise

The Alfred Hitchcock, or Making A Clever Visual Comparison. In Hitchcock's celebrated film *Spellbound*, the main character's memory of a terrible ski accident—ski tracks in the snow—is jarred by markings on a white tablecloth and dark stripes on a white robe. In graphic design, a visual comparison can be just as rich. Compare similar things, as Hitchcock did; opposites, like wet juicy grapes to a desert; or random things (not products), like a pickle to a porcupine.

Combining Things

I. CONSTRUCT A SUBSTITUTION.

Take a visual or object and substitute something else for one of its parts. The substitution should have smooth transitions or edges. The result should make us look twice to see if we're observing it correctly.

The point of this exercise is to create a visual that will surprise the viewer and also convey an idea or message.

Examples:

• On a photograph of a man, substitute a squared-up halftone of a German Shepherd's eyes for his own eyes.

• Replace the petals of a flower with X-Acto #11 blades.

2. SYNTHESIZE.

Create an image that synthesizes different elements to form a new, more complex image. Use it to illustrate a theme or idea.

The point of this exercise is to find an original and intriguing way to create a visual message.

Examples:

• Combine flat shapes with volumetric shapes. Or linear elements with photographic elements. Or two-dimensional things with three-dimensional ones in a collage.

• Combine computer-generated images with hand-painted images.

• Create a photomontage.

3. FABRICATE.

Combine found objects to express a theme like *life* or *death*.

The point of this exercise is to realize that there are many ways to create a visual.

Examples:

• Find different printed materials, like wrapping paper and magazine and newspaper pages, and create a collage depicting *birth*.

• Go to a junkyard or flea market and find different objects related to a theme. Combine them into a three-dimensional illustration and photograph it.

celebrity exercise

The Woody Allen/Franz Kafka, or Asking, "What If . . . ?" What if a character in a movie came off the screen into real life? What if a professor in Brooklyn entered the novel *Madame Bovary*? That's just what happens in Woody Allen's film *The Purple Rose of Cairo* and in his short story "The Kugelmass Episode." Allen's characters come out of their natural environments. He challenges our ideas about reality and artificial constructs in film and literature, by simply asking, "What if . . . ?" What if a person turns into a cockroach? That's the premise of Kafka's *Metamorphosis*; the main character awakes to find that he has turned into a cockroach! "What if . . . ?" is a classic exercise that helps prompt creative thinking.

4. CREATE A MERGE.

Take two different objects or images and merge them into one new thing. The new object should appear seamless, as if it had always existed. This may be done in two or three dimensions.

The point of this exercise is to find ways to create original visuals that convey design concepts or messages that will delight, intrigue or otherwise leave an impression with the viewer.

Examples:

• Merge a croissant and a tennis ball to represent the French Open tennis tournament.

• Find common aspects of two different things and create a synthesis of them—for example, two things that make sounds, like a whistling tea kettle and a trumpet mouthpiece.

• Just for fun, using image-processing software like Adobe Photoshop, merge the features of two animals. ∎

Tinker With Graphic Elements

1. CONJURE UP COLOR FROM BLACK AND WHITE.

Create textures, tones and patterns from black and white that are so rich they "feel" colorful.

The point of this exercise is to see that varying combinations of black and white can produce a great range of weights and values that can be as visually exciting as color.

Examples:

• Design a rainbow using black and white patterns.

• Use black-and-white newspaper clippings to create a "colorful" collage.

2. CREATE AN ILLUSION.

On a two-dimensional surface, create the illusion of three-dimensional space.

The point of this exercise is to learn to manipulate the picture plane to create different types of spatial relationships. Various types of illusion have different feelings and can convey a diversity of ideas.

Examples:

• By varying the widths of lines and the distances between them, produce a warp, an optical illusion where the surface of the page seems to recede and advance, like the ones created in the Op Art period.

• Create a trompe l'oeil effect by using light and shadow and manipulating the picture plane. Fool the viewer's eye into believing something three-dimensional exists on a two-dimensional surface.

3. CHANGE A TEXTURE.

Change the texture or pattern of something we are used to seeing all the time.

The point of this exercise is to find ways to surprise viewers by altering something they take for granted.

Examples:

• Take a photograph of a Chinese shar-pei dog and replace its fur with the texture of corduroy fabric.

• Change the pattern of a fingerprint.

• Replace the texture of bark on a tree with something artificial like steel wool.

4. MAKE A SOUND.

Attribute (the illusion of) sound to a word, composition or visual.

The point of this exercise is to demonstrate that visual art can appeal to our other senses.

Examples:

• Choose an onomatopoeia, like *hiss* or *cluck.* Design it so that the word imitates the sound or action it refers to.

• Take a visual and make it seem as if sound is emanating from it. ∎

celebrity exercise

The Amy Tan, or Creating a Mood. In all of her novels and children's stories, Amy Tan is able to create different moods. *The Joy Luck Club* tells the loving stories of Chinese mothers and their Chinese American daughters. In each case, and in each book, she establishes a particular mood. Designers can create an extremely wide range of moods with color, shapes, composition, light and shadow, using all the design elements and principles. Which colors can evoke a somber mood? A romantic mood? Which shapes can invoke a frightening feeling? A serene feeling?

Perception

1. USE A PERCEPTION/REALITY COMPARISON.

Compare two visuals—images or objects—to make a statement about how we perceive something versus its generally accepted reality. (This is a homage to the great *Rolling Stone* "Perception/Reality" campaign.)

The point of this exercise is to learn to make a clear yet engaging visual comparison.

Examples:

• Compare the way a baby appears to its mother to the way it actually looks to others.

• Highlight a child's perception of the size of a classroom or a new bicycle.

2. CHANGE THE CONTEXT.

Take something we are used to seeing in one context and put it in a different setting.

The point of this exercise is to attract the viewer by doing something unexpected.

Examples:

• Use letterforms or type as parts of the anatomy.

• Park a car in a bedroom. Place a ballerina in a battlefield. Grow a tree indoors. Place cauliflower in a bowl of fruit.

3. PORTRAY SOMETHING FROM AN UNUSUAL PERSPECTIVE.

Draw or photograph something from an atypical point of view.

The point of this exercise is to increase awareness, communicate a feeling or idea or make a dramatic point by using an angle people are not used to seeing.

Examples:

• Photograph someone lying on a bed, from the foot of the bed, almost at eye level with the person's feet.

• Stand in the center of a room. Turn your head to one side. Draw the room by starting at one end as you slowly turn your head 180 degrees. Use as many pages as necessary.

4. COMMUNICATE TIME IN VISUAL FORM.

Visualize time.

The point of this exercise is to learn to manipulate graphic elements and principles to visually communicate an abstract continuum or idea.

Examples:

• Reflect the passage of time by establishing a definitive rhythm in your design.

• By establishing a visual sequence of events, suggest a succession from past through present to future.

• Communicate a span of years by aging an image like a person's face or by ripening a banana.

• In sequential format, diagram how to do something, like picking your nose or tying your shoe. ■

celebrity exercise

The Groucho Marx, or Giving It Attitude. Groucho Marx's irreverent humor had attitude. In the same vein, many people have now embraced the new digital fonts which are irreverent towards traditional mores of typography. Besides digital fonts, any graphic design can have attitude, which can range from totally irreverent to marvelously cheeky. Of course, the client has to be open to design "attitude." As Mark Kaufman of Art O Mat Design says, "Clients, as we see it, come in three flavors: the good, the bad and the stiff. On any project, how we approach it depends on several factors—the product or service being promoted, the target audience, the budget and, most importantly, the client. Using humor ultimately rests with how great your client is."

Making Comparisons

1. MAKE A VISUAL COMPARISON.

Side by side, compare opposite things, like a desert and a lake. Or compare similar things like velvet and fur.

The point of this exercise is to re-examine the time-honored visual device of comparison.

Examples:

• Compare close-up photographs of textures like linen and lamb's wool.

• Compare Victorian architecture to a Baroque church.

2. VISUALIZE THE QUESTION: *WHAT IS REAL?*

Compare something that is authentic to something that is fake or purports to be real. Or compare what is true with what is false or alleged.

The point of this exercise is to extend the range of visual comparisons and find ways to create "real" scenes or convey ideas about reality.

Examples:

• Show a person holding a photograph of himself holding a photograph.

• With type, design a false statement next to a true statement.

• Stage and photograph a real-life incident, like a robbery or an arrest.

• Set up a "candid" photograph.

3. CREATE A VISUAL METAPHOR OR ANALOGY.

Think of a metaphor or analogy for your client's product. Use visuals of the metaphor or analogy instead of the product.

The point of this exercise is to seduce your viewers, not hit them over the head with the product.

Examples:

• To show that all people cannot be nurtured the same way, make a visual analogy to the care of different plants.

• To show how rough certain materials can be, use cacti as a metaphor for something scratchy and rough. ∎

celebrity exercise

The Coen Brothers, or Seeing It From an Atypical Point of View. The Coen brothers are known for their unusual cinemagraphic angles; they use all kinds of strange points of view in films such as *Raising Arizona* and *Barton Fink*. Students or novice designers tend to think of things from a frontal point of view. Using an atypical or strange point of view, which makes us see something from an unusual or unexpected angle, can make for novel visuals.

Doing the Unexpected

1. CHANGE A SYMBOL.

Alter a well-known symbol, such as a flag, religious icon or a country's emblem, to modify its meaning.

The point of this exercise is to manipulate the accepted meaning of symbols.

Examples:

• Alter a royal crown to symbolize a loss or corruption of power.

• Change the color or texture of a symbol to alter its primary meaning.

2. REINTERPRET A CLICHÉ.

Reinvent a hackneyed visual, like a happy face or a unicorn.

The point of this exercise is to give worn-out things a new twist.

Examples:

• Delete one eye from a happy face to make it an organ donor.

• Change the colors of a skull and crossbones.

3. CROP A VISUAL.

Choose a theme. Find four visuals or make four visuals that relate to the theme. Crop them so that the imagery is more abstract.

The point of this exercise is to create fresh and pleasantly puzzling visuals.

Examples:

• Find pictures of furniture. Crop them so that we only see parts of the furniture, like table legs or chair backs.

• Crop photographs of reptiles, animals and insects so that we can recognize the creatures by their skin patterns and colors.

celebrity exercise

The William Shakespeare/Don Rickles, or Borrowing From Language. Bad puns make people groan. But truly great puns like Shakespeare's can draw a smile from the audience. Visual metaphors can be compelling, amusing and memorable. Or they can be comically insulting, like Don Rickles's "You're a hockey puck." Visual metaphors are some of a designer's best devices; they lure the viewer in. Try borrowing from language: Use visual similes, metaphors, analogies and puns. (Caveat: Unless the pun is truly funny or brilliant, use a metaphor.)

4. CHANGE THE SCALE.

Take something we usually see as small and make it big, and vice versa. Keep it in its usual surroundings, however, to demonstrate the shift in scale.

The point of this exercise is to learn the element of surprise for your design repertoire.

Examples:

• Show a person eating an enormous ear of corn.

• Miniaturize one of the three great pyramids.

5. DESTROY SOMETHING.

Destroy an archetype or an appliance by adding to or subtracting from it.

The point of this exercise is to use a humorous device to attract the viewer and convey a message.

Examples:

• Put nails on the surface of an iron.

• Paint a goatee on an archetypal female like Sophia Loren. Put lipstick on an archetypal male like John Wayne or Mike Tyson.

6. RETHINK A SELF-PORTRAIT.

Create a self-portrait without using your face. Find something else (not necessarily a body part) that characterizes you. Identify what represents you best.

The point of this exercise is to find new ways to approach a standard formula.

Examples:

• To convey his ability as a percussionist and band leader, Tito Puente could depict his hands in motion.

• Amy Tan's self-portrait could be a hand-written excerpt from one of her novels placed over richly textured Asian silk.

7. DEPICT A METAMORPHOSIS.

Take two things, such as a lion and a Chihuahua, and in gradual steps transform one into the other. The two can have a logical relationship, like a caterpillar and a butterfly or a chicken and an egg; they can be unrelated, like a television and a pickle; or they can be abstract shapes, like a square and a circle.

The point of this exercise is to express or suggest movement, change or evolution.

Examples:

• Gradually change one color into another, like red into green.

• Transform a number into the word for that number. ∎

Playing With Type and Image

I. GIVE TYPE A VOICE.

Design a word so that its connotative meaning is the same as its denotative meaning.

The point of this exercise is to learn that almost everything you design has at least two levels of meaning. Remember that connotative meaning expands communication possibilities.

Examples:

• Design the word *whisper* to sound like a whisper.

• Take a word like *stable* and find five typefaces that would convey the appropriate meaning for it.

2. COMMUNICATE THE OPPOSITE.

Design a word or phrase so that its connotative meaning or suggestive meaning is the opposite of its denotative meaning. Or use an illustration in a composition in such a way that its original meaning is usurped.

The point of this exercise is to learn that you can manipulate suggestive meaning and messages. You want to think in broad terms.

Examples:

• Design the word *tough* so that it suggests delicacy.

• Choose any adjective and suggest an ironic meaning through design.

• Take an illustration and reduce, frame, position or alter it in some way, so that its original meaning is completely dispossessed.

3. MAKE IT DO WHAT IT SAYS.

Using the letters of a word, communicate its meaning by repositioning or altering (lengthening, reversing, cropping, etc.) one or two letters.

The point of this exercise is to realize the creative possibilities in typography and to see that sometimes the solution is right in the letterforms themselves.

Examples:

• Turn the *F* in *Faint* on its back.

• Create a mirror image of the word *twins*. ∎

celebrity exercise

The Three Comedians, or Reinventing Something. Highlighting the ordinary and making the common uncommon is what some of our funniest comedians do. This exercise is a homage to Jerry Seinfeld, Ellen DeGeneres and Paul Reiser. It made them millions; maybe it'll get you into an annual or two. (If you're already in every annual, then it'll get you a monograph.) Try strategically changing the color of something we see all the time. Put something in different surroundings. Rename or relabel something. Make us see something as if we're seeing it for the first time.

Let's Communicate

1. MAKE IT VISUAL.

Take something not usually shown in visual form, like an emotion or a sound, and present it visually. No clichés allowed—no hearts to show love, etc.

The point of this exercise is to communicate an abstract idea visually.

Examples:

• Present a distinctive sound like "buzz" or "hiss" in such a way that we recognize it immediately.

• Visualize a powerful emotion like anxiety or elation, both clearly and cleverly.

2. GIVE IT SOME PERSONALITY.

Using color, texture, pattern and shape, design an exclamation point or ampersand to reflect your personality or that of a famous person or character. Your choice of typeface is critical.

The point of this exercise is to manipulate graphic elements and forms to communicate a distinct personality.

Examples:

• To reflect the personality of someone who is exuberant but unstable, don't place the dot directly under the stroke of the exclamation mark.

• A metallic and embellished ampersand would express a flamboyant personality. ∎

celebrity exercises

• **The Marcel Duchamp, or Destroying an Archetype.** Destroying an archetype can yield bitingly humorous results. Marcel Duchamp defaced the Mona Lisa by giving her a goatee and writing "L.H.O.O.Q.," an allusion to the model's ambivalent sexuality. What archetype would you like to destroy today—the Statue of Liberty? The Macintosh apple logo? Your imagination is your only limit.

• **The Ella Fitzgerald, or Giving It Style.** Legendary singer Ella Fitzgerald not only had one of the greatest voices in the history of recorded sound, but she had awe-inspiring style. Whether she was singing a ballad or scatting, she made a song her own. However, she didn't impose a false style on any composer's music; she maintained her signature while interpreting things appropriately.

• **The Pina Bausch, or Staying Open to the Possibilities.** Dancer/choreographer Pina Bausch juxtaposes unlikely combinations of music and dance. Choosing unusual scores for her novel choreography, she creates great contrast and makes the audience see things differently. Probably the most fundamental element of creativity is noticing the possibilities in any given problem.

more celebrity exercises

The Dorothy Parker, or Being Sarcastic. A mainstay of humor is sarcasm; read the works of Dorothy Parker and her circle of humorist writers. A visual can be sarcastic too. Graphic design can mock, can be caustic and even cynical. Type and visuals can be designed with tongue in cheek.

And one last visual thinking exercise—don't just stop with these exercises; think of your own artistic heroes, no matter what their area of expertise, and try to identify what you admire most about their work. Then figure out how you can apply that admirable quality to *your* next graphic design project.

visual thinking
in practice

| part | three

Jilly Simons likes to brood, ruminate and allow a design problem to stay in the back of her mind. Steven Brower finds solutions while walking along the sidewalks of Manhattan. Martin Holloway believes it's important to realize that graphic design problem-solving and creativity occur simultaneously. Creative people are motivated by curiosity; they love to explore. Here's a chance to see how a diverse group of designers solves design problems and what they think about creative visual thinking.

interview

Steven Brower

Steven Brower is the principal of Steven Brower Design in New York City. For eight years prior he was Vice-President/Art Director of Carol Publishing Group/Citadel Press, New York. He is the recipient of numerous national and international awards, and his work is in the permanent collection of Cooper-Hewitt, National Design Museum, Smithsonian Institution. He is on the faculty of the School of Visual Arts, New York, and Marywood University's "Masters With the Masters" program in Scranton, Pennsylvania. Born and raised in Manhattan and the Bronx, he attended the High School of Music and Art and the School of Visual Arts, and now resides in New Jersey with his wife and daughter.

Q. Why did you choose graphic design as a career?

Graphic design chose me. When I was in elementary school I was "commissioned" by the other students to draw type and pictures for their book reports. I was "hired" at first to draw dinosaurs, and in fifth and sixth grade, naked girls. Later I was the art director of my junior high school year book. I attended the High School of Music and Art. I went to the School of Visual Arts from 1970 to 1972 and dropped out to play music. Eventually I rechose design. I graduated from Cal State in 1984. Upon graduation, I started freelancing out in California. But my career really started when I came back to New York and worked in publishing at New American Library. Later, I worked for Carol Publishing for eight years as art director.

Q. How do you view book jacket design?

I liken a good jacket to an album cover. I always felt the album cover was part of the music experience. You listen to the album; you look at and read the album cover. A book jacket should become part of whatever the whole experience is. In that way, you can become emotionally invested in a design piece; it can become very personal. Certainly, if you're hanging a poster up, it can become part of your life. You can form an attachment. I still don't think that's the same kind of experience as listening to music or watching a movie. I've never been moved to tears by a

Steven Brower

piece of graphic design.

Q. Clearly, you have an affinity for book covers and jackets and posters. Are you interested in other design categories?

I'm interested in all areas of design. I love designing. Book covers come easily to me because I know the format. It's easy to visualize what the cover should look like. I've tried never to separate covers from other types of design. Design is design. There's a problem and you have to solve it.

I've been in business for myself for a little over two years and I'm branching out more now. I'm doing editorial work. I'm now assigning art for *Nation* magazine, and I've done op-ed pieces for *The New York Times*. One area I'm interested in is music, for obvious reasons.

There are publishing designers, people who do only that for their entire career. But I would get bored if that's all I did. One of the reasons I went into publishing is because I love to read. The irony is that reading has become less enjoyable because I have to do it for my work, for designing book covers. It's a shame.

Q. How do you come up with creative ideas?

I have no problem coming up with creative solutions. I never force myself. I just allow it to happen. It happens on the train. It happens when I'm walking. I always wonder what I look like when I'm walking around New York having a creative moment. I'm probably mumbling to myself.

Solutions happen at once. I can visualize the solution.

Q. How does working in New York City affect your design?

When I first left Carol Publishing, I tried to work at home in New Jersey for a couple of months. But on a personal level, it was the wrong thing to do, because I began to feel isolated. Walking down the street and seeing posters affects me. Just the environment of New York City is so edgy that it adds to creativity. When I worked at Carol, I worked completely in isolation. Now I share studio space with other designers; it's a nice creative environment to work in. There's a creative air.

Q. Do you ever get stuck for ideas and if so, how do you jump-start your ingenuity?

If a solution doesn't come, generally I look at historical work. I have old annuals that I look through. What that does is spur something in me. I'll respond to something and it gets me going. It's not a direct influence—you wouldn't notice it in my work.

Q. You're a musician. Is music a creative influence on your work?

No, I can't say that it is. I see design

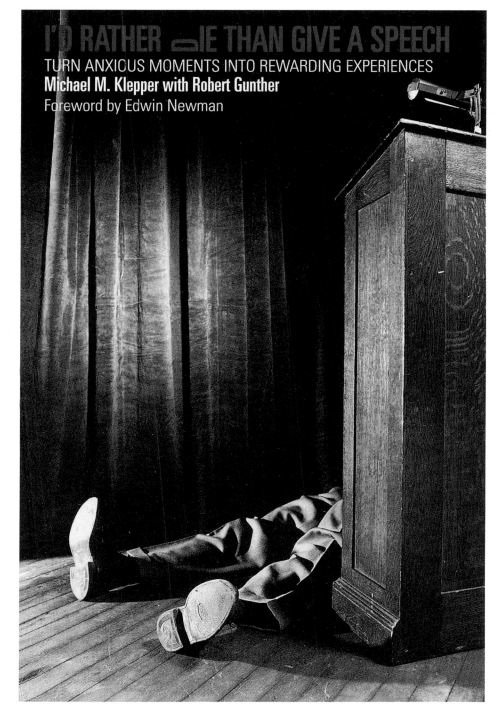

title: *I'd Rather Die Than Give a Speech*

description of work: Book cover

design firm: Steven Brower Design/New York, NY

art director/designer: Steven Brower

photographer: Richard Fahey

client: Carol Publishing Group

"Rather than create the expected, a mundane all-type cover suitable to the subject matter, I decided to have a little fun. The viewer does too.

"When I give talks now, the first slide I put up is the cover for I'd Rather Die Than Give a Speech. *I don't say anything; I just put it up on the screen. It sums up my feelings on public speaking. It's literal. It's taking the title and making an image that goes along with that. And people can relate to that."*

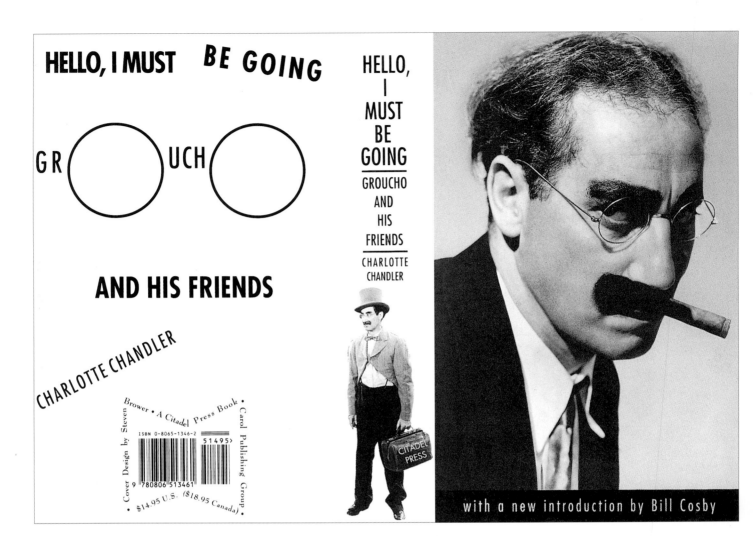

title: *Hello, I Must Be Going*

description of work: Book cover

design firm: Steven Brower Design/New York, NY

art director/designer/illustrator: Steven Brower

client: Carol Publishing Group

"This cover design captures the personality of the book's subject in a variety of humorous ways. On the front, his image is used as an icon without type necessary. On the spine, he has packed his bags, enacting the title. On the back, his iconography is reduced to a purely typographical solution. The starkness of black and white represents the honesty and forthrightness of Groucho's humor as well as the film era from which he comes."

and music as separate. I see music as more emotional and design as intellectual. In fact, that's one of my frustrations with design: It's a very cool medium. It's not an emotive medium, as music is. They exist in different parts of my psyche.

Design is conceptual and it's a very intellectual endeavor. The most you can get out of somebody is perhaps a chuckle, but it's not a very deep response, whereas music can affect people deeply. And film and music expand over time; you have more time to affect the viewer or listener. In design, you have one shot. So you get one response, maybe two responses. In fact, you can make a design a little ambiguous to hold the viewer's attention for two more seconds.

Q. What is the role of humor in design?

Humor, like all conceptual design, is a gift from the designer to the viewer. It is a way of treating the commonplace in an unexpected way. Laughter is universal, the great equalizer. It is a form of disarmament. If the client laughs out loud, it is very hard

to then argue against the work in most cases. At the same time I see it as an act of rebellion, a way of subverting content and a chance to politicize, criticize, agitate and provoke. It is the visual equivalent of doing something that gets you sent to the principal's office. One of my crowning achievements occurred during a cover meeting, when a room full of company heads and marketing and sales people laughed hysterically at a comp and then set it on fire.

A visual joke or pun is different than most forms of humor that elapse over time. It is the narrative and the punch line all in one. Generally my rule of thumb is that if I laugh when coming up with the idea, so will the audience. I hope for a guffaw, but a staccato "Ha!" will suffice.

Q. Do you find that people get your humor?

I teach at the School of Visual Arts, in the Continuing Education program. During a class discussion, one of my students was talking about the type of design that is subtle and mysterious and not obvious. She felt that design meant taking something obvious and making it not obvious. I replied that what I do is take the obvious and make it so extremely obvious that it's funny.

When I'm being funny, it's such a broad humor that most people get it. I really enjoy hearing people laugh out loud at something funny.

Q. What is the single best piece of advice you would give to someone trying to do what you do?

Don't do what I do. Do what you do.

I really do see design as a form of self-expression, and I know that's counter to what most people believe. I like to be given a problem to solve, which is why I'm a graphic designer and not a fine artist. There is definitely a difference between the two, because in graphic design, people give you a problem to solve. But I still see it as a form of self-expression. And everyone is an individual, so you have to do what is right for you.

Find out what is right for you and convey *you*. To satisfy yourself, you have to express your own sensibility. ∎

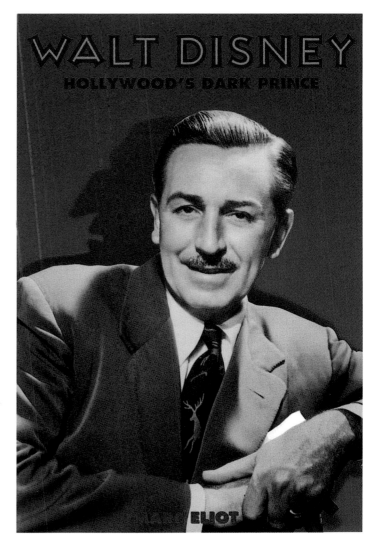

title: *Walt Disney: Hollywood's Dark Prince*
description of work: Book jacket
design firm: Steven Brower Design/New York, NY
art director/illustrator: Steven Brower
client: Carol Publishing Group

"I knew I wanted to do a play on Disney's icons. Disney is extremely litigious, so I had to be really careful not to use an actual icon, but to use the flavor and approximate the style without being exact. I looked at Disney work. The color scheme and shadow are Disney-esque, but not overtly Disney. The typography has a period flavor to go along with the photograph.

"The smiling publicity photo of Uncle Walt represents his public persona. In contrast, the background illustration hints at his darker side, done in mock Disney style. This jacket is a visual representation of the book's contents. It is also a colorful, attention-getting graphic.

"When I was about to go out on my own, I went up to Hyperion to see the art director there. I was showing him my portfolio and while he was leafing through it, he came to this cover. He said, 'We won't even discuss this one.' Hyperion is owned by Disney."

speaking of creativity...

Rick Eiber

Born in Ohio, Rick Eiber studied architecture and visual communication at Ohio State University in Columbus. He began his Master's degree at the MIT Center for Advanced Visual Studies in Cambridge, Massachusetts, and completed it at the University of Wisconsin in Madison. Eiber then went on to become Project Director at the Center for Advanced Research in Design in Chicago, before becoming Vice President and Design Director of RVI Corporation.

Next he taught graphic design at the University of Washington in Seattle. At this time, he also established Rick Eiber Design (RED). Previously he worked at F. Eugene Smith Associates and Richardson/Smith (now Fitch), and as a communications officer in the U.S. Navy. Eiber is author, editor and designer of the new *World Trademarks: 100 Years*, (Graphis Press), and is a member of the Alliance Graphique Internationale (AGI).

Rick Eiber

Go with the flow. Despite the desire to keep tight control of the entire design process, accidents will occur. Your attitude toward these events can make the activity either painful or exciting.

If you don't understand something, get clarification. Don't guess because it's too awkward to ask.

Ideas are cheap, transient thoughts. If one escapes or is rejected, grab hold of another.

Design is intelligence made visible. Your solution says a great deal about your research methods, organization, attitude, experience and creative process, as well as your design skill.

What is your intent—to capture attention, persuade, inform or motivate to action? Each requires a different approach. To try to do all at once may not be possible within your project's life cycle or yours.

You need to realize how you define success: a happy client, a pocketful of money, the number of awards, peer recognition, personal growth, opportunities available, location, freedom? Everyone's answer is a different combination, and what motivates them to be in this business may be different from what motivates you. It's your combination that makes you unique. Reflect that balance in your own creative approach.

Outstanding creative work doesn't need identification. We know it when we see it. Respect it because it's original. Respond

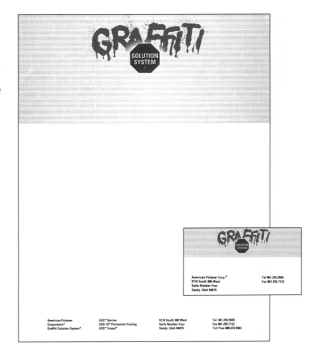

title: Graffiti Solution System Logo

description of work: Logo for product line and application

designer: Rick Eiber

design firm: Rick Eiber Design (RED)/Preston, WA

client: American Polymer Corporation

"The problem was to express visually the idea of the product as a successful way to stop damage and thereby discourage graffiti. The logo uses a red octagon to reinforce the idea of stop and a graffiti-like depiction of the word to express the idea of tagging. The back surface was printed with a brick pattern to suggest an architectural surface which might be spared.

to it because it grabs us. Strive for it because it's taught to be a goal. Just remember that you can't buy creativity. That's what makes it so desirable and so hard to acquire. ∎

Martin Holloway

Martin Holloway, currently the chair of the Department of Design at Kean University, specializes in lettering and calligraphy. He received a B.F.A. from the Virginia Commonwealth University and a M.F.A. from the University of North Carolina at Greensboro. He's worked over thirty years as a practicing graphic designer and has taught graphic design for twenty-five years. He has received over twenty-five industry awards for design, and many of his students have gone on to distinguish themselves as award-winning designers, art directors and agency and studio executives.

Martin Holloway

Creativity is an attitude. It is tempting to define creativity by its end product: This is a good (creative) painting; that is a bad (commonplace) painting. But one must remember that there is no litmus test for creativity—opinion is divided, tastes are different, definitions are in conflict.

It is easier to understand creativity as an attitude—as a motivation viewpoint that allows some people to produce works that are judged as creative. It is the attitude toward problem-solving that makes a person creative.

It is also important to keep in mind that in graphic design, problem-solving and creativity occur simultaneously. If graphic design does not solve a problem, then it is simply self-indulgence—a kind of pointless talking to one's self. Creativity in graphic design is a qualitative judgement of problem-solving—a problem may be solved in a boring manner, but it will probably not be as effective as a creative solution.

The creative approach—the *right* approach—is deceptively simple: Avoid the commonplace; try something different. This is deceptive because human instinct wants to discover what works and then do it—and keep doing it over and over, as long as it keeps working. The creative person understands that repackaging a message can make the message more attractive, but doesn't have to change its meaning. Look for a new twist, a variation in tried and true methods. Trying change for the sake of change is not a meaningless exercise for the creative person—it is a systematic method for achieving better results. ∎

title: "Country Things" and "Investing with Northgate"
description of work: Logos
design firm: Martin Holloway Graphic Design/Warren, NJ
designer/illustrator/hand lettering: Martin Holloway

"I see the imagery in both 'Country Things' and "Investing With Northgate' as objects—things—rather than as typographic headlines or illustrations. 'Country Things' is a traditional needlepoint doily; 'Investing with Northgate' is a fragment from a financial document. The authenticity implicit in the methods—a stitched, simple design determined to large degree by the grid and simulated engraving, using letterforms and classical decorative leaf forms from U.S. paper money—creates a degree of credibility that an illusionistic rendering does not have. The method of execution matches substantially the method of the original resource objects, which are loaded with associative meaning for the viewer. Meaning implicit in the original technique is transferred to the new image."

interview

Jilly Simons

Jilly Simons is a designer and the principal of Concrete, a Chicago graphic design firm. Her design philosophy searches for a visual language which stresses honesty, originality, strength and subtlety. Simons's work has been honored, exhibited and published nationally and internationally and is represented in the permanent collection of Cooper-Hewitt, National Design Museum. She is frequently invited to lecture and judge design competitions throughout the United States. Since 1995 she has taught design intermittently at the University of Illinois, Chicago. She is currently on the advisory board of the American Institute of Graphic Arts, Chicago, after having served on the executive board, and was recently an executive board director at the American Center for Design (ACD).

Q: How do you come up with creative ideas? Any secret methods?

It works best for me if I have time to brood, ruminate and let it stay in the back of my mind. I work on something else, and it kind of happens. Most of it is driven by what the need is. Very often, it depends on what we're asked for.

Q: Do you ever get stuck for ideas and if so, how do you jump-start your ingenuity?

I go through a process of wandering around, changing my environment. The best thing for me is to put it on the back burner for awhile, if I have the luxury of doing that. On some projects the immediate need drives some of it. We really try to look at the project from different perspectives, so that we can get a different angle. That's a lot harder—to try to do something that you haven't already done. It isn't an easy slot. It pushes the envelope, just finding that fresh idea amongst the muddle of ideas. You can't be lazy.

Q: What is the biggest creative influence on your life?

Life itself. It's everything. It comes and goes. It's a difficult question, because I can't really say it's one person, or one particular time; sometimes it has to do with what I've read or a group of people I might be around or something I've seen that may shift my thought. It varies. It's difficult to isolate and select one thing.

Jilly Simons (photo: Greg Samata)

Change does a lot for me, as opposed to the inspiration of one mentor or anything like that. Change of environment, travel. Again, it's a different perspective, being able to look at something from a different angle. Or having a new vocabulary because of the change. That really drives a lot of it for me. Exposure to arenas that I haven't experienced before and then pulling inward and attaching that experience to existing thought. Sometimes it feels so good it's like wizardry.

Q: What is the most satisfying aspect of your career as a designer?

Making things, strong results and good relationships. And then, for me, what has really helped me personally is recognition from my peers. It's really encouraged me, given me something I'm unable to give myself. It's getting back something from your peers that encourages dialogue. That's been terrific.

The other thing for me is that it's given me the opportunity to teach and to meet various people. Concrete doesn't specialize in any particular areas, so one of the interesting things is being

title: *I'll Be*

description of work: Baby book

design firm: Concrete/Chicago, IL

designers: Jilly Simons, Susan Carlson

copywriter: Deborah Barron

client: The Bauer family

"This casebound book serves as an unconventional birth announcement and celebration of a family. The concept derives from wondering what baby Jake Bauer will become (thus the title I'll Be). The book is written from Jake's perspective, and since his life story has just begun, it contains only three chapters. The bulk of the book filled with blank page alludes to the unwritten chapters of his life to come. The tongue-in-cheek text, glossary and Bauer Bodoni typeface all play into the ironic tone of the piece."

introduced to a variety of businesses and different philosophies. If I were in a different field, I probably wouldn't have had the same range and diversity. Even if I were working in an ad agency, I'd probably be slotted in a particular area or require a certain bent, like an affinity toward consumer products or auto-motive, etc.

Q: What's the most troublesome part of your career as a designer?

A lot of the things we do take courage. Often the client needs to be comfortable with being a little different. Even though you're very charged by a concept, they may not buy it. If you're responsible and have really thought the project through, you'll feel, going in, that they should trust you, but it'll often happen that they just don't get it, and sometimes it's very hard to come up with the right language to convince them. I think for me the hardest thing is generating new business. I'm very dependent on the call coming to me. Some people are able to get on the phone and convince someone to see them—they're phenomenal at it.

Q: What's the most interesting part of the creative process to you?

For me, it's developing the concept. It's definitely the germination, when the ideas are happening; it's the most nourishing part.

Q: What's the worst part of the creative process to you?

After it's produced and then you first see it, it's always the hardest part. It's been around; you see all the flaws. I want to "fix" it and change pieces. It's as though I'm seeing it with fresh eyes!

Q: What makes someone a creative designer?

It has a lot to do with concept development and ideas. Process. How they approach an idea. There are a lot of people who do very beautiful work, and their craft is just terrific. But what takes it to the top, when it isn't just the pure beauty of the craft, is when it has an idea behind it that really works and is well-thought-out—when it's original. And sometimes, it's not that it's just original, but it's so appropriate. When it's so appropriate to what you're doing with it, that's when it's really thrilling and it really works.

Q: What is the single best piece of advice you would give to someone trying to do what you do? What's the best advice you give to your students?

To keep your eyes and ears open and to be as well-read or as intellectually stimulated as possible, because that's where a lot of what you do comes from. The more depth and breadth you have, the more you can put into your work. ■

title: *Tautological*
description of work: Book
design firm: Concrete/Chicago, IL
designers: Jilly Simons, Susan Carlson
copywriter: Deborah Barron
client: A piece of Concrete publishing

"This piece evolved at a time when much of design dialogue and criticism was about legibility. Do people read? Are they working through the multi-faceted, complex levels of contemporary typography? My intent was to demonstrate that it is more of a stretch for people to think and interpret on their own than it is to read, no matter how complex the reading material is. It is more difficult to dissect and interpret when pro-vided with images only. I was particularly interested in a variety of interpretations and meanings. It is peculiar that, as early readers, we find interpreting simple visual imagery easier and fun-filled, but as we mature, it seems to give us a headache. Interpretation is a puzzle, painful to unlock, but hopefully thought provoking. It is plain-ly hard work, apparently harder for most than deciphering the experimental eclectic typographic styling of today.

"Although I was indeed challenging viewers to stretch logic taut, I was also looking to them to create visual associations of their own. I succeeded in creating a dialogue with viewers; strangely, most wanted to hear my reasoning!

"The piece itself is redundant. The rubberband stings on contact and, of course, requires a stretch to remove. The deliberate lack of traditional bindery allows further visual combination to be revealed."

Mark Kaufman

Mark Kaufman is a principal of Art O Mat Design, based in Seattle. Along with wife and partner Jacqueline McCarthy, Kaufman has been providing design, marketing and illustration for commerce and the arts since 1990. Art O Mat's client roster includes Entercom, the Greater Seattle Chamber of Commerce, the Seattle Symphony, the Technology Alliance and the Seattle International Film Festival. Kaufman's editorial illustrations and comic strip *Soapbox* are regular features in the Pacific Northwest's music and entertainment magazine, *The Rocket*. This "filth" has also graced the pages of *Eastside Week, The New York Press,* and *National Lampoon.* He studied advertising and graphic design at New York City's School of Visual Arts. Over the past fifteen years, his work in New York and the Pacific Northwest has earned numerous awards, including recognition from American Corporate Identity, *Print*, the New Jersey Art Directors Club, and *Creativity.* He now spends most of his free time trying to steer clear of people who are under the impression that Birkenstocks and Gore-Tex are "groovy."

Q. Why did you choose graphic design as a career?

Like most people, I guess you dream of being a cowboy or an astronaut, but growing up in New Jersey meant that riding the range was out, and having absolutely no aptitude for math quite naturally led to art school. There is also that desire to chase that hint of some small talent that may have brought you some attention. Once in art school I had wanted to go into advertising.

However, when I attended the School of Visual Arts, it seemed as if everyone but myself had a father or an uncle on Madison Avenue. That's when I switched over to the design department, where it seemed, to *me* anyway, that the talent level was higher but people were far less well-connected.

Q. What is the most satisfying aspect of your career as a designer?

That I'm using my mind for good instead of evil.

Q. What is the biggest creative influence on your life?

My wife and partner in the Art O Mat, Jacqueline McCarthy.

Which is the real satisfying aspect of the previous question. It is possible to work with your spouse in other businesses—in insurance, as travel agents, running a delicatessen—but we are lucky to be in a field that requires us to be creative, to bounce ideas off each other, learn about new things together. It inspires me to work harder than I might if I worked for or with someone else.

Q. Do you find inspiration in the other arts, like painting, literature, film, dance or music?

Of course. Seeing a great film, reading a great book, slapping a 45 on the turntable may not show up in your work in a concrete way, but it probably affects your work subconciously. Something from a painting you saw long ago might spur an idea that you build upon when you're searching for the answer to a problem. Television, engineering, graffiti, a street fight, whatever—if you take the time to look, you see things from a different perspective than your own. One of my favorite movies is *Thunder Road* with Robert Mitchum. He produced it, starred in it, wrote the original story and composed the title song, sung by

Mark Kaufman

Keely Smith! Despite all the work that went into this highly personal project, Mitchum still managed to make coolly detached nonconformity look easy. The epitome of cool!

Q. How do you come up with creative ideas? Any secret methods?

Hmmm . . . that's one of those questions that I'd be curious if anyone had a real answer for. For me it's a seat-of-the-pants type of thing. Sometimes it's sitting right down with a cocktail napkin and jotting down ideas. Other times ideas just seem to come to you; who knows? I'm sure that some people have techniques that they rely upon, but that seems stifling to me. How can you pursue ideas if you approach everything in the same way? Of course you need to do the research on a product. You have to know what the client wants to achieve. But even with all that, you're still starting with a blank piece of paper.

Q. Do you ever get stuck for ideas and if so, how do you jump-start your ingenuity?

Jump-starting ingenuity for me is usually a matter of ignoring the problem for awhile. Deadline pressures may not allow you to do that for long, but even a short spell of reading the newspaper, cleaning up my pile of trash that I call a desk—anything not to be obsessed with the problem at hand—is a help.

Q. What's the most interesting part of the creative process to you?

That one split second, that brief moment when you think you're on to something. When the light bulb buzzes on. After that it's a matter of pursuing that idea to its logical conclusion, which is also interesting. Other than that, it's just work.

Q. Is there a difference between a creative design solution and an aesthetically pleasing solution? If so, what is it?

I think that a creative design solution can be aesthetically pleasing, but I don't believe that something that is merely pretty is a creative solution. There needs to be some thought behind what you are doing, some reason for choosing a typeface or color. One thing that drives Jacki and me nuts is when clients break out the paint swatches and want you to match the eggplant shade they painted their living room. Who cares! Unless they're going to invite all 20,000 people on their mailing list to their house, it doesn't really matter to the issue at hand. They

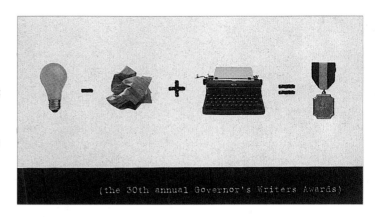

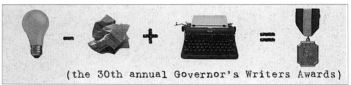

title: Governor's Writers Awards
description of work: Postcard and bookmark
design firm: Art O Mat Design/Seattle, WA
designers: Jacqueline McCarthy, Mark Kaufman
client: Washington Commission for the Humanities

"The Governor's Writers Awards are awarded annually to writers and publishers in the state of Washington. Our concept for this event was to use visual cues to tell the story of a writer's art. Besides the invitation postcard and program, we also developed a bookmark to serve as a reminder of the event."

blow right by the visual thinking required to get their message out and, consequently, have a weaker story to tell.

Q. Some people say that in order to be creative, you need to work without constraints or rules. Some say the more constraints you have, the more creative you can be. What do you think?

I fall in the latter category. Without rules or constraints, how can you bend them or break them? Also, the time constraints that have been foisted upon us in the brave new digital/cellular/wired world forces me to have a little self-discipline. I'm not always chasing windmills. I need to focus on a couple of good ideas instead of being all over the map with a dozen mediocre ones. Even though we might do hundreds of thumbnails at the outset of a job, most of these are weeded out, some are filed away for future use, and we're usually left with a couple, two, three strong starting points. What you do with these is where the creativity is. ∎

creative case study

Arnie Arlow

Arnie Arlow is Executive Vice President/Creative Director of Margeotes/Fertitta + Partners, where he has been since 1994. For ten years prior he was at TBWA, where he created and supervised advertising for Carillon Importers' Absolut Vodka that won two Kelly Awards, an Effie and a Grand Effie. Arlow, a native New Yorker, is a graduate and former trustee of Cooper Union. He studied in Paris on the Fulbright Grant for Fine Arts and, in 1995, was the recipient of Cooper Union's Augustus Saint-Gaudens Award for Professional Achievement in Art. He is currently an active member of the One Club for Art and Copy and the Art Directors Club of New York.

Arnie Arlow

Michel Roux of Carillon Importers acquired the rights to distribute Stolichnaya Vodka in 1994, subsequent to losing the distribution rights to Absolut Vodka earlier that year.

At the same time, I joined Margeotes/Fertitta + Partners. We had the unenviable task of turning around the declining Stolichnaya brand, something that had never been accomplished in the distilled spirits category, while also competing with Absolut, which Michel and I had helped build into the most powerful, leading imported vodka.

We needed to develop an advertising campaign for Stolichnaya that could distinguish the brand from all other premium vodkas, especially Absolut, and with something instantaneously recognizable and uniquely "ownable" to Stolichnaya.

Since Russia is considered the birthplace and home of vodka and associated with the finest quality vodka in the world,

title: Freedom of Vodka

description of work: Stolichnaya Vodka Advertising Campaign

design firm: Margeotes/Fertitta + Partners/New York, NY

creative director: Arnie Arlow

artists: Leonid Gore, Konstantine Jouravlev, Serguei Volcov, Fathulla Shakirov, Khurshida Kamalova

client: Michel Roux, Carillon Importers Ltd., NJ

title: Stolichnaya Holiday Ads

description of work: Stolichnaya Vodka advertising campaign

design firm: Margeotes/Fertitta + Partners/New York, NY

creative director: Arnie Arlow

artist: Yuri Gorbachev

client: Michel Roux, Carillon Importers Ltd., NJ

we decided to use authenticity as our concept. Our executions were based on an original Russian graphic style called Constructivism, developed after the revolution in 1917, when the Russian people ended the brutality of the Czarist regime and essentially gained their freedom.

We commissioned original paintings exclusively from Russian artists to be consistent with our focus on authenticity. We then stenciled the words *Freedom of Vodka* on top of the paintings to capitalize on the contemporary feelings for Russia's struggle for its newfound freedom. These words were also meant to subtly motivate consumers to rethink their choice in imported vodkas and switch to Stolichnaya.

The beginning of the campaign focused mainly on announcing our arrival and creating excitement about the new look of Stolichnaya. We then started using images from the arts, nightlife, fine dining, business, fashion, film, travel and even the information superhighway to appeal to various interests and

lifestyles. The campaign developed an energy and emotion that appealed to consumers of premium vodka and confirmed their belief that Stolichnaya was not only authentic, but also superior.

Stoli Ohranj was introduced in May 1994 and became very successful, paving the way for the unprecedented simultaneous launch of six new Stoli flavors in January 1997. Each of these executions concentrated on a single flavor by using unique imagery to capture the essence of the flavor. All together they created a sort of campaign within a campaign, thereby not comprising the total message and look of the brand.

Since the holiday season is extremely important to the distilled spirits industry, we need to be very visible during that time of year, yet we like to think of our holiday executions as greetings rather than advertising. The warmth and simplicity of Russian folk art hopefully sends a message of caring and friendship from the people of Russia to the people of America. ∎

interview

Rick Tharp

After graduating in 1974 from Miami University of Ohio with a degree in Fine Arts, Rick Tharp opened his design studio, THARP DID IT, in Old Town Los Gatos, just south of San Francisco the next year. Four others share the studio with him, where the focus is on corporate and retail visual identity, packaging design and environmental graphic design. Although the studio's client base has grown internationally, its philosophy remains refreshingly provincial: "Always have fun doing it." Today, they do it mostly for wineries, restaurants and the occasional jumbo-size computer company.

Their many awards include the West Coast Show Gold and Bronze Medals for wine packaging, a CLIO Award for wine label design, a Society for Environmental Graphic Design Gold Medal for restaurant design, and a Gold Medal for a wine label from the Vinitaly International Packaging Competition. Their posters for BRIO Toys of Sweden are in the permanent collection of the Smithsonian Institution's National Design Museum.

Q. What is the most satisfying aspect of your career as a designer?

Knowing that I can draw a better line without a straightedge than a computer-aided designer can. Not necessarily a *straighter* line, but definitely a *better* line. Also knowing that the career I chose will continue to satisfy me until I'm no longer here. God, I hope they have drawing boards wherever I end up!

Q. What work are you most proud of?

I am most proud of the work that has been a collaborative effort with very talented people: architects, interior designers, photographers, writers, illustrators and other graphic designers. It's like playing tennis with someone better than yourself. You play better.

Q. What changes has your work gone through?

In this business, one's work is dictated by the client's needs. Change comes with a change in the kind of work one is asked to do for them. Another way to change your work is to change clients. I also hope that over time, my work gets better. That is a welcome change.

Portrait of Rick Tharp digging through garbage for ideas
(illustration by Ward Schumaker)

Q. What is the biggest creative influence on your work?

There is no singular creative influence on my work. However, a number of things have influenced me. A book titled *The Push Pin Style*, given to me in the mid 1970s, was the inspiration that convinced me I was a graphic designer and not a fine artist. It was full of work by Milton Glaser, Seymour Chwast, Barry Zaid and a whole bunch of other guys whose names I couldn't, and still can't, pronounce. Their work successfully blended fine art, illustration and typography into clear and powerful graphic communication. Other current sources of inspiration for me are written metaphors from those like Kurt Vonnegut. Somehow their "art" seems to influence and sharpen my communicative skills.

Q. How do you come up with creative ideas?

A few years ago I asked Milton Glaser that same question and he told me, "My inspiration comes from the most unlikely places, usually when I pay attention to something I haven't paid

title: Eye of the Swan bar code, Simpson Paper Company bar code, *HOW*
Magazine bar code

description of work: Bar codes

design firm: Tharp Did It/Los Gatos, CA

designer: Rick Tharp

client: Sebastiani Vineyards, Simpson Paper Company, *HOW* Magazine

To Rick Tharp, putting a bar code on a wine label was like putting one on the Mona Lisa, until he discovered a solution. While working on Eye of the Swan wine packaging, Tharp wanted to carry the lyrical feel of his new front label design onto the back label. The back label carried a short description of the wine and the Universal Pricing Code (UPC) symbol, but Tharp made it an integral part of the label theme. To the casual viewer it appears as a field of cattails. To the supermarket scanner it's just another UPC. Since then, Tharp has designed numerous packages for small wine, food and sportswear companies, as well as the occasional jumbo-sized computer company, and often-times incorporates bar codes into the theme of his packaging.

Tharp adds, "In order to feel the design one must immerse oneself in the subject. If you are interested in designing bar codes, try laying your head on a supermarket bar code scanner to really feel what it's like to be a bar code. Then go home and reinvent yourself."

attention to before, such as the way a shadow falls across a curb or the way a television set distorts the color of an image or . . . exceptionally good work done by anyone.

When I asked Primo Angeli where his creative inspiration comes from, he simply replied, "I don't know." That seems to be my best answer to your question: I don't know. I believe, however, that ideas already exist within the problems themselves. It's just a matter of pulling them out and presenting them as solutions. If the answer is inherently part of the question, then I let the problem dictate the solution.

Q. Any secret methods for coming up with creative ideas?

If I told you, it wouldn't be a secret any longer. . . .

Okay, I'll tell you. Much of my creative inspiration comes from garbage. When I'm in San Francisco, I spend Friday evenings going through the Dumpsters behind Kit Hinrichs's, Michael Vanderbyl's and Barry Deutsch's studios. When I'm in New York, there's a lot of great stuff to be found in James Victore's garbage.

Q. What is the single best piece of advice you would give to someone trying to do what you do?

Keep trying and don't ever stop trying. Also, don't break rules just to break rules. But on the other hand, don't let them get in the way either. ∎

Karl Hirschmann

Karl Hirschmann graduated with a Bachelor of Fine Arts degree from the University of Kansas in 1986 and promptly moved to Colorado, where he spent ten years working professionally in Denver and Boulder. He has served on the AIGA Colorado Board of Directors and won awards for his work from *Print* and *Communication Arts*. In January 1997, he formed Hirschmann Design in Boulder. He hopes to build his firm's reputation on work that playfully communicates memorable ideas.

Q. What is the biggest creative influence on your life?

The first time I read *A Designer's Art* by Paul Rand, something clicked for me. I realized that design should be about concepts and communication. This book really opened my eyes to the potential of ideas and creative play in graphic design.

Q. How do you come up with your creative ideas? Any secret methods you are willing to share?

I research, think, sketch and think some more. I try to juxtapose elements from the problem, looking for similarities or differences. Then I put the pencil to paper and try to visually articulate those thoughts. This really sounds very simple. Too bad it isn't easy.

Q. Do you ever get stuck for ideas and if so, how do you jump-start your ingenuity?

The process of creativity can be a struggle and sometimes I do get stuck. I handle this by either working harder or by backing off and doing something else, like taking a long walk or a cold shower or reading a good book or browsing at a used bookstore or visiting a record shop or taking a long drive.

Q. Is there a difference between work that wins awards and work that satisfies clients? If so, what is the difference?

Awards are nice. Client satisfaction is important. I do not believe that work that wins awards and work that satisfies clients are mutually exclusive. Sometimes it just seems that way.

Q. What do you do if the client starts playing art director?

I think it is important to be open minded when dealing with clients. But, as Alan Fletcher noted, "If your mind is too open, people can throw all sorts of rubbish into it."

Karl Hirschmann

Q: What is your definition of creativity? Visual thinking? Is there a difference between a creative design solution and an aesthetically pleasing solution? Is so, what is it?

Creativity is the process by which a designer utilizes his or her skills, knowledge and thinking to bring something unique and imaginative into the world. The difference between a creative design solution and an aesthetically pleasing solution can be summed up in one word: concept. Some solutions are pretty and shallow, others are more thoughtful and require participation by the audience. My mom told me it's not okay to be shallow and I believed her.

Q: Some people say that in order to be creative, you need to work without constraints or rules. Some say that the more constraints you have, the more creative you can be. What do you think?

title: Hidden Rock Ranch

description of work: Logo/cattle brand

design firm: Hirschmann Design/Boulder, CO

art director/designer/illustrator: Karl Hirschmann

client: Marc, Susan, Mike and Chris Hirschmann

"I have always been fascinated by the term 'head of cattle.' Why not make a brand that actually incorporates the head of a cow? The symmetry of the capital H completes the concept."

title: Hirschmann Design Logo

description of work: Symbol for a design studio

design firm: Hirschmann Design/Boulder, CO

art director/designer/illustrator: Karl Hirschmann

client: Hirschmann Design

"Hirsch is the German word for deer. Add antlers and a tail to a lowercase h and it becomes a deer."

I really appreciate having constraints. Understanding the parameters of a problem allows me to focus my energies on developing an effective and creative solution.

Q: What attributes must a good designer have? A creative design solution?

Good designers are thoughtful and curious, with a sense of humor. Good designers are intelligent. Good designers love words and the ambiguity inherent in language. Good designers understand that they must create responsible work that communicates appropriately.

An idea is the heart of all creative design solutions. A creative design solution is not derivative as it comes from a unique

problem. A creative design solution allows the audience to participate and view the subject from a different perspective.

Q: What is your favorite type of project? Why?

I enjoy creating logos and icons. Designing marks allows me to combine my quirky sense of humor with precise geometry. Logo design is very challenging. I am forced by the inherent constraints to create a concise and elegant graphic statement.

Q: What is the single best piece of advice you would give to someone trying to do what you do?

Understand the difference between what you want and what you need. ■

Denise M. Anderson

Denise M. Anderson, President/Design Director of DMA, started her design career at Ronnie Solomon Design. She then became an art director for DBD International with type enthusiast David Brier and, later, Vice President/Art Director at David Morris Design Associates before starting her own company.

Anderson has an innate passionate sense of design and enthusiasm to explore new areas. In her newly formed business, she is on a mission to be "a force to be reckoned with." She practices this philosophy on clients such as Aris Isotoner, Hanes, HMV Record Stores and Pershing, a division of Donaldson, Lufkin and Jenrette Securities.

She teaches part time at Kean University and serves as secretary on the Board of Directors of the Art Directors Club of New Jersey.

Denise Anderson
(photo: Greg Leshé)

As a part-time teacher at Kean University of New Jersey, I try to instill in my students my philosophy on choosing a career: "Do what you love, and money will follow." Being a designer is a great life choice because you never feel like you are working. Design becomes an integral part of your life twenty-four hours a day, seven days a week for always. Everyday life becomes your greatest resource. When you are a designer you are sensitive to everything visual. Even how you hang your toilet paper will become an aesthetic decision.

For the past few years, I have designed Pershing's Customer Conference kit. Besides working with a theme, I am asked to create something more graphically spectacular than the previous year. This year I wanted to create a high-contrast, shimmering texture in the sky for "Foundation for the Future." I produced the kit in the following way:

1. Glued two sheets of Fox River Confetti, 80# cover together (for bulk) to house insert sheets and a program booklet

2. Drytrapped two hits of silver as an underlayment to add color

3. Printed two separate hits of the same Pantone blue

4. Printed a matte varnish to seal the colors, because they would not dry quickly enough to apply the spot varnish

5. Printed a spot pearlized UV varnish

Since the largest sheet of paper was smaller than the flat size of the piece, the interior pocket was printed separately with the outer band and hand-glued into the 800 pieces needed.

It was a challenging printing project, and the printer and I added steps to achieve the desired results (second blue in steps 3 and 4). The piece was well received by the client as well as the recipients (senior management in brokerage firms). ■

title: Foundation for the Future

description of work: Customer conference kit

design firm: DMA/Jersey City, NJ

design director: Denise M. Anderson

designers: Denise M. Anderson, Laura Ferguson, Jennifer Harold

illustrator: Jeff Kruger

client: Pershing, division of Donaldson, Lufkin, and Jenrette Securities Corporation

Eva Roberts

After studying design at North Carolina State University School of Design, Eva Roberts spent fifteen years in the northeast as a professional designer. She also taught at the Boston Museum of Fine Arts School, the Swain School of Design and the University of Massachusetts/Dartmouth (formerly Southeastern Massachusetts University). In 1991, Roberts returned to North Carolina to join the faculty of East Carolina University, where she is now an Associate Professor in communication arts. Her work has been recognized by design organizations including the American Institute of Graphic Arts, the American Center for Design and the Type Directors Club.

Eva Roberts

North Carolina Literary Review, based in the English Department at East Carolina University, seeks to combine the best attributes of an academic journal with a contemporary magazine for serious readers, whether they are scholars or not.

As a hybrid, *NCLR* presented a unique opportunity. The writing in this publication may be non-fiction, fiction or poetry. Articles are presented so that no prior knowledge is required—or if specific information is needed, sidebars and/or footnotes provide additional material.

It would have been easier to design a handsome standard format, but much less interesting. Everyone involved in this project is motivated by love of

title: *North Carolina Literary Review*, Vol 2, No. 2

description of work: Literary journal

designer: Eva Roberts

client: East Carolina University English Department

language, both visual and verbal. The editorial staff had a difficult time at first with many of the design concepts. We were breaking so many conventions and standards—familiar approaches that seemed to them the "right way."

Our creative approach is quite simple—all designers and illustrators read the material and seek inspiration from content. Ideas, imagery and inspiration all come from a response to the words—the language. Too often designers are motivated by concerns other than the inherent message. Of course, some messages are more exciting than others, but always one must avoid assumptions about what can or should be done.

We are all much more programmed than we care to admit and bring lots of preconceived notions to design solutions. The computer facilitates an exploratory approach with long publications, such as a journal.

One can "sketch" in a tight form with words and images, share concepts with others and have an ongoing evolution supported by comprehensives that are more mutually understood. Since this is a text that is meant to be read, we strive to maintain readability, though at times, it may be more challenging.

This design brings unity to eclectic subject matter while allowing each article to make a distinctive contribution to the whole. One of the more gratifying aspects of this project has been the feedback from writers who are not used to having their work visually interpreted with such attention. Generally they are a little shocked and quite pleased. Always we hope to inform, challenge, provoke and entertain. ■

speaking of creativity...

Susan Knape

An unusual creative director formally trained neither as an art director nor copywriter, Susan Knape of The Knape Group nonetheless combines the judgment, imagination, intelligence and leadership ability to direct work to lead to Knape Inc.'s recognition by *ADWEEK* Magazine as the Southwest's top creative shop in 1996.

Knape has been a Kim Dawson model and an active community volunteer. She combines her role as a caring and supportive mom for two young daughters with that of agency head. She's produced effective and award-winning work for a wide variety of clients, from health care to high tech, from financial and real estate to sports marketing.

Susan Knape

Running an advertising and design business is tough. And to do it well—to produce the kind of work we're proud of, the kind that wins awards and recognition—is toughest of all.

I am not a designer. But I am a lover of great design. I've made it my life's work to promote great design and to build a safe, healthy work environment for those who create it.

We've learned that producing this kind of work requires a lot more than just brilliant design and copy skills. That's easy to prove. Just put a talented designer or writer in the wrong environment and watch what happens. They wither and die. Great work requires the passion, faith and focus of every discipline and every person involved in the process. Now, this may seem outside the scope of this interview. But it's really not, because no matter how great an idea is, to be seen and recognized it has to be produced.

Everyone who works here and everyone we work with must believe in this kind of work. Not simply because it's fun to impress people with our creative prowess, but because great creative is actually the right thing for the client.

Now some clients may believe that increasing sales is all that matters. But that's not true. If a business desires long-term success, its design and advertising has to help people establish an emotional relationship with the brand. If a business simply wants short-term results, if it screams one obnoxious promotional message after another, then it takes on the personality of an annoying salesman. A business like that might achieve short term results, but eventually it's going to pester the hell out of people. And chase off any chance of repeat business in the process.

So our work strives to define and focus an appropriate brand image as much as it strives to achieve results. And these two goals should never be separated under any circumstances.

It's hard for an advertising and design firm to stay focused on this as it grows up. Doing a lot of project work, as opposed to having the sole responsibility for a brand, poses many challenges. If you're not careful, it can lead to bad habits creatively. That's why, as we've grown to become a full-service agency, we've worked so hard to keep everyone focused on one thing: doing what's right for the brand.

If the client understands, and the account people understand, and the media department understands, and the producers understand, and our suppliers understand—if each of us understands that our singular mission is to protect the personality of the brand, then brilliant creative is the only kind of work that will meet anyone's standards. We encourage all of our clients to keep that bar raised very high. In turn, we raise it even higher for ourselves and our suppliers. With everyone so focused, we are bound to be successful—both our clients and ourselves. And award-winning work simply becomes a satisfying side effect. *Very* satisfying. ■

title: Rail Runner Logo

description of work: Proposed logo for DART bus service called "Rail Runner"

design firm: The Knape Group/Dallas, TX

creative director: Les Kerr

designer/illustrator: Dan Birlew

client: Dallas Area Rapid Transit

"The Rail Runner bus service was created specifically for commuters using Dallas's new light rail trains. This symbol appropriates an age-old device, the rebus, but arranges the elements in an elegant and contemporary manner, to make it immediately translatable and extremely memorable."

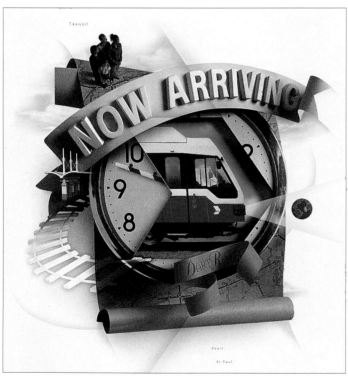

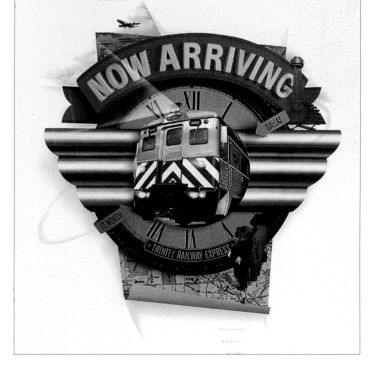

title: Dallas Area Rapid Transit Commemorative Art

description of work: Campaign/DART commemorative art used for posters, outdoor, advertisements, direct mail and collateral

design firm: The Knape Group/Dallas, TX

creative director: Les Kerr

art director: Dan Streety

photographer: Fredik Broden

client: Dallas Area Rapid Transit

"Dallas Area Rapid Transit broke new ground when it opened the first mass transit train system in the state of Texas. Working with paper, finishing line photos and a big computer, we built a series of collages to introduce light rail and commuter rail, showcasing the many advantages of the system. This image was used on everything from invitations to tickets to outdoor boards."

How to Keep Your Visual Creativity Alive

A Brief Anecdote

When I was a design student, I went to see a performance of Mozart's great opera "The Marriage of Figaro." There was a moment in the performance when several characters were lined up on stage and simultaneously sang different parts. Although each part was different, the music and voices blended together to form a unique whole. I thought, *That's how design works. All the parts, as separate and distinct as they are, have to work together to form a whole design and message.* It had finally clicked for me and it came from an operatic performance. Thanks, Amadeus!

There is so much in the world to learn from and so much to inspire us. Whether you find inspiration in nature or a rummage sale doesn't matter. What matters is finding it. Creative visual thinkers seem to find inspiration everywhere. Designers need stimulation and renewal in order to continually come up with creative visual solutions. Dealing with clients, planning, doing research and developing concepts to solve design problems isn't easy. Designers are under a lot of pressure every day to be creative; everyone needs or does something to find stimulation.

Design-Related Suggestions

Designers are the creators of visual artifacts; they reflect contemporary culture and the spirit of their age. They are artists/explorers/interpreters/thinkers. Therefore:

- Analyze other art forms, other designers' work.
- Develop a range—from irreverent to serious, from slapstick to subtle, from large to precious.
- Take pleasure in the process.
- Try different approaches (appropriate for the concept).
- Don't design everything the same way.
- Forget the cliché "If it ain't broke, don't fix it." Sometimes change for the sake of

inspirations

Wade Koniakowsky, Big Bang Idea Engineering, Carlsbad, CA

I live close to the Mexican border, the city of Tijuana to be exact. Tijuana, at least some parts, could be considered a third world culture. As such, there are tremendously low production values in their print advertising, signage, billboards, etc. I find in this a wealth of what I call "accidental design." In internships we do at Big Bang, we send the student to Tijuana with a camera to record examples of this. You'd be amazed how cool some of it is. Billboards that have been pasted up and torn down so many times that the texture and color of the refuse becomes an art form in itself. This is one of the things that inspires me.

change is good and can
stimulate you.

- Refine ideas.
- Make lists.

Sensory Input

A designer needs stimulation and renewal.
Therefore:

- Surround yourself with brilliance—great movies, films, books, painting, sculpture, architecture, other designers, creative people and examples of great work.
- Be playful.
- Use all of your senses.
- Be aware of your environment.
- Do the unexpected.
- Change your schedule.
- Read comedy.
- Learn another artistic medium, like Latin dancing, haiku or playing an instrument.
- See good films.
- Embrace the liberal arts.
- Try another art, like ceramics, photography, sculpture or painting.

Personal

You can't live on design alone and you can't work twenty hours a day and hope to be
creative. Therefore:

- Rest, eat right, exercise and breathe.
- Play.
- Get off the couch.
- Be happy, do stuff, get out, enjoy.

inspirations

Tony Ciccolella, AARP/Washington, DC

Our Web site is putting together a new content area. Originally titled Web Thoughts, it is a periodic questionnaire to site visitors about not-so-serious topics in the news, e.g., George Bush's plane jump—an attempt to have a little bit of fun. It was decided that the main visual on this page would be the results of the previous survey in the form of a pie chart. It was also suggested that the area could take on a newspaper metaphor. All we needed was an appropriate name for the area.

Thinking cap on, I took a stroll for lunch to the Library of Congress (hey, I'm in the neighborhood). I'm inside the library's gift shop, and I pick up a copy of their magazine, *Civilization*. Just on an impulse. Flipping through the pages on the walk back, I see an article in the back of the magazine about statistics. The article title—"American Pie Charts."

Inspiration!

We are calling the site The American Pie. Under the masthead graphic on the page we added the slogan, "Just a Few Slices of Life . . ."

So where do I find inspiration? In the backs of magazines, on long lunch walks, in government building gift shops, or just by plain dumb luck?

My vote is for Plain Dumb Luck (though in Chinatown, the Lumb Duck is pretty good too).

There is a modern (twentieth century) myth about creativity: Only innovation is creative. Not true. New is nice; however, there are many ways to be creative. You don't have to come up with something new to be creative.

Breaking all the rules is cool, but you don't have to be a rebel to be creative, either. Or throw tradition and established design principles out the window. Other periods valued tradition, as do many cultures today. One can simultaneously make use of tradition and be creative.

Creative people are open to possibilities. They are not myopic. They notice things. They carefully listen and observe. They take something and twist, change, recreate or reinvent it. Creative people look at something or hear something and say, "Hey, I could use that to . . ." or "What if I merged this with that?"

When you stay in your comfort zone and do what you always do because it works, you shortchange your creative potential. If there is any secret to staying creative throughout your career, it is this: Stay open to possibilities and be willing to experiment.

And reread this book. ■

permissions

All pieces were used by permission of the design firm.

p. 11 © April Greiman.

p. 13 © Stand for Children/Children's Defense Fund.

p. 15 © George Tscherny, Inc.

p. 16 © Muller + Company.

p. 17 © 1996 Morla Design, Inc.

p. 19 © Carbone Smolan Associates.

p. 21 © 1996 Morla Design, Inc.

p. 23 © DeMartino Design (Studio d).

pp. 24-25 © Carbone Smolan Associates and Herman Miller.

p. 26 © 1996 Vrontikis Design Office.

p. 27 © Edwin Thomason.

p. 29 © 1997 Ellen Bruss Design.

pp. 30-31 © 1996 Nesnadny + Schwartz.

p. 33 (top) © The Knape Group and Bitspit; (center) © The Knape Group and DART; (bottom) © Barbara A. deWilde.

p. 36 (left) © Hornall Anderson Design Works and Talking Rain; (right) © George Tscherny, Inc. and UCLA Extension.

p. 37 © 1995 Matsumoto Incorporated.

p. 38 © Doublespace and Hypermedia Communications.

p. 39 © AARP.

p. 40 (top) © 1993 Matsumoto Incorporated; (bottom) © Mires Design and Agassi Enterprises.

p. 41 © 1996 Nesnadny + Schwartz.

p. 42 © DeMartino Design (Studio d).

p. 43 (left) © Barbara A. deWilde; (right) © 1996 Jack F. Harris, Jr.

p. 44 (left) © Shin Matsunaga; (right) © Studio Reisinger.

p. 45 © Pentagram Design.

p. 46 © Studio Reisinger.

p. 47 (top) © 1995 Joseph Ferratella; (bottom) © Segura Inc.

p. 48 © 1996 Matsumoto Incorporated.

p. 49 © Shin Matsunaga.

pp. 50-51 © Gunter Rambow.

p. 52 © SullivanPerkins.

p. 53 © 1996 Playpen.

p. 54 (left) © Pentagram Design; (right) © Muller + Company.

p. 55 © Primo Angeli Inc.

p. 56 (left) © DeMartino Design (Studio d); (right) © Barbara deWilde.

p. 57 © Doublespace and Rollerblade.

p. 58 (top) © Mires Design and Tsunami Dive Gear; (bottom) © Pentagram.

p. 59 © Studio Reisinger.

p. 60 © Expeditors International and Leimer Cross Design.

p. 61 © April Greiman.

p. 62 © Pentagram Design.

p. 63 © 1997 Sayles Graphic Design.

p. 64 © Muller + Company.

p. 65 © 1997 Global Dining, Inc.

p. 66 © Mires Design and Agassi Enterprises.

p. 67 © Sara Slavin.

p. 68 © Hornall Anderson Design Works and Starbucks Coffee Company.

p. 69 © 1996 Robert Greenhood.

p. 70 © 1996 Sayles Graphic Design.

p. 71 (left) © 1995 Matsumoto Incorporated; (right) Mires Design and Industry Pictures.

p. 72 © 1997 Steven Brower.

p. 73 (top) © Hornall Anderson Design Works and Capons Rotisserie Chicken; (bottom) © 1996 Loved Production.

p. 74 © 1991 Matsumoto Incorporated.

p. 75 © Gunter Rambow.

p. 76 © 1997 Quantum Corporation. Quantum and the Quantum logo are registered trademarks of Quantum Corporation in the US and other countries.

p. 77 © Kazumasa NAGAI and Takeo Co., Ltd.

p. 78 © 1997 Steven Brower.

p. 79 © Rick Eiber Design.

p. 80 © Carbone Smolan Associates and Bettmann Archives.

p. 81 © Shin Matsunaga.

pp. 82-83 © Studio Reisinger.

p. 84 (top) © Hirschmann Design; (bottom) © Muller + Company.

p. 85 (top) © The Knape Group and Station Store; (bottom) © Mires Design and Magic Carpet Books.

p. 86 (left) © Muller + Company; (right) © 1997 Digital Stock.

p. 87 © 1996 Pantone Inc.

p. 88 © Concrete® and Mohawk.

p. 89 © Kazumasa NAGAI and Mitsubishi Electric Co., Ltd.

p. 90 © The Knape Group and Kelley Baseball Company.

p. 91 (left) © Barbara A. deWilde; (right) © Joel Nakamura.

p. 92 © 1997 New England Marionette Opera Ltd.

p. 93 © 1997 April Greiman.

p. 94 © Morla Design and Apple Computer.

p. 95 © Gunter Rambow.

p. 96 © Studio Reisinger.

p. 97 © Joel Nakamura.

p. 98 (left) © Hornall Anderson Design Works and CW Gourmet; (right) © Hirschmann Design.

p. 99 (top) © Design Studio at Kean College; (bottom) © 1995 Strategic Communications.

p. 100 © Muller + Company.

p. 101 © 1996 EvansGroup.

pp. 102-103 © 1997 Taco Del Mar.

pp. 104-105 © 1997 STA Travel.

p. 106 (left) © 1997 Steven Brower; (right) © Mires Design and Nextec Applications, Inc.

p. 107 © Carbone Smolan Associates and The Simpson Paper Company.

p. 108 © Segura Inc.

p. 109 (left) © 1997 Opera North; (right) © Harrison Wilson & Associates and Novartis Pharmaceutical.

p. 110 © Primo Angeli Inc. and Harden & Huyse.

p. 111 © Shin Matsunaga.

p. 112 © Segura Inc.

p. 113 © Kazumasa NAGAI and Mitsubishi Electric Co., Ltd.

p. 114 © Marty Anderson Design Associates, Inc. and The Production Club of Greater Washington.

p. 115 (top) © Hirschmann Design and Colorado Chapter of the American Institute of Graphic Arts; (bottom) © 1997 Sayles Graphic Design.

p. 116 (left) © Barbara A. deWilde; (right) © Gunter Rambow.

p. 117 © 1997 NCR Corporation, Dayton, Ohio USA.

p. 118 © 1995 Sayles Graphic Design.

p. 119 (left) © Muller + Company; (right) © Mires Design and Carl Vanderschuit.

p. 120 © plus design inc.

p. 121 © DeMartino Design (Studio d).

p. 135 © 1997 Steven Brower.

p. 136 © 1997 Steven Brower.

p. 137 © 1997 Steven Brower.

p. 138 © 1996 Rick Eiber Design, Preston, WA.

p. 139 © Martin Holloway Graphic Design.

p. 141 © Concrete® and the Bauer Family.

p. 143 © 1994 Concrete®.

p. 145 © Art O Mat Design.

pp. 146-147 © Margeotes/Fertitta + Partners.

p. 149 © 1985 Tharp Did It.

p. 151 © Hirschmann Design.

p. 152 © DMA and Pershing.

p. 153 © North Carolina Literary Review.

p. 154 © The Knape Group and Dallas Area Rapid Transit.

index